My
GoPro® Hero
Camera

Jason R. Rich

800 East 96th Street,
Indianapolis, Indiana 46240 USA

D1621859

My GoPro® Hero Camera

Copyright © 2015 by Pearson Education, Inc.

ISBN-13: 978-0-7897-5525-4

ISBN-10: 0-7897-5525-4

Library of Congress Control Number: 2015932280

Printed in the United States of America

Second Printing: July 2015

Trademarks

All terms mentioned in this book that are known to be trademarks or service marks have been appropriately capitalized. Que Publishing cannot attest to the accuracy of this information. Use of a term in this book should not be regarded as affecting the validity of any trademark or service mark.

GoPro Hero is a registered trademark of GoPro, Inc. This book is not affiliated with or sponsored by GoPro, Inc.

Warning and Disclaimer

Special Sales

For information about buying this title in bulk quantities, or for special sales opportunities (which may include electronic versions; custom cover designs; and content particular to your business, training goals, marketing focus, or branding interests), please contact our corporate sales department at corpsales@pearsoned.com or (800) 382-3419.

For government sales inquiries, please contact governmentsales@pearsoned.com.

For questions about sales outside the U.S., please contact international@pearsoned.com.

Editor-in-Chief
Greg Wiegand

Senior Acquisitions Editor
Laura Norman

Development Editor
Todd Brakke

Managing Editor
Kristy Hart

Senior Project Editor
Lori Lyons

Copyeditor
Apostrophe Editing Services

Senior Indexer
Cheryl Lenser

Proofreader
Debbie Williams

Technical Editor
Paul Sihvonen-Binder

Editorial Assistant
Kristen Watterson

Compositor
Bronkella Publishing

Graphics Technician
Tammy Graham

Contents at a Glance

Table of Contents

14 Troubleshooting Camera-Related Problems and Overcoming Common Shooting Mistakes 271

About the Author

Jason R. Rich is an accomplished author, journalist, and photographer, as well as an avid traveler. Some of his recently published digital photography-related books include *iPad and iPhone Digital Photography Tips and Tricks* (Que) and *How to Do Everything Digital Photography* (McGraw-Hill). For Que, he also created the *Using Your GoPro Hero3+: Learn To Shoot Better Photos and Videos* video course, and has written numerous other book about the iPhone, iPad, interactive entertainment, and the Internet.

As a photographer, his work continues to appear in conjunction with his articles published in major daily newspapers, national magazines, and online, as well as within his various books. He also works with professional actors, models, and recording artists developing their portfolios and taking their headshots, and continues to pursue travel and animal photography.

Through his work as an enrichment lecturer, he often offers digital photography workshops and classes aboard cruise ships operated by Royal Caribbean, Princess Cruises Lines, and Celebrity Cruise Lines, as well as through Adult Education programs in the New England area. Please follow Jason R. Rich at www.jasonrich.com, on Twitter (@JasonRich7), or on Instagram (@JasonRich7).

Dedication

This book is dedicated to my family and friends, including my niece, Natalie, and my Yorkshire Terrier, Rusty, who is always by my side as I'm writing.

Acknowledgments

Thanks once again to Laura Norman and Greg Wiegand at Pearson for inviting me to work on this project and for their ongoing support. I'd also like to thank Todd Brakke and Kristen Watterson for their assistance, and offer my gratitude to everyone else at Pearson whose talents helped to make this book a reality.

A sincere thank you also goes out to the folks at GoPro for creating such awesome cameras, and to the various third-party companies that have developed innovative mounts and accessories that make these camera so much more versatile.

Finally, thanks to you, the newest members of the global GoPro community, who are about to embark on a fun and exciting photography and videography adventure, as you learn how to fully utilize your GoPro camera.

We Want to Hear from You!

As the reader of this book, *you* are our most important critic and commentator. We value your opinion and want to know what we're doing right, what we could do better, what areas you'd like to see us publish in, and any other words of wisdom you're willing to pass our way.

We welcome your comments. You can email or write to let us know what you did or didn't like about this book—as well as what we can do to make our books better.

Please note that we cannot help you with technical problems related to the topic of this book.

When you write, please be sure to include this book's title and author as well as your name and email address. We will carefully review your comments and share them with the author and editors who worked on the book.

Email: feedback@quepublishing.com

Mail: Que Publishing
 ATTN: Reader Feedback
 800 East 96th Street
 Indianapolis, IN 46240 USA

Reader Services

Visit our website and register this book at quepublishing.com/register for convenient access to any updates, downloads, or errata that might be available for this book.

The GoPro Hero4 is a powerful HD video camera and high-resolution digital camera wrapped up into a single handheld device.

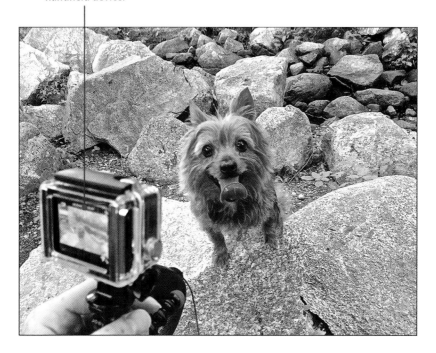

In this chapter, you are introduced to the GoPro cameras and what they can do when used with an appropriate housing and mount for your shooting situation. Topics include the following:

→ Discover the advantages of shooting with a GoPro camera

→ Understand the differences between camera models

→ Learn why using the camera with the proper housing and mount is essential

Overview of the GoPro Cameras

Any point-and-shoot or digital SLR camera can be held in the hands of a photographer and then aimed at an intended subject to snap a photo. However, until recently, if that same photographer wanted to include himself within the photo, shoot outside in harsh weather conditions, or take pictures underwater, that became a more challenging task that required much more elaborate and rather costly equipment.

If that same photographer wanted to capture HD video of his subject in similar circumstances, also up until recently, it required a different set of costly equipment.

Today, using any of the relatively low-cost GoPro camera models, virtually anyone can capture professional-quality and visually stunning high-definition photos and HD video indoors or outdoors, plus shoot in almost any conditions without fear of damaging the equipment. Now, photos and video can easily be shot in snow, rain, or even underwater with minimal preparation.

Plus, because of the ultra-small size of the GoPro cameras, and the vast selection of optional housings and mounts available for them, any of the GoPro cameras can be mounted directly onto someone's body or equipment, enabling them to capture action from a first-person or third-person perspective. This feature alone has transformed the way people capture and share their action or adventure-oriented experiences.

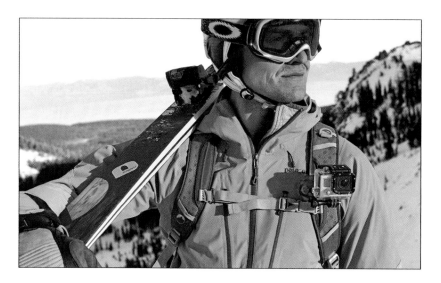

Not only are the GoPro cameras extremely versatile, using one of the GoPro cameras with Wi-Fi (and in some cases Bluetooth) capabilities, it's possible to remotely control the camera from up to several hundred feet away, and then wirelessly transfer photos or videos directly to a smartphone, tablet, or computer to edit that content and then share it in a variety of ways via the Internet.

As soon as you get your hands on a GoPro camera, how you take pictures and shoot video will change forever. Whether you're a proud parent who wants to document moments in your family's life, capture and share the antics of your pet, chronicle your travels, or shoot photos or video of yourself engaged in intense activities—like skateboarding, skiing, snowboarding, surfing, snorkeling, scuba diving, biking, off-roading or skydiving—this and so much more is not only possible using a GoPro camera, but it's also relatively easy and fun to accomplish.

Understanding the Skill and Art of Digital Photography

Think of digital photography and videography as both a skill and an art form. The technology that's built in to today's digital cameras, including the GoPro cameras, is equivalent to what you can find in a computer. Like a computer, a GoPro camera has an operating system, processor, digital storage, menus to navigate, buttons to push, and commands to learn.

Thus, learning how to properly use your GoPro camera requires skill. After all, you need to know which features and functions to use, when to adjust the camera's settings and options, and how to operate the camera.

In addition to this skill set, becoming a skilled digital photographer or videographer also requires creativity. The art form aspect of digital photography/videography involves choosing what to shoot, when to shoot, and how to best frame your shots. For example, after you select your intended subject, you need to determine the best shooting angle or perspective from which to position the camera and then how to best utilize light, based on your current shooting situation.

Many amateur photographers and videographers simply hold the camera in their hands, center their subject within the viewfinder, and then shoot their subject from a head-on perspective. This approach is, in a word, boring. To capture shots and video footage that's visually interesting and artistic, you need to make some creative and subjective decisions as the photographer/videographer. Then, after you shoot your images or video, you need to make creative decisions when editing. Hence, digital photography is also an art form.

What if I'm Not Creative?

Don't worry, even if you don't yet consider yourself to be a creative person or a skilled photographer/videographer, you're about to discover how to tap the capabilities of a GoPro camera and learn how to utilize your own hidden creativity to achieve truly impressive results.

Choosing the Right GoPro Camera for You

GoPro now offers several GoPro camera models, the most popular of which are the low-cost GoPro Hero, the more advanced GoPro Hero3+, and the cutting-edge GoPro Hero4 (Silver or Black editions). As of mid-2015, the Hero4 Black is the most advanced and powerful GoPro camera available.

Appearances Can Be Deceiving

Although all the GoPro cameras are lightweight, battery-powered, and ultra-small, plus they look similar from the outside, each offers slightly different features and functions that directly impact the quality and clarity of the photos or video you can capture.

Depending on your budget, as well as how and where you'd ultimately like to use your camera, it's essential that you select the right GoPro camera model to meet your needs. This is particularly important for shooting high-definition (HD) video.

>>>Go Further

WHERE TO BUY YOUR GOPRO CAMERA AND ACCESSORIES

All GoPro cameras, housings, mounts, and accessories offered by GoPro, Inc. can be purchased directly from the GoPro website (www.gopro.com). However, you can also find these products sold at all popular consumer electronics stores (such as Best Buy), sporting equipment stores (including Easter Mountain Sports and REI), as well as mass-market retailers (including Wal-Mart and Target).

You can also shop online and often find the best deals on these cameras, as well as on third-party accessories, housings, and mounts. Visit Amazon.com or eBay. com, for example, and within the search field, enter **GoPro Camera** or **GoPro Camera Accessories**.

Amazon.com often offers discounted bundle packages that might include a GoPro camera, memory card (which is typically sold separately), and a selection of other accessories, housings, and mounts.

You can also visit the websites for companies that manufacture third-party housings and mounts, such as GoPole (www.gopole.com), Peak Designs (https://peak-design.com) or Octomask (www.octomask.com).

What You Should Know About Digital Camera Resolution

The quality of photos you can take using any digital camera depends directly on its *resolution,* which is measured in megapixels (MP). The more megapixels used to capture an image, the more detail and color vibrancy you can see within the image.

Understanding Megapixels (MP)

A pixel is one tiny dot. A megapixel is composed of one million dots. Thus, when you refer to a digital camera, such as the GoPro Hero4 that shoots digital images at 12 megapixels, this means that each image is composed of approximately 12 million individual pixels.

Higher resolutions translate directly to larger digital file sizes for storing images on the camera's memory card or later on your computer's hard drive. Higher-resolution images require more storage space.

Understand the Basics About HD Video Resolution

The term *high-definition video* (aka *HD video*) is thrown around a lot these days, and most people assume that as long as a camera can shoot HD video, that the video footage they shoot is automatically the highest quality possible. Unfortunately, things aren't that simple.

There are several industry-standard HD resolutions, including 720p, 1080p, 2.7K and 4K. Like digital photographs, video resolution is also measured in pixels, or individual colored dots that together form a single frame within your video footage.

For example, video shot at 720p uses a frame size of 1,280 by 720 pixels, so each frame is composed of 921,600 individual pixels. Video shot at Ultra HD (4K) resolution is typically 4096 by 2160 pixels per frame. The following graphic offers a visual comparison that can help you understand HD video resolution.

Keep in mind, the higher the resolution, the more vibrant and detailed your video footage will be because a lot more information is captured within each frame. Plus, your field of view when shooting in HD or Ultra HD is much wider.

In addition, depending on how you plan to edit and showcase your HD or Ultra HD video footage, you need to consider how many frames per second (FPS) at which you need to shoot.

Typically, HD video is shot at 24 frames per second. However, the higher the FPS, the more editing versatility you have to showcase your footage in ultra-slow motion.

Use a Higher FPS Setting When Shooting Fast Action
You'll typically want to capture high action at a higher frames per second rate, so you have more editing options when cropping the frame or choosing a playback speed.

Also, when shooting HD video, consider your *field of view* (*FOV*). All HD television sets display a rectangular-shaped video image. How much is visible to the sides of your shots when the camera is facing forward is what FOV refers to. For example, some GoPro cameras can shoot using a Narrow, Medium, or Ultra Wide FOV.

When you combine these three factors—resolution, FPS, and FOV—literally dozens of possible combinations are available for capturing your HD video. As you'll soon discover, shooting at 30 FPS, 4K resolution, using an Ultra Wide FOV doesn't always make the most sense, nor is this the most practical.

The higher the resolution, FPS, and FOV you choose, the larger your digital video file sizes. Thus, to capture video at 30 FPS, 4K resolution using an Ultra Wide FOV, you need to use a microSD memory card with an extremely high-storage capacity to store your raw footage. Then, you need a computer with a large capacity hard drive, plenty of RAM, a fast processor, and a 4K-compatible display to later view and edit the footage.

It's Not All Good

Not All Televisions Can Display 4K Resolution

Only the newest and most cutting-edge television sets display HD video in 4K resolution. The 720p or 1080p HD television sets that make up the bulk of televisions sold over the last 10 years are not compatible with video shot in 4K video resolution.

You'll learn more about video resolution, FPS, and FOV in Chapter 10, "Shooting HD Video," and Chapter 13, "10 Strategies for Shooting Awesome HD Video," but for now, you need to understand that the various GoPro camera models offer a different selection of video-shooting options.

Comparing GoPro Camera Models

As of mid-2015, GoPro offered five different GoPro camera models, including the GoPro Hero, GoPro Hero3 White, GoPro Hero3+ Silver, GoPro Hero4 Silver, and the GoPro Hero4 Black.

Much of the information offered throughout this book applies to all these models, but as you learned in this chapter, each model's capabilities vary.

Table 1.1 offers an at-a-glance comparison between these camera models and some of their key features; although throughout this book, much more emphasis is placed on using the more advanced shooting features built in to the GoPro Hero3+ and Hero4 cameras.

Table 1.1 At-a-Glance GoPro Camera Comparison

	GoPro Hero	GoPro Hero3 White
Suggested Retail Price	$129.99	$199.99
Camera Resolution for Digital Images	5MP	5MP
WGVA Video Resolution	Not Available	50 or 60 FPS (Ultra Wide FOV)
720p Video Resolution	50 or 60 FPS (Ultra Wide FOV)	25, 50, or 60 FPS (Ultra Wide FOV)
720p SuperView Video Resolution	50 FPS (Ultra Wide FOV) or 60 FPS	Not Available
960p Video Resolution	Not Available	25 or 30 FPS (Ultra Wide FOV)
1080p Video Resolution	25 or 30 FPS (Ultra Wide FOV)	25 or 30 FPS (Ultra Wide FOV)
1080p SuperView Video Resolution	Not Available	Not Available
1140p Video Resolution	Not Available	Not Available
2.7K (4:3) Video Resolution	Not Available	Not Available
2.7K Video Resolution	Not Available	Not Available
2.7K SuperView Video Resolution	Not Available	Not Available
4K Video Resolution	Not Available	Not Available
4K SuperView Video Resolution	Not Available	Not Available
Simultaneous Photo & Video Shooting	No	No
Wi-Fi + Bluetooth Capabilities	No	Wi-Fi Only

Note: FPS = Frames Per Second, FOV = Field of View

GoPro Hero3+ Silver	GoPro Hero4 Silver	GoPro Hero4 Black
$299.00	$399.99	$499.99
10MP	12MP	12MP
50, 60, 100 or 120 FPS (Ultra Wide FOV)	240 FPS (Ultra Wide FOV)	240 FPS (Ultra Wide FOV)
25, 30, 50, 60, 100, or 120 FPS (Ultra Wide, Medium, or Narrow FOV)	25, 30, 50, 60, 100, or 120 FPS (Ultra Wide, Medium, or Narrow FOV)	25, 30, 50, 60, 100, or 120 FPS (Ultra Wide, Medium, or Narrow FOV)
Not Available	50, 60, or 100 FPS (Ultra Wide FOV)	50, 60, or 100 FPS (Ultra Wide FOV)
25, 30, 50, or 60 FPS (Ultra Wide FOV)	50, 60, or 100 FPS (Ultra Wide FOV)	50, 60, or 120 FPS (Ultra Wide FOV)
25, 30, 50, or 60 FPS (Ultra Wide, Medium, or Narrow FOV)	24, 25, 30, 48, 50, or 60 FPS (Ultra Wide, Medium, or Narrow FOV)	24, 25, 30, 48, 50, 60, 90, or 120 FPS (Ultra Wide, Medium, or Narrow FOV)
Not Available	24, 25, 30, 48, 50, or 60 FPS (Ultra Wide FOV)	24, 25, 30, 48, 50, 60, or 80 FPS (Ultra Wide FOV)
Not Available	24, 25, 30, or 48 FPS (Ultra Wide FOV)	24, 25, 30, 48, 50, 60, or 80 FPS (Ultra Wide FOV)
Not Available	Not Available	25 or 30 FPS (Ultra Wide FOV)
Not Available	24, 25, or 30 FPS (Ultra Wide or Medium FOV)	24, 25, 30, 48, or 50 FPS (Ultra Wide or Medium FOV)
Not Available	Not Available	25 or 30 FPS (Ultra Wide FOV)
Not Available	12.5 or 15 FPS (Ultra Wide FOV)	24, 25, or 30 FPS (Ultra Wide FOV)
Not Available	Not Available	24 FPS (Ultra Wide FOV)
No	Photo Every 5, 10, 30, or 60 Seconds, or Manual	Photo Every 5, 10, 30, or 60 Seconds, or Manual
Wi-Fi Only	Yes	Yes

The Camera's Software Can Add New Features

Every GoPro camera has a built-in and upgradable operating system (just like a computer), which GoPro calls the Camera Software. Periodically, GoPro updates this software, which gives some or all GoPro camera models new or enhanced features and functions.

For example, in early 2015, the GoPro Software update introduced a Time Lapse video mode, 30/6 Burst photo mode (meaning the camera captures 30 digital images in six seconds), and an Auto Rotate feature, along with the option to record video at 720p, 240fps, and 2.7K 60fps to the Hero4 Black camera.

To fully utilize any of the GoPro camera models, you need to use it with an optional housing and potentially an optional mount, which are sold separately. These options will be discussed in Chapter 3, "Overview of GoPro Camera Housings," and Chapter 4, "Overview of GoPro Camera Mounts."

A handful of optional accessories are also available, such as the LCD Touch BacPac display and the Smart Remote, which make working with many of these cameras much easier. GoPro offers camera bundles, like the GoPro Hero4 Black Music and GoPro Hero4 Black Surf editions, which also come with a selection of specialized accessories, along with the camera itself.

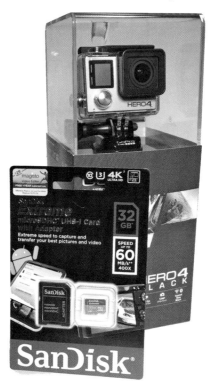

What's not included with any GoPro camera, but that's needed to use it, is a microSD memory card. See Chapter 6, "Choosing the Best Memory Cards for Your GoPro Camera," for more information about choosing the best memory card to meet your needs.

USE YOUR GOPRO TO SHOOT FROM UNIQUE PERSPECTIVES

Earlier, I talked about how GoPro cameras are designed to be worn by the photographer or videographer (or mounted on equipment he's using), allowing photos or video to be shot from a first-person perspective. In other words, the viewer sees the action from the photographer or videographer's point-of-view.

Using certain mounts or accessories, you can also shoot from a third-person perspective, allowing the viewer to see the photographer or videographer in the shot as she's engaged in an activity. What's great about many of these mounts is that you can securely position the camera at the perfect height and angle to capture your subject.

Because of its small size and durability, your GoPro camera can shoot at unique angles, in situations in which other cameras could not function. I cover the techniques for shooting photos or video from each of these perspectives throughout this book.

The GoPro Hero Is Ideal for Beginners

Priced at $129.99, the GoPro Hero offers the fewest options for shooting digital images or HD video. In every sense of the word, this is a consumer-oriented camera. Despite its limitations with all the available housings, it is waterproof, shock-resistant, highly-durable, and useful in a wide range of shooting situations.

Lower-End Cameras Shoot at Lower Resolutions

As a still camera, the lower-end GoPro Hero camera shoots at just 5MP resolution.

For video, this entry-level GoPro Hero can shoot at 720p or 1080p resolution only and offers far fewer FPS and FOV options. Another drawback to this camera model is that it does not offer Wi-Fi or Wi-Fi + Bluetooth capabilities. Thus, you cannot remotely control the camera using the optional GoPro Smart Remote, nor can you wirelessly control it from your smartphone or tablet using the optional GoPro App.

Anytime you want to transfer images from the camera's microSD memory card, you must either remove the card from the camera and insert it into a memory card reader that's connected to your computer or mobile device, or connect a USB cable between your camera and computer or mobile device.

It's Not All Good

Sorry—No Upgrades Available

Keep in mind that the GoPro cameras are not upgradable. Most people, regardless of their digital photography or videography skill level, appreciate the more advanced features and better shooting resolutions offered by the GoPro Hero3+ or GoPro Hero4. You should consider making the additional financial investment to acquire one of these higher-end camera models.

The GoPro Hero3+ Is a Full-Featured Camera

Before the GoPro Hero4, the GoPro Hero3+ represented GoPro's top-of-the-line camera. The Hero3 White and Hero3+ Silver continue to be viable options for more advanced digital photographers and videographers who want to capture higher-quality digital images and video footage in a wide range of shooting situations.

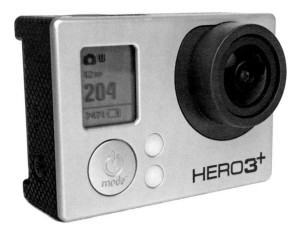

What the Hero3+ camera lacks is the capability to shoot in 4K video resolution, which is one of the key advantages of the latest Hero4 model. Being able to shoot at 4K resolution is a feature mainly used by professional videographers and/or people who have access to a 4K resolution television set or monitor.

Each GoPro Camera Model Offers Different Shooting Capabilities

One of the most noticeable differences between the GoPro Hero3 White and the GoPro Hero3+ Silver is the resolution when shooting still digital images (5MP versus 10MP, respectively). When shooting at 1080p HD video resolution, you also have more FPS and FOV options when using the GoPro Hero3+.

The GoPro Hero3+ is ideal for adventure enthusiasts who want to capture high-resolution photos and videos while engaging in many types of activities. Because of its Wi-Fi capabilities and other shooting features, it can be remotely controlled, plus it offers a plethora of other useful features and functions that make it versatile.

The GoPro Hero4 Offers Cutting-Edge Functionality

In addition to offering 12MP resolution when shooting still images, the GoPro Hero4 has the capability to capture Ultra HD video (4K resolution), which is currently the highest resolution that consumer-oriented television sets and computer monitors display.

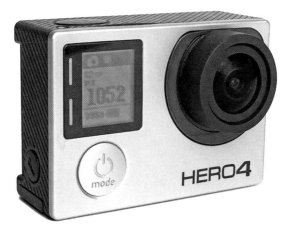

The GoPro Hero4 has shooting modes that work particularly well in low light or at night. For some, the camera's capability to shoot video and capture digital photos at the same time is also a useful feature.

This top-of-the-line GoPro model is best suited to serious digital photography or videography enthusiasts and professionals, as well as to hard-core adventure seekers who want to capture every aspect of their activities in extreme detail, regardless of the shooting conditions.

Digital Camera Technology Is Always Changing

As with every aspect of consumer technology, the technology built in to GoPro cameras evolves quickly. By the time you read this book, more advanced GoPro camera models may be available, with higher-resolution photo and video shooting options. If this is the case, and your budget allows, seriously consider acquiring the most-advanced camera you can afford.

Using Housings to Protect Your Camera

GoPro cameras are rather fragile and can easily be damaged by water, dirt, physical abuse, or harsh weather conditions. However, when a camera is sealed within many of the optional housings, it becomes waterproof, shockproof, and extremely durable in hot or cold climates.

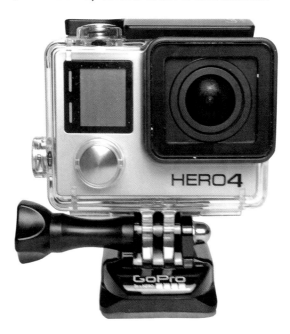

Unless the GoPro camera is fully encased within a sealed GoPro camera housing, it will not be protected against water, dirt, physical abuse, or other harsh conditions. One of the keys to getting the best results from your GoPro camera is to choose the best housing for the shooting situation at hand.

It's Not All Good

Not All Housings Are Alike

Not all GoPro camera housings offer equal protection. Some are designed to offer full waterproof protection, as well as protection against dirt and physical damage. Other housings do not fully encase the camera. These are not waterproof. Instead, they're used to offer some protection against physical damage and dirt, while giving users access to the camera's ports and built-in microphone.

The GoPro Standard Housing is waterproof (to a depth of about 131 feet). Meanwhile, the GoPro Dive Housing is fully waterproof to a depth of about 197 feet. This is the type of housing you should use when swimming, surfing, snorkeling, scuba diving, water skiing, jet skiing, kayaking, or boating.

The optional Skeleton Housing offers some protection for the camera lens and body against physical abuse, while giving the photographer or videographer full access to the camera's ports. This is important if you want to shoot video and capture sound using an external microphone. When using the Skeleton Housing, the camera is neither waterproof nor shockproof.

The camera housings are designed to fit the GoPro camera perfectly and encase it. Each optional housing has two sections that are detachable. The front of the housing protects the front and sides of the camera body (including the lens). The back of the housing protects the camera body's back.

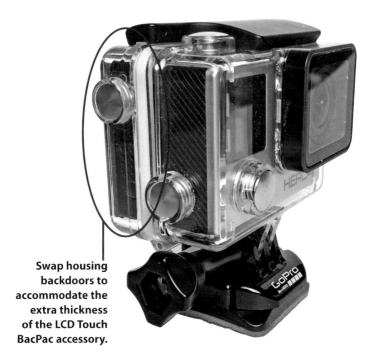

Swap housing backdoors to accommodate the extra thickness of the LCD Touch BacPac accessory.

The optional LCD Touch BacPac or Battery BacPac increases the thickness of the camera body. Thus, you need to attach an appropriate housing backdoor to properly protect your camera.

Each housing comes with multiple backdoor options. A Standard Backdoor can be used with the camera alone. The Touch Backdoor can be used with the LCD Touch BacPac, so you can use your finger to access the touch screen while the camera is within a housing. The Skeleton door offers access to certain ports and doors while the camera is encased.

When using the LCD Touch BacPac or Battery BacPac, a specially sized backdoor is available that houses the camera body and one of these accessories in a waterproof environment, which offers the maximum protection.

Learn About Housing Options in Chapter 3

You learn more about the various GoPro housing options and how to best use them from Chapter 3, "Overview of GoPro Camera Housings."

Taking Better Shots Using Mounts

Whether you shoot photos or video, it's essential that you keep the camera as steady as possible (avoid shaking), even if you engage in a high-action or fast-paced activity.

Although the GoPro cameras are small and easily fit in the palm of your hand, if you try holding the camera while you shoot, it becomes susceptible to the shaking and movement of your hands. Even if you avoid too much excessive shaking, your fingers often get in the way of the lens, and get in your shots. In addition, if you engage in some type of activity, chances are you need your hands for that and can't properly hold the camera.

To help keep the camera as steady as possible, plus provide hands-free operation while shooting, a wide range of optional mounts are available.

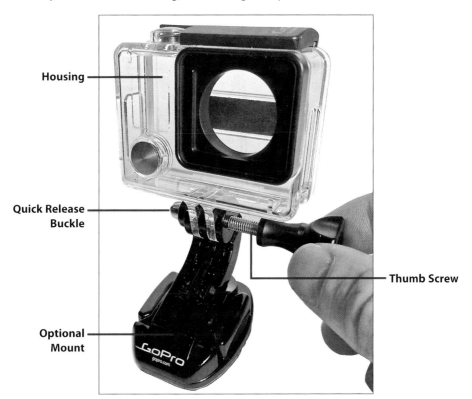

Housing

Quick Release Buckle

Thumb Screw

Optional Mount

These mounts enable you to connect the camera to a traditional tripod, monopod, to yourself, or to all sorts of special equipment. There are optional mounts that enable you to attach the GoPro camera directly to your hat, safety helmet, chest, wrist, surfboard, skis, skateboard, bicycle, rifle or gun, musical instrument, vehicle, scuba or snorkeling mask, or even your dog.

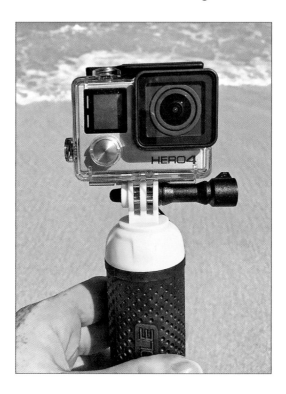

Extension arms, flexible tripods, handheld grips, and other mounts can give you more versatility for attaching your camera to something to capture yourself (or your intended subject) from a traditional, first-person or third-person perspective.

Choosing the Right Mount Matters

For a variety of reasons, the most important of which is to securely hold your camera in place, while also avoiding excessive shaking, it's essential that you use the appropriate mount with the appropriate housing to achieve the best results based on your shooting situation.

On its own, the GoPro camera cannot float; although, with the proper housing, it is waterproof. When swimming, waterskiing, surfing, snorkeling, or scuba diving, you want to securely attach the camera to an optional accessory, such as the Bobber, which serves as both a handle and brightly colored floatation device. For scuba diving or snorkeling, you can securely attach the camera directly to one of Octomask's dive masks (www.octomask.com).

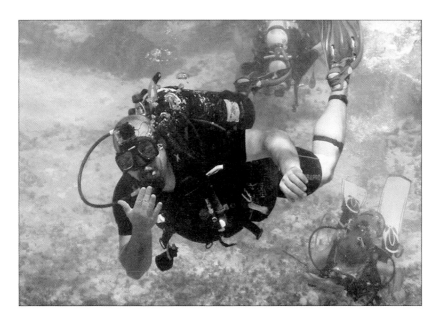

Learn About Mounts in Chapter 4

In Chapter 4, "Overview of GoPro Camera Mounts," you discover literally dozens of optional and specialized camera mounts available from GoPro and third-party companies.

Making Better Use of Camera Features Using Accessories

Beyond protecting the camera with a housing and securing it to a mount that then enables you to attach the camera directly to your body or specialized equipment, a variety of optional accessories are available for the GoPro cameras that further expand their capabilities.

Although Chapter 5, "Must-Have GoPro Camera Accessories," showcases a wide range of these optional accessories, one that you should definitely consider is the LCD Touch BacPac screen.

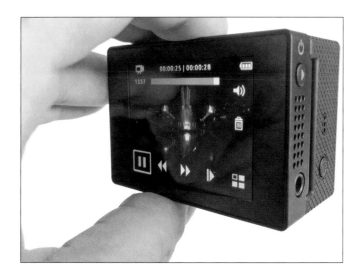

Not only does the optional LCD Touch BacPac provide your camera with a full-color viewfinder as you shoot, but it also makes it much easier to adjust the camera's settings and work with the interactive menu system used by the camera's operating system.

Another extremely useful accessory is the optional Smart Remote, which is a handheld device that enables you to remotely control the camera from up to 600 feet away. This remote control device is waterproof (up to 33 feet).

The GoPro App Has Several Uses

If you're a smartphone or tablet user, the free GoPro mobile app enables you to remotely (wirelessly) control your compatible GoPro camera from your mobile device.

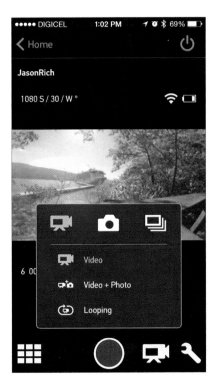

The GoPro mobile app enables your iOS (shown), Android, or Windows Mobile smartphone or tablet's screen to serve as your camera's viewfinder; while at the same time, you can remotely adjust the camera's settings and activate the shutter button.

When you finish shooting, the GoPro mobile app enables you to transfer your digital images or video footage (assuming the content was shot in a resolution that's compatible with the app) from the camera's memory card directly to the mobile device, where you can view, edit, and then share your content via the Internet.

Most GoPro Cameras Have a Wireless Mode

Depending on your GoPro camera model, a wireless connection can be established when your camera and mobile device connect to the same Wi-Fi network (which some GoPro cameras can generate), and Bluetooth wireless connection.

After you transfer photos to your mobile device, you can use a third-party app to enhance or edit the images and then share them via Facebook, Instagram, or email. You can also use a video editing app on your mobile device to edit your raw video footage and then upload it to YouTube or Facebook without ever needing a computer.

Learn More About the GoPro Mobile App

Chapter 15, "Using the GoPro Mobile App," covers how to use the GoPro mobile app, and in Chapter 17, "Sharing Your Photos and Videos," you learn more about third-party photo and video-editing software.

The GoPro Studio Software Offers Professional Video-Editing Tools

To edit your HD video on your desktop or notebook computer, the free GoPro Studio software for PCs and Macs offers a powerful yet surprisingly easy-to-use toolkit for editing video and achieving professional-quality results.

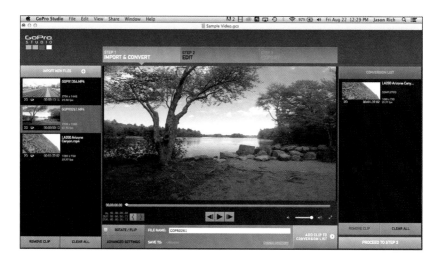

Using the GoPro Studio software, you can add titles, animated scene transitions, sound effects, and background music to your video production.

You can also use third-party video editing software packages for PCs and Macs, such as Apple's iMovie and RePlay for the Mac, which enable you to import your raw video that was shot using a GoPro camera, and then edit and share your content.

Gathering Your GoPro Equipment

As you begin to gather together everything you need to shoot professional-quality photos and video using your GoPro camera in specific shooting situations, use the following checklist to ensure you have everything needed at your disposal:

- The GoPro camera (See Chapter 2, "Getting Started.")

- Appropriate camera housing (See Chapter 3.)

- Appropriate camera mount (See Chapter 4.)

- Camera accessories, such as the LCD Touch BacPac, Smart Remote, battery charger, and USB connection cable (See Chapter 5.)

- One or more microSD memory cards with ample storage space available (See Chapter 6.)

- At least one or two fully charged GoPro camera batteries (See Chapter 7, "Keeping Your Batteries Charged.")

- External microphone and the optional 3.5mm Mic Adapter (See Chapter 11, "Capturing Sound and Using Artificial Light While Shooting Video.")

- External lighting (See Chapter 12, "Adjusting the Camera's Setup Menu Options.")

- Your smartphone or tablet with the GoPro App installed (See Chapter 15.)

Throughout this book, you'll discover how to best use your GoPro camera, in addition to the optional housings, mounts, and accessories, to best capture your intended subject, whether you use the GoPro as a traditional point-and-shoot camera or video camera, or you use it to capture action from a first-person or third-person perspective.

Every GoPro camera comes bundled with the camera, one battery, a Standard Housing, a USB cable, at least one mount, and several other accessories.

In this chapter, you learn all about the GoPro camera. Topics include the following:

→ An overview of the camera's buttons, ports, and Status Screen

→ How to set up the camera to shoot photos or video for the first time

→ More information about controlling the camera remotely

2

Getting Started with Your GoPro Camera

Your GoPro camera comes packaged with almost everything you need to start shooting photos or videos. However, depending on which camera model and bundle configuration you select, the contents in the box vary, and additional equipment and accessories are required.

The GoPro Hero4 Black, for example, comes with the camera, a Standard Housing, one rechargeable battery, two basic mounts, a three-way pivot arm (which works with a mount), two Quick Release Buckles (one for each mount), a USB cable, and a Skeleton Backdoor for the housing.

Other Hero4 bundles, such as the Hero4 Black/Surf and Hero4 Black/Music, are available from GoPro and include different mounts and accessories.

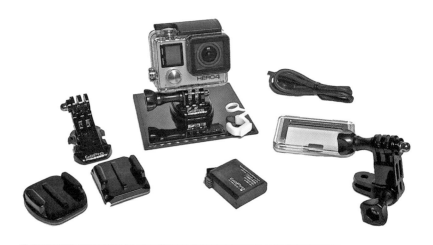

Memory Card Not Included

What's not included with the camera is the required microSD Memory Card. You learn more about microSD Memory Cards in Chapter 6, "Choosing the Best Memory Cards for Your GoPro Camera."

Overviewing the GoPro Camera's Body

The GoPro camera is tiny and lightweight. The Hero4 weighs just 3.1 ounces. (Other models weigh less.) However, it's packed with technology and comes preinstalled with a robust operating system.

Before you begin taking photos or shooting video, you must become acquainted with the camera so that you know how to prepare it to get the best possible results.

It's Not All Good

Accessing Buttons When Using a Housing

Even when your GoPro is fully encased within a housing, you can still manually access all its buttons, including the Power/Mode and Shutter/Select buttons. However, unless you use the optional Skeleton Housing, you do not have access to the camera's ports or SD memory card slot. To access the battery compartment, the camera must be removed from its housing altogether.

The Front of the Camera

The front of most GoPro camera models, including the Hero4 (shown here without a housing) contains four important components: the lens, the LCD Status Screen, the camera's Power/Mode button, and two Status Lights.

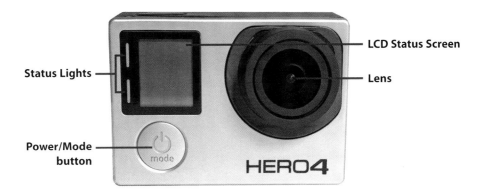

Status Lights

LCD Status Screen

Lens

Power/Mode button

HERO4

- **Lens:** All models of GoPro are equipped with a fixed, ultra-wide lens. The lens is designed to capture photos or videos with an extremely wide field of view; although, some of its shooting modes enable you to switch from ultra-wide to a medium or narrow field of view. There is no zoom feature built into the lens.

- **Power/Mode button:** Use the circular silver button on the front of the camera to turn on the camera's power and to manually switch between the main shooting modes and options, such as Video, Photo, Multi-Shot, Playback, and Settings.

- **LCD Status Screen:** Using text, numbers, and tiny graphic symbols, this display showcases information related to what your camera is currently set to do.

- **Status Lights**: There are two small, colored LED lights on the front of the camera. The blue light is the Wireless Status (if applicable). The red light indicates the Camera Status. Depending on your camera model, the appearance of these lights varies slightly. The camera often generates audible beeps in addition to using these Status Lights.

It's Not All Good

Power/Mode Button Doesn't Work

If you press the Power/Mode button to turn on the camera and nothing happens, this is typically because there is no battery installed within the camera or the battery is dead.

If you need to reset the camera, press and hold the Power/Mode button for 8 seconds. All your content and custom settings will be saved, and the camera will reset. This should rarely, if ever, need to be done.

The Back of the Camera

On the back of some GoPro camera models is a door to the battery compartment, as well as the camera's proprietary Hero Port, which allows you to connect either the optional LCD Touch BacPac or Battery BacPac accessory. For example, the Hero3+ model has this configuration. You can also find another red LED Status Light.

Bottom Battery Access
The battery compartment access for the Hero4 is on the bottom of the camera.

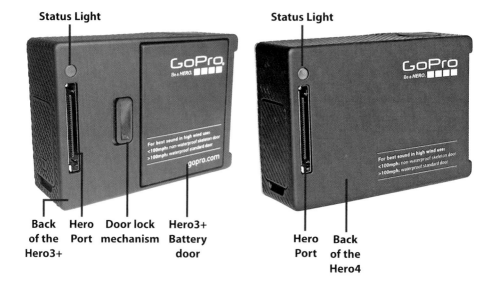

Status Light · Status Light

Back of the Hero3+ · Hero Port · Door lock mechanism · Hero3+ Battery door · Hero Port · Back of the Hero4

- **Battery compartment:** Most of the GoPro cameras are powered using small interchangeable and rechargeable batteries. On some camera models, including the Hero3+, access to the battery compartment is located on the back of the camera. Use your finger to move the lock mechanism from right to left, and then remove the battery door to access the battery compartment.

- **Status Light:** This is one of four red camera Status Lights located on the camera's body. All the red camera Status Lights indicate the same information but are visible from different angles while you use the camera.

- **Hero Port and corresponding latch:** Connect the GoPro LCD Touch BacPac or Battery BacPac to the back of your camera by first lining up either accessory's latch with the camera's port latch and then inserting the accessory's port connector into the camera's Hero Port.

One Battery Isn't Always Enough

The GoPro camera comes with one battery. Due to the relatively short battery life each offers, you should consider investing in at least one or two additional batteries to extend your available shooting time. Be sure to purchase the appropriate batteries for your specific camera model.

You can find more information about using the GoPro camera with its rechargeable batteries, and where to acquire additional batteries that are compatible with your camera in Chapter 7, "Keeping Your Batteries Charged."

The Right Side of the Camera

With the front of the GoPro camera facing toward you as you hold it, on the right side of the camera's body is the port door. Remove this door to reveal several of the camera's ports, as well as the microSD Memory Card slot.

Audio Alert microSD
Speaker Card slot

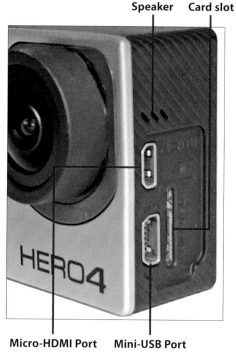

Port Door Micro-HDMI Port Mini-USB Port

- **Micro-HDMI Port:** Using an optional cable (sold separately), you can connect your camera directly to an HD television to view the digital photos and video files that are stored on your camera's memory card while the card is still in the camera.

- **Mini-USB Port:** The USB cable that came with your GoPro camera works with this port. After you use this cable to connect your camera directly to your computer, you can recharge your camera's battery or transfer photos or video stored within the camera's memory card without first removing the card from the camera.

- **microSD Memory Card slot:** Before you begin shooting, a microSD Memory Card (sold separately) must be inserted into the camera. This is where your digital photos and video are stored until you transfer them to your computer or mobile device where you can view, edit, and permanently store them. After a memory card is full, you can insert another card and continue shooting or transfer the content from the existing memory card to your computer or mobile device, reformat that card (to delete its contents), and then continue shooting on that same card.

Wired or Wireless

Between the camera and a computer, the content transfer process requires the supplied USB cable. To transfer content between the memory card (that's installed within the camera) and a smartphone or tablet, this process is done wirelessly via a Wi-Fi/Bluetooth connection and the GoPro App.

About microSD Memory Cards

As you'll discover shortly, the microSD Memory Card to be used with your GoPro camera must have a Class 10 or UHS-1 rating and can have a capacity up to 64GB.

In addition to the card's storage capacity, you also should consider its read/write speed. Be sure to read Chapter 6 before investing in memory cards.

CONNECT YOUR GOPRO CAMERA DIRECTLY TO AN HD TV

The optional Micro-HDMI cable ($19.99) that's available from GoPro's website (or any authorized GoPro dealer) enables you to connect your camera directly to an HD television set or monitor to view what you've shot, before transferring the content elsewhere. This is necessary if you are not using the optional LCD Touch BacPac display or the GoPro mobile app to view content because there is no viewfinder/playback screen built in to the GoPro camera.

To do this, connect the HDMI cable to your GoPro and your television, and set your TV to the appropriate input. Then, select the Playback option from the camera's Settings menu.

If you want to connect your camera directly to a Composite television set or monitor using the Red, Yellow, and White RCA jacks that are built in to the television, instead of using the optional Micro-HDMI cable, you need to use the optional Mini USB Composite cable ($19.99) that's also available from GoPro's website or from any authorized GoPro dealer.

The Left Side of the Camera

What's on the left side of the camera varies slightly between camera models. On the Hero3+, for example, you can find the Wi-Fi On/Off button and a tiny Audio Alert speaker. On the Hero4, you can find the Settings/Tag button, as well as the latch to access the battery door (located on the bottom of the camera). Also on the Hero4, you can use the Settings/Tag button while you film video to manually mark key moments so that you can easily find them later when editing the content.

The Top of the Camera

Located on the top of the GoPro camera is the Shutter/Select button, another red Status Light, and a built-in microphone.

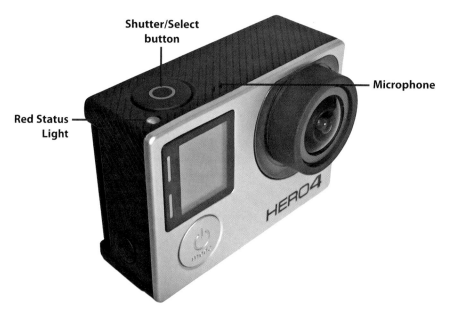

Shutter/Select button

Microphone

Red Status Light

- **Shutter/Select button:** Use the Shutter/Select Button to snap each photo when the camera is in Photo mode (unless you're remotely controlling the GoPro camera using the Smart Remote or GoPro mobile app). When the camera is in Video mode, the Shutter/Select Button starts and stops the recording process. When navigating through the menu options displayed on the Status Screen, use the Shutter/Select button to select and set a displayed menu option.

- **Status Light:** This is another of the four red Camera Status Lights located on the camera's body. All the red Camera Status Lights indicate the same information but are visible from different angles.

- **Microphone:** When shooting video, your GoPro camera is designed to simultaneously record audio. You can use the camera's built-in micro-phone for this purpose. To record audio with better quality, connect an external microphone to your camera via the camera's Mini-USB port. However, to do this, in addition to an external microphone (sold sepa-rately), you need the optional 3.5mm Mic Adapter. You'll learn more about this in Chapter 11, "Capturing Sound and Using Artificial Light While Shooting Video."

The Bottom of the Camera

On the majority of the GoPro camera models, nothing is located on the bottom of the camera body. However, on the bottom of the GoPro Hero4 (shown here), you can find the door for the camera's battery compartment.

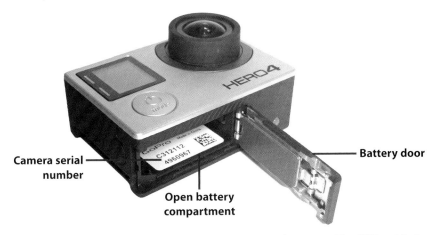

Camera serial number

Open battery compartment

Battery door

To recharge your camera's battery, you have several options. The USB cable is inserted into the camera's Mini-USB port and can be connected to your computer (via its USB port), or to an optional wall charger ($39.99). An optional auto charger ($29.99) is also available for charging on the go.

An easier option is to purchase an external battery charger, such as GoPro's Dual Battery Charger for Hero3+/3 ($29.99) or the Dual Battery Charger + Battery for Hero4 ($49.99). These chargers, which are available from the GoPro website (or authorized GoPro dealers), enable you to recharge two batteries simultaneously using a standard electrical outlet. The camera is not needed to charge the batteries when using an optional battery charger.

Thus, you can use one charged battery within the camera while you're shooting and have two spare batteries charging simultaneously in the charger.

Many other, less expensive, single and dual battery chargers are available from third parties.

Battery Life

Depending on the GoPro model and specific camera features you use, the average battery life per charge will vary greatly. For example, the Hero4 can shoot 4K video at 30fps for approximately 1 hour per battery charge with the Wi-Fi/ Bluetooth feature turned off. However, if you use the LCD Touch BacPac with the Hero4 camera, and Wi-Fi, the battery life is considerably shorter because these options require additional power to function.

Exploring the LCD Status Screen

Whether you're preparing your camera to shoot photos or video, or you're actually engaged in the shooting process, the information that displays on the LCD Status Screen is important.

Status Varies Among Camera Models

The location and appearance of options displayed on the Status Screen, as well as what options are available from the various menus, vary based on the GoPro camera model you use, as well as which version of the Camera Software is installed. Menu options are also impacted by what optional equipment is connected to the camera. What you see here is meant to give a general overview. You'll see more details in forthcoming chapters.

Depending on what you're doing at any given moment with the camera, the Status Screen displays multiple pieces of information at once. The information can be in the form of text, numbers, and symbols. The figure included here shows an overview of the basic information and where it appears.

Field of View

Camera Mode

Spot Meter
(On/Off)

Current
Resolution/
Frames Per
Second setting

Protune option
status (On/Off)

Number of files
shot and stored
on memory card

Video recording
time remaining
on microSD card

Wireless status
(On/Off)

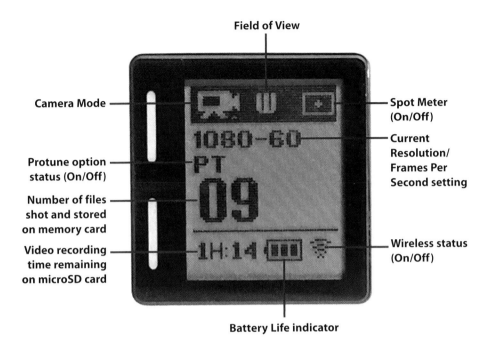

Battery Life indicator

PROTUNE IS A MORE ADVANCED SHOOTING OPTION

Depending on which GoPro camera model you use, the Protune option may be available just for shooting video, or for the Hero4, it's available when shooting photos or video. The older and lower-end camera models do not offer this feature.

Protune enables you to achieve more professional-quality results because you can manually tinker with and fine-tune specific aspects of the camera's operation.

For example, when shooting video using Protune on a Hero4, you can manually adjust White Balance, Color, ISO Limit, Sharpness, and EV Comp, which are options you'll learn more about within Chapter 10, "Shooting HD Video."

When you turn on the camera, its currently selected Shooting Mode displays, followed by details pertaining to that shooting mode. Press the Power/Mode button on the front of the camera to toggle between the Shooting Mode options, which include

- **Video:** Select this option to begin shooting HD video using the default video shooting options or options you previously set from the Settings menu.

- **Photo:** Select this option to begin shooting high-resolution digital photos using the default Photo options or options you previously set from the Settings menu.

- **Shooting/Multi-Shot Mode:** When shooting still images, the Power/Mode button switches between the Burst and Time Lapse shooting modes. You can customize these shooting options from the Settings menu.

- **Playback:** This main menu option is displayed only when your camera is connected directly to a television set or monitor (using an optional cable), or the LCD Touch BacPac is connected to the camera.

- **Settings:** From this menu, you can customize dozens of camera-related settings, as well as many options related to specific shooting modes and shooting resolutions. After you customize any of these settings, they'll remain saved and active until you manually change them. For example, if you set up the camera's default shooting mode to be Photo, anytime you turn on the camera, it will automatically be set to shoot still digital images in the resolution you've previously set.

When the wanted option or shooting mode displays on the Status Screen, press the Shutter/Select button to select and activate it.

Your GoPro camera utilizes a rather complex menu hierarchy, which gives you manual access to a wide range of camera features and functions directly from the camera. To make this a bit easier to understand, you learn about specific camera and shooting-related features and functions throughout this book, and how to adjust related menu options and settings in the context of their use.

The exact same information can be displayed on the Status Screen, Touch BacPac display, and within the GoPro App. However, it is much easier to customize the menu options and adjust camera settings using the LCD Touch BacPac display or the GoPro App from your smartphone or tablet.

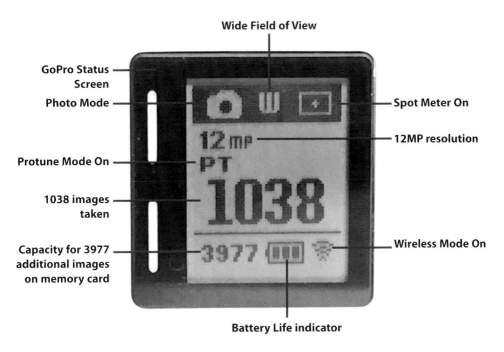

Wide Field of View

GoPro Status Screen

Photo Mode

Spot Meter On

12MP resolution

Protune Mode On

1038 images taken

Capacity for 3977 additional images on memory card

Wireless Mode On

Battery Life indicator

When you use either of these alternate displays, the user interface showcases more information in an easier-to-understand format.

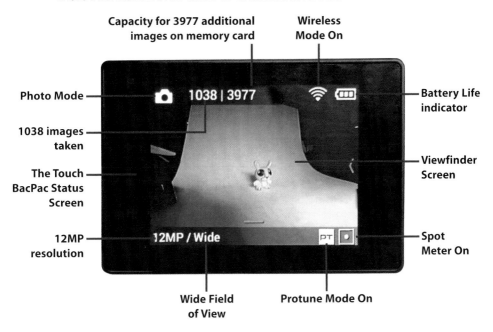

Capacity for 3977 additional images on memory card

Wireless Mode On

Photo Mode

Battery Life indicator

1038 images taken

The Touch BacPac Status Screen

Viewfinder Screen

12MP resolution

Spot Meter On

Wide Field of View

Protune Mode On

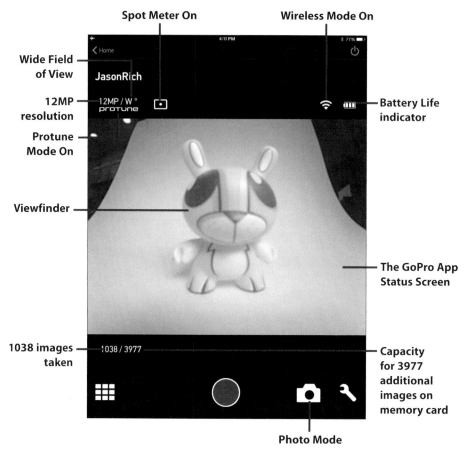

Shown in these three examples, the GoPro Hero4 camera is set to Photo shooting mode, at 12MP resolution, with a Wide Field of View. Wireless, Protune, and Spot Meter features are turned on for demonstration purposes to showcase these icons.

There are currently 1,038 images stored on the camera's memory card, which has a current capacity of 3,977 images. (This changes if HD video is also stored within this memory card.) The battery level displays as a graphic.

The Status Screen that's located on the front of the camera, as well as on the Smart Remote (which has an identical Status Screen), displays detailed information but typically uses confusing abbreviations and icons to best utilize the limited space on the screen.

Your GoPro Camera's Menu Hierarchy

The Hero4's main menu has five options: Video, Photo, Multi-Shot, Playback, and Settings. These options each have submenus.

The following charts offer an at-a-glance summary that shows which features and functions can be selected, accessed, or modified from the Video, Photo, and Multi-Shot submenu options.

The Playback option has no submenus, and it only appears when the camera is connected to the LCD Touch BacPac display or a TV set. You can find more information about the Settings submenu options in Chapter 12, "Adjusting the Camera's Setup Menu Options."

Protune Has Its Own Submenu Options

For each shooting mode that Protune offers (which varies by camera model), you can adjust individual Protune-related settings, including White Balance, Color, ISO Limit, Sharpness, and EV Comp. These Protune-related settings can be set differently and saved separately for each shooting mode.

Keep in mind, the available menu options vary based on camera model and which version of the Camera Software is installed.

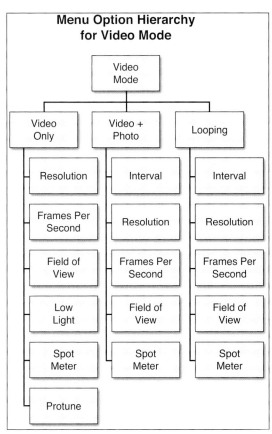

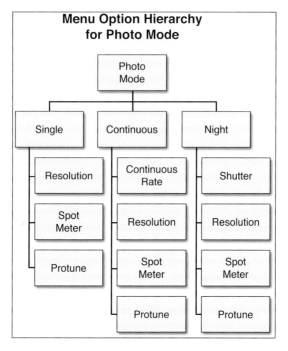

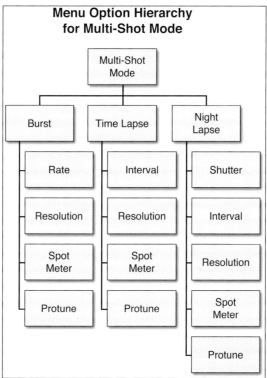

Status Lights Provide Useful Information About Your Camera

Your GoPro camera is equipped with four separate red LED Status Lights (located on different sides of the camera, including the front, back, top, and bottom), and depending on the model, one separate blue LED Status Light.

The Status Lights on the top and bottom of the camera can switch between red or blue, based on how the camera is being used. These red Status Lights visually indicate a variety of things, so you can see what your camera is doing from almost any angle.

For example, when you turn the camera on or off, the red Status Lights flash several times, and the camera simultaneously generates a few beeps. Then, if you start recording video, the red Status Lights flash continuously to indicate you're currently filming.

Alternatively, when you snap a single digital image, the red Status Lights blink once, offering a visual indicator that the Shutter button has been pressed (either manually or remotely) and that one image has been captured and saved.

If the camera is set to Burst or Time Lapse shooting mode, for example, the red Status Lights blink each time a photo is taken. Then, when you turn off Time Lapse mode and stop shooting, the red Status Light flashes three times.

When a battery is in the camera, and the camera is connected to an external power source and is charging, the red Status Lights remain on. When the battery is fully charged, the red Status Lights turn off.

Not All Status Lights Are Always Illuminated

Depending on what information the Status Lights are being used to convey, sometimes only the front light is active. For example, when your camera's Wireless option is turned on, but the camera's power is off, only the front blue Status Light flashes. This indicates that a wireless connection can be established with the GoPro App or Smart Remote, and you can remotely power on and take control of the camera.

Meanwhile, the blue Wi-Fi/Bluetooth Status Light can be seen from the front of the camera, and indicates when the wireless feature of the camera is turned on and active. For example, even if the camera is turned off, the blue Status Light continues to flash if the camera's wireless option is turned on. In

this case, you can remotely turn on and start using the camera via the Smart Remote or GoPro App from up to several hundred feet away from the camera, without ever physically touching the camera.

Turn Off Indicators

From within Settings, you can turn off the Status Lights and the Sound Indicator audio alerts, so they do not function at all. These features use up little battery power, so keeping them on is typically beneficial.

Setting Up the Camera for the First Time

Each time you begin using your GoPro, regardless of the shooting situation, you need to properly prepare the camera. However, the first time you turn on the camera to begin using it, a few extra steps are required to properly set up the camera.

Insert Battery and SD Card

To initially set up the camera for the first time, follow these steps:

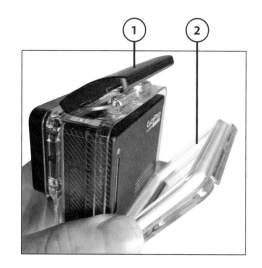

1. Take the camera out of its housing, by lifting up the black plastic latch found on the top of the housing.

2. Open the housing by separating the top of the housing's front and back.

3. Open the side door of the camera to insert a microSD memory card. Refer to Chapter 6 for instructions on how to do this (not pictured).

4. Open the Battery door on the side or bottom of the camera (depending on your camera model).

5. Replace the spent battery with one that is fully charged. Although you can simply charge a spent battery by connecting the GoPro to the supplied USB cable and power source, you can save time using an optional GoPro battery charger and instead insert a second, fully charged battery into the camera.

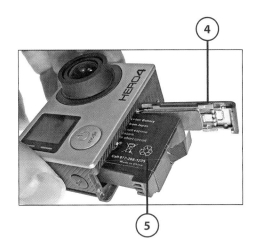

Battery Status

While the camera is plugged into an external power source, if a battery within the camera is charging, the red Status Lights on the camera remain turned on. When the battery is fully charged, the Status Lights automatically turn off.

Prepare the Camera

With the battery and SD card installed, you can now continue setting up your camera:

1. Check to see if your camera's operating system software is up to date (not pictured). (See, "Updating Your Camera's Operating System," later in this chapter.)

2. If applicable, connect the optional LCD Touch BacPac or Battery BacPac accessory to the camera's body.

3. Insert the camera into an appro-
 priate housing based on your
 intended shooting situation. You
 should choose the best housing
 based on where you'll be shoot-
 ing to achieve the best results and
 provide the maximum level of
 protection for the camera. (Refer
 to Chapter 3, "Overview of GoPro
 Camera Housings.")

4. Connect the housing to an
 appropriate mount based on
 your intended shooting situation.
 Make sure you securely connect
 the camera to whatever equip-
 ment you'll be using it with. (Refer
 to Chapter 4, "Overview of GoPro
 Camera Mounts.")

5. Depending on how you'll be
 using the camera, establish a
 wireless connection between the
 camera and the Smart Remote
 or the GoPro mobile app. This
 requires you to complete the pair-
 ing process (not pictured).

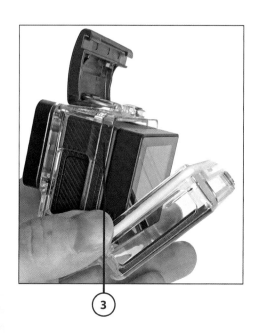

Using the Smart Remote

See Chapter 5, "Must Have GoPro
Camera Accessories," to learn how
this is done when using the Smart
Remote. If you'll be using the
camera with the GoPro mobile
app that's running on your smart-
phone or tablet, see Chapter 15,
"Using the GoPro Mobile App,"
to learn how this pairing process
works.

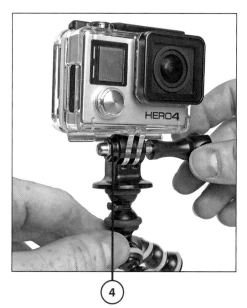

Customize Settings

The camera comes with each of the Shooting Modes set to default settings. To alter any of the default settings, access the camera's menu and follow these steps:

1. Turn on the camera by pressing the Power/Mode button for 2 to 3 seconds until the Status Lights blink and the camera beeps.

2. Press the Power/Mode button on the camera to toggle through the main menu options. At this point, choose a shooting mode and start taking pictures or shooting video, or select the Settings menu to adjust camera settings.

3. Press the Shutter/Select button to access the Settings menu when the wrench-shaped icon appears on the Status Screen. Do the same to select the Setup menu. From this Setup menu, you can manually adjust options relating to more than a dozen camera-related options and features, plus set the Time/Date within the camera.

Default Settings

The default GoPro Hero 4 Settings are

- Video: 1080p, 30fps, SuperView
- Photo: 12MP, Wide FOV
- Multi-Shot: Burst Option (set up to shoot 30 images per second)
- QuickCapture: Off
- Wireless: Off

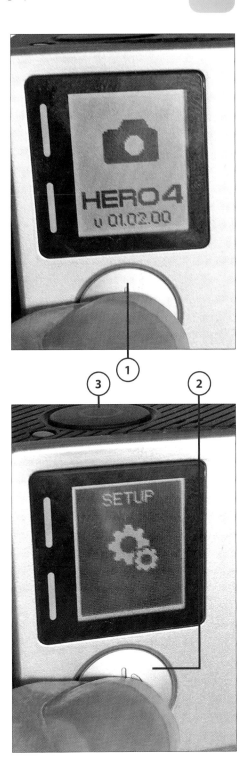

4. Select the Time/Date option (its icon looks like a calendar) to set or adjust this information.

5. Ultimately, anytime you take photos or shoot video, the time and date it was shot are recorded automatically as part of that content's digital file information (metadata).

6. To exit out of the Settings menu, press and hold the Shutter/Select button for 2 seconds. You're now ready to start taking pictures or shooting video.

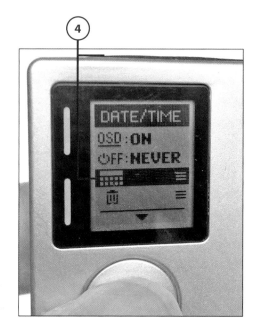

SET UP YOUR CAMERA TO BE REMOTELY CONTROLLED

You can control your GoPro camera remotely via Wi-Fi or Bluetooth (depending on the camera model), using the optional GoPro Smart Remote or the GoPro App that's running on your smartphone or tablet. The first time you want to use either the Smart Remote or the GoPro App, you need to pair the camera to your remote or mobile device. See Chapter 5 for more information on pairing the Smart Remote and Chapter 15 for details on pairing with your mobile device.

After the Wi-Fi or Bluetooth connection is established, you can remotely turn the camera on or off, adjust the camera's settings, and control the camera's operation from up to several hundred feet away. When using the GoPro App, you can also use your mobile device's screen as your remote (real-time) viewfinder when taking photos or filming video (as long as the video resolution settings are also compatible with the app).

It's Not All Good

Yes, Your GoPro Can Overheat

The GoPro cameras, when encased within a proper housing, are designed to operate in hot or cold temperatures. However, if the camera becomes too hot, a thermometer icon appears on the Status Screen and generates an audible alert. This indicates that the camera needs to cool down immediately.

If this warning status appears, turn off the camera and allow it to cool down, and remove it from the extremely hot climate, if possible, until the warning icon disappears.

Updating Your Camera's Operating System

When you purchase a new GoPro camera, the operating system (OS) that controls the camera and its operation comes preinstalled on the camera. However, GoPro periodically updates the OS to fine-tune the features and functions your camera offers.

In early-2015, GoPro released a software update that introduced new features to the GoPro Hero4 Silver and Hero4 Black cameras. These new software-driven features include a Time Lapse video mode, a 30/6 Burst shooting mode (allowing for 30 still digital images to be shot in six seconds), and an Auto Rotate feature (that automatically adjusts video content shot when the camera is mounted upside down). The Hero4 Black was also granted the ability to shoot video at 720p resolution at 240 fps (which is ideal for capturing HD-quality slow motion footage), as well as 2.7K resolution at 60 fps.

Software versus Software

GoPro refers to the OS software as the Camera Software. It should not be confused with the GoPro Studio software for the PC or Mac, or the GoPro App for your smartphone or tablet.

You can update your camera's software using one of three methods, as shown in the tasks in this section. The best method to use depends on which camera model you use. If you use the Hero4, any of these Camera Software update methods work.

When applicable, using the GoPro mobile app (that's running on your smartphone or tablet) offers the easiest way to update the Camera Software when this becomes necessary.

Using the GoPro Mobile App on an Android or Windows Mobile Device

Throughout this book, details about using the iPhone and iPad version of the GoPro mobile app are showcased. Although the features and functions offered by the Android and Windows Mobile versions of the mobile app are the same, the appearance of the command icons and the location of various app-related functions or menu options will vary. For more information about using the GoPro mobile app on an Android or Windows Mobile device, visit https://gopro.com/support/articles/getting-started-with-gopro-app.

Update Using the GoPro Mobile App

The easiest option (for camera models that support it, including the Hero3+ and Hero4) is to update the camera's software via the GoPro App that's running on your smartphone or tablet. Shown here is how the software update process works on an iPad. It's very similar if done using the GoPro App running on an iPhone, Android, or Windows mobile device. To do this, follow these steps:

1. Launch the GoPro App on your mobile device, and establish a wireless connection between the camera and your smartphone or tablet.

Pairing a Device

This requires a Wi-Fi or Bluetooth connection (depending on the camera model) that your camera creates through a process called pairing. You can learn more about this pairing process in Chapter 15.

2. From the app's main menu screen, click the Settings icon.

3. From the App Settings menu on your iOS mobile device, turn on the virtual switch associated with the Auto Download option. If an update is available, the app automatically downloads it and then transfers the software to your camera's memory card when a wireless connection is established. The camera software update then installs itself onto the camera automatically.

Check for Internet

Your mobile device requires an Internet connection, and then a wireless connection with your camera, for this process to work.

Update the Hero4 Using GoPro Studio Software

The following steps show you how to update the Camera Software on a Hero4 using the GoPro Studio software on your computer:

1. Download and install the GoPro Studio software onto your Windows or Mac computer. To do this from your computer, access the GoPro website (www.gopro. com), and then scroll down to the bottom of the website's home page (not pictured).

2. Click the Download Update option listed under the Camera Software Updates heading.

3. If you're not using the Hero4 camera, from the update page select your camera model from the Select Other Camera menu that's displayed near the top-right corner of the screen.

4. Click the Download GoPro Studio button. Follow the on-screen prompts, based on whether you're using a PC or Mac, to download and install the GoPro Studio software onto your computer. Later, this software will also be used to edit the video you shoot with your camera.

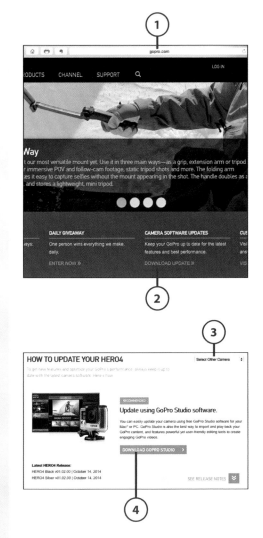

5. Launch the software on your computer (not pictured).

6. Make sure a microSD Memory Card is inserted into your camera.

7. Turn on the camera.

8. Connect the camera to your computer via the supplied USB cable. The computer automatically identifies the camera. If an update is available, the Camera Software Update window displays. Follow the onscreen prompts and then wait until the entire installation process is complete before attempting to disconnect the camera from the computer or use the camera.

Camera Resets

The camera operating system software is first downloaded to your computer from GoPro's website and then transferred to the camera, where it is automatically installed. During this process, the camera resets itself multiple times.

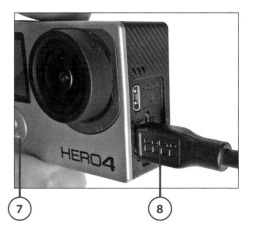

Updating the Operating System Manually

There is also a method for updating the camera's software without using the GoPro Studio software. This method, which requires a microSD Memory Card reader that you can connect to your computer, is what you need to use with the lower-end GoPro Hero camera, but it also works with other camera models, including the Hero3+ and Hero4. Follow these steps to use this manual method for updating the Camera Software:

1. From your computer, go to http://gopro.com/support/product-update/register-camera.

2. Scroll down and click on the Update Your Camera Manually option. When prompted, enter your camera's 14-Digit Serial Number. This number can be found on the camera's packaging or by removing the battery from the battery compartment.

3. Enter your first name, last name, and email address within the appropriate fields of the website.

4. Click on Next Step to continue.

5. From the Update Your GoPro web page screen, click the Download Update button (not pictured).

6. Select between Wi-Fi & Firmware Update, Wi-Fi Update Only, or Firmware Update Only if given these options by the website. (The Wi-Fi Update refers to the wireless connection that can be established between your camera and the Smart Remote or the GoPro App.)

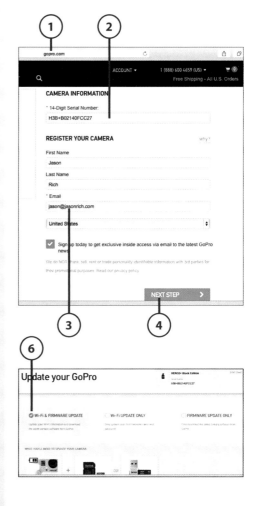

7. Create a name for your camera, as well as a password. You'll be prompted to confirm this password. Do so and click the Next Step button to continue.

8. Click on the Download Update button found on the left side of the web page. The necessary update will be downloaded to your computer.

9. Click the Next Step button to continue.

10. With the camera turned off, remove the microSD Memory Card from your camera, and insert it into an optional microSD Card Reader. Connect the Card Reader to your computer via its USB port. Click the Next Step button to continue (not pictured).

11. Locate the UPDATE.zip file that was downloaded to your computer from the GoPro website, and double-click it. On a Mac, by default, the file is saved to your Downloads folder (not pictured).

12. Drag the newly created UPDATE folder to the GoPro Camera's memory card device listing. On the Mac, this is on the left side of the Finder window. Click the Next Step button to continue.

13. With the camera turned off, re-insert the memory card into the camera (not pictured) and turn it on. The system updates automatically.

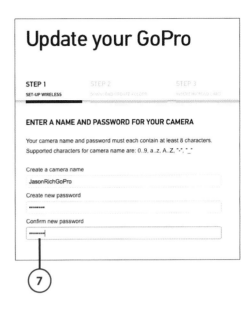

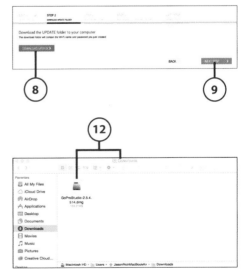

Expect Resets

Expect the camera to reset multiple times. Watch the LCD Status Screen for messages relating to the progress. When the installation process finishes, click the Finish button on the website. Your camera has now been updated and is ready to use.

Frame
Housing

It's best to use your
camera while it's encased
within an appropriate
GoPro housing.

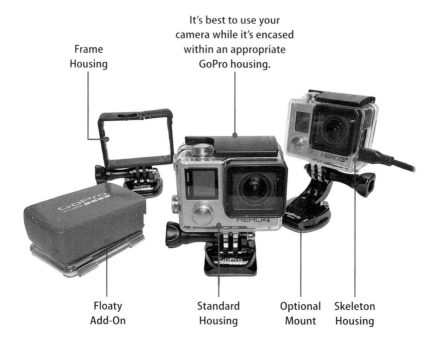

Floaty
Add-On

Standard
Housing

Optional
Mount

Skeleton
Housing

In this chapter, you learn all about the optional housings available for your GoPro camera and discover some of the best uses for them based on your shooting situation. Topics include the following:

→ How to insert and remove your camera from a housing

→ An explanation of housing backdoors

→ An overview of housings available from GoPro, plus strategies on when to best use each housing based on your shooting situation

Overview of GoPro Camera Housings

What makes the GoPro cameras so durable are the optional housings available for them—not the camera body itself. Even if you plan to shoot in the calmest, cleanest, and driest conditions, you should still use a housing with your camera to protect it from damage, water, and dirt.

A single speck of dust or a fingerprint on the camera's lens can ruin all your shots until the lens is cleaned. Meanwhile, if the camera body is exposed to even a small amount of water, serious damage can easily occur.

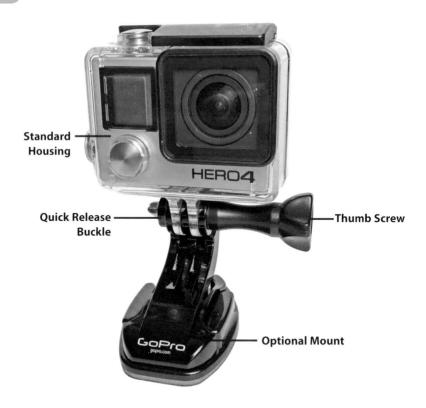

Standard Housing

Quick Release Buckle

Thumb Screw

Optional Mount

The good news is that GoPro offers optional camera housings designed for specialized uses. Most of the time, the Standard Housing (which makes the camera waterproof down to 131 feet with the appropriate backdoor) provides the necessary protection and versatility needed in a wide range of shooting situations. However, with this Standard Housing, you have several backdoor-related options.

Available from GoPro's website (as well as GoPro authorized dealers) are several other housings (sold separately), including the Blackout Housing, Skeleton Housing, Dive Housing, the Frame Housing, and the Duel Hero System Housing. You will also discover additional housing options are offered by third parties.

Most GoPro Housings Use a Quick Release Buckle

In addition to providing protection, the bottom of each housing features GoPro's proprietary Quick Release Buckle and detachable Thumb Screw, which enable the camera (within its housing) to be securely attached to any specially designed mount or related accessory. More information about mounts can be found in Chapter 4, "Overview of GoPro Camera Mounts."

You need to choose the most appropriate housing for your intended shooting situation. Then, as you're shooting with the camera, it's your responsibility as the photographer or videographer to keep the housing clean, particularly the area in front of the lens.

Inserting and Removing Your Camera from a Housing

The majority of the optional housings for the GoPro cameras are made from durable and clear plastic. The front of the housing connects to the backdoor via a hinge, and the top of the housing features a latch. Between the front and backdoor of most housings is a watertight rubber seal.

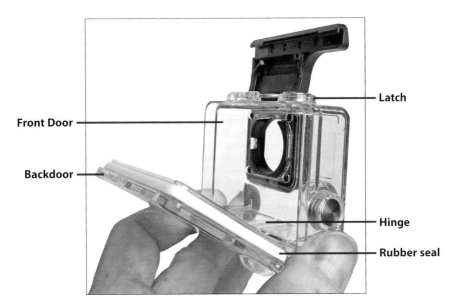

Because the majority of the housings are designed to completely encase the camera, these housings offer external buttons that correspond directly to the buttons built in to the camera. Thus, you still have manual access to them.

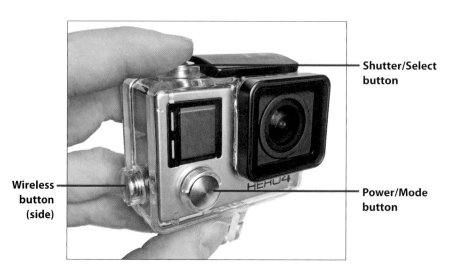

Shutter/Select button

Wireless button (side)

Power/Mode button

Remove the Camera

To remove the camera from a hous-
ing, follow these steps:

1. Unlock the latch on the top of the housing by lifting up the front of the latch.

2. Unhook the rear section of the top latch from the housing.

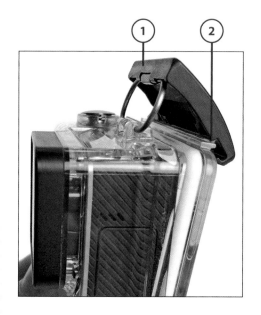

3. Separate the front and backdoor by moving them apart, keeping in mind that the front and back-doors are attached via the hinge at the bottom.

4. Remove the camera from the housing.

Protect the Housing's Latch Mechanism

When a housing is not in use, it's a good idea to keep the top latch closed to prevent the latch mechanism from accidentally bending or breaking.

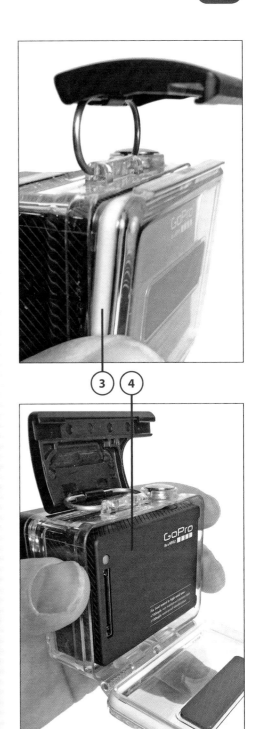

Insert the Camera into a Housing

To properly insert your camera into a housing, follow these steps:

1. Attach the proper backdoor to the housing using the information provided within the section of this chapter titled, "Using the Appropriate Backdoor for a Housing."

2. The front and backdoor of the housing should connect together via the hinge at the bottom of the housing. The top latch, however, should be unlocked.

3. Check the camera and its lens to make sure it's clean. Also check to ensure a memory card is installed within the camera and that the battery within the camera is fully charged.

4. Check the housing to make sure it is clean and that there's no water or dirt inside it. Make sure that the area in which the lens will go within the housing is clean on the inside and outside.

5. Carefully insert the camera into the front of the housing. It should line up perfectly.

Snug Fit

When inserting your camera into a housing, the fit should be perfect, and in most cases, the camera should wind up fully encased and well protected. When inserting the camera into a housing, the housing can remain connected to a mount, or you can attach an optional mount to the housing later.

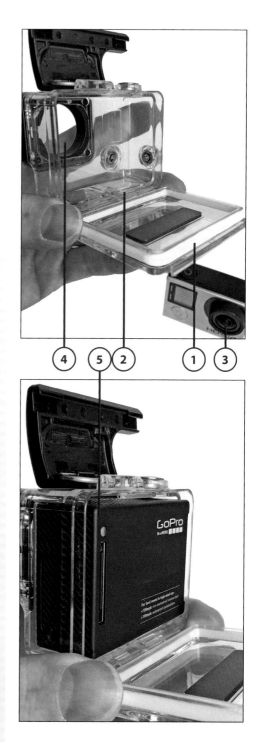

6. Close the backdoor, making sure the rubber seal is intact.

7. Connect the rear portion of the top latch that's connected to the front door to the appropriate hinge on the backdoor.

8. Press the front and backdoor together with your fingers, and then press down on the top latch to lock it into place. The camera is now encased and protected within its housing. It's now safe to expose the camera to water, dirt, and other harsh conditions, assuming you're using an appropriate waterproof housing.

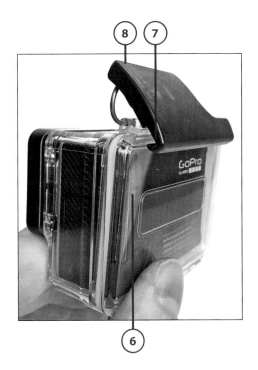

Keeping Your Housing Clean

Although the proper housing protects your GoPro camera from water, if water drops land on the housing and remain over the camera's lens while you're shooting, your photos or videos can easily get ruined. The same is true for dirt or dust.

To wipe the lens, always use a microfiber lens cleaning cloth—not your finger, shirt sleeve, tissue, or paper towel.

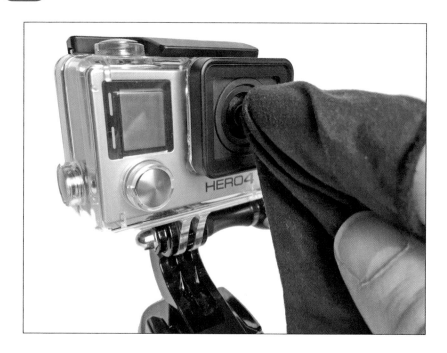

It's a good strategy carry a microfiber lens cleaning cloth with you at all times when shooting, so if you notice water drops or dirt covering the lens (or the housing), you can quickly wipe it clean.

A Micro Fiber Lens Cleaning Cloth Is a Low-Cost Investment

You can purchase a microfiber lens cleaning cloth from anyplace that sells cameras, eyeglasses, or sunglasses, as well as most pharmacies. They typically cost between $5.00 and $8.00.

Using a microfiber lens cleaning cloth is even more important if you wind up needing to directly wipe off or clean the camera's lens. The glass that comprises your camera's lens is delicate and can easily get scratched if you use anything but a proper lens cleaning cloth.

Especially after the camera (while within the housing) has been exposed to dirt or salt water, you need to rinse off the housing using fresh water and then dry the housing with a lens cleaning cloth.

When rinsing the camera, pay careful attention to the rubber seal on the housing's backdoor. This seal must be kept clean, but you should avoid touching it with your fingers or lens cleaning cloth. Allow this area of the housing to air dry. This is important for maintaining the integrity of the watertight seal that the housing provides.

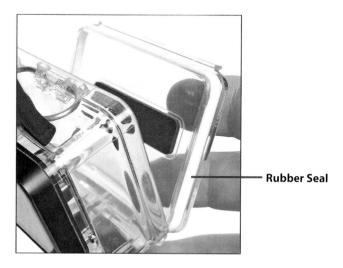

—— **Rubber Seal**

If this rubber seal becomes compromised with a hair, speck of dirt, or corrosion from salt water, it could allow the housing to leak, causing your camera to get damaged. If you notice this rubber seal weakening or cracking over time, or if it gets too dirty and can't be cleaned, replace the backdoor altogether.

There is never a need to use harsh cleaning solutions (including glass cleaner) when cleaning the camera or its housing.

Using the Appropriate Backdoor for a Housing

Choosing the appropriate backdoor for your selected housing is as important as choosing the proper housing for your shooting situation. There are two main considerations when selecting a housing backdoor:

- The width of the backdoor (which determines whether the housing can accommodate an accessory)

- The design of the backdoor (which determines whether it offers waterproof protection)

This Standard Backdoor offers a watertight seal for the camera but offers no direct access to the camera's ports, battery compartment, or memory card slot. There are several Standard Backdoor variations, so the one you're using may look slightly different. Make sure it is a waterproof Standard Backdoor, however, if you'll be using the camera in or around water.

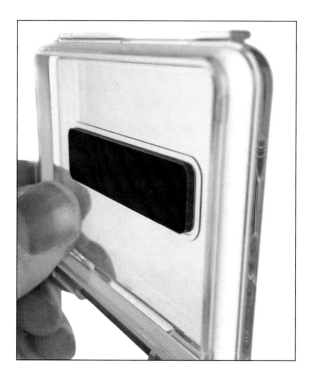

Each housing comes with a backdoor that perfectly fits the GoPro camera when no accessories are connected to the camera. The Standard Housing Backdoor is constructed from solid (clear) plastic and helps to create a watertight seal with the front door of the housing.

When the camera is encased within one of these standard housings (utilizing a Standard Backdoor), you have no direct access to the camera, but it is fully protected and waterproof (to a depth of 131 feet).

If you use your GoPro camera with the LCD Touch BacPac or Battery BacPac, either of these accessories increases the thickness of the camera. Thus, you need to replace the backdoor of your housing with one that can accommodate this extra thickness.

Some Accessories Come with Specialty Housing Backdoors

When you purchase the LCD Touch BacPac or Battery BacPac accessory (sold separately) each comes with several thicker backdoors in a variety of configurations. You need to detach the existing backdoor from your housing and then attach one of these thicker backdoors, which are also sold separately.

In addition to a Standard Housing Backdoor, there are two other types of backdoors that can be attached and used with most housings.

Instead of a solid plastic backdoor, GoPro offers a Touch BacPac Backdoor. This is constructed of a softer plastic. Thus, if you use the LCD Touch BacPac with the camera, using a Touch BacPac Backdoor enables you to use the touch screen while the camera is encased within a housing. This does, however, impact the level of protection that's offered. For example, using this backdoor with your camera waterproofs it to a depth of only10 feet.

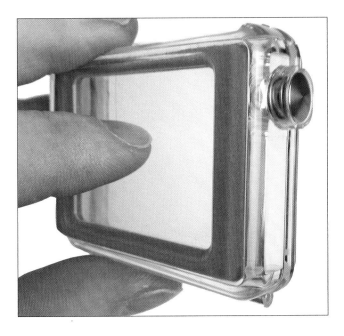

The GoPro Hero4 is shown here encased in a Standard Housing with a Skeleton Backdoor. Because the camera is not fully sealed within the housing, the camera's built-in microphone can capture better quality sound when you shoot video, and you can access the LCD Touch BacPac display.

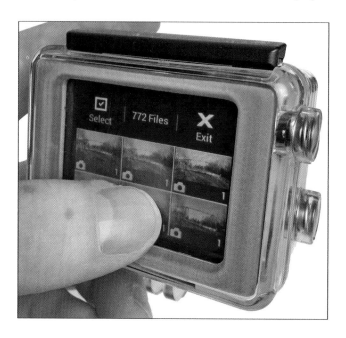

However, because it's wide open, this backdoor offers no waterproof protection whatsoever. It also doesn't grant you access to the camera's ports. For this access, you need to use the optional Skelton Housing, not the Standard Housing with a Skeleton Backdoor attached.

>>>Go Further

ADVANCED CONSIDERATIONS

The Skeleton Backdoor enables you to record better sound quality when recording video. For example, if you're engaged in a high-speed activity that you're trying to film, the Skeleton Backdoor reduces wind noise recorded by the camera's built-in microphone as you're shooting video. However, this type of backdoor should be used only when engaged in low-intensity activities, where the camera will not be exposed to dirt or water.

Likewise, the GoPro camera when encased in a Standard or Dive Housing is fully waterproof, but it does not float! So, if you're swimming, snorkeling, surfing, or engaged in some other ocean-based activity, and the camera accidentally gets loose, it will sink…fast.

To prevent this and make it easier to spot, seriously consider attaching GoPro's optional Floaty Backdoor add-on (sold separately, $19.99).

The Floaty Accessory attached to a Standard Backdoor

The Floaty Backdoor add-on is brightly colored and made from a foam-like material that attaches securely to the Standard or Dive Backdoor and allows the entire camera to float. This optional accessory comes with an extra Standard and Dive Housing Backdoor because using a special adhesive, the Floaty is designed to stay attached to the backdoor it's being used with.

Swap the Housing's Backdoor

To replace the housing's backdoor, follow these steps:

1. Hold the housing upright in your hands.

2. Remove the camera and any mount that's attached to the housing.

3. Open the backdoor so that the backdoor points slightly downward. Gently pull straight down on the backdoor until it snaps apart from the front door.

4. Select the backdoor you now want to attach (not pictured).

5. While keeping the backdoor at an angle, line up the hinge on the front door with the metal bar related to the hinge on the backdoor.

6. Push upward on the backdoor until the hinge clicks and locks into position.

7. Without inserting the camera, try closing the housing to make sure the seal is tight after you close the top latch (not pictured). If it is, insert the camera and close the housing.

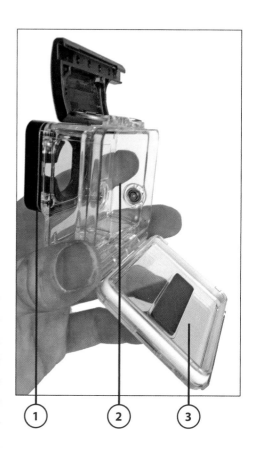

No Tools Needed

The backdoor you opt to use with the camera's housing depends on what equipment you plan to use with your camera, as well as the shooting situation. Replacing the backdoor of a housing is easy, and no tools are required. The trick is to be gentle so that you don't accidentally break the plastic hinge of the housing.

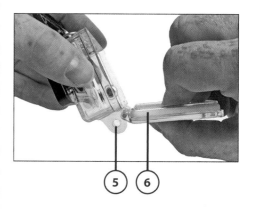

Discovering Your Housing Options

Now that you understand that a variety of different housing options are available, and you can use each housing with one of several different backdoors, take a closer look at various housings, and focus more on what each is used for. It's never a good idea to use your GoPro camera without some type of housing.

Choose the Right Housing for Your Camera Model

Because the design of the camera body varies slightly by camera model, some of the housings are offered in a version compatible with just the Hero, Hero3/Hero3+, and Hero4 camera models. Be sure to purchase housings that are designed specifically for your camera model.

Standard Housing

The Standard Housing with a Standard Backdoor attached is shown here with the GoPro Hero4 camera.

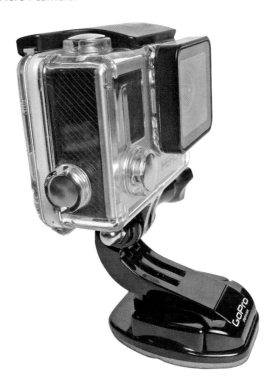

This is the housing that came bundled with your camera. It's the most versatile, and when in use with a Standard Backdoor, it fully encases your camera to offer watertight protection to a depth of 131 feet.

Use this case when you film in or around water and in harsh climates, and to prevent your camera from being directly exposed to dirt or dust.

You can purchase a replacement GoPro Standard Housing for $49.99 from the GoPro website (or any GoPro dealer). If you plan to use the optional LCD Touch BacPac display or Battery BacPac with your camera, you need to acquire a separate and thicker Standard, Skeleton, or Touch BacPac Backdoor to use with this housing.

Table 3.1 can help you select the most appropriate backdoor when using the Standard Housing, based on your shooting situation.

Table 3.1 Choose the Best Backdoor Option When Using a Standard Housing

Backdoor Type	When To Use It
Standard Backdoor	This backdoor offers waterproof protection to the camera (to a depth of 131 feet). With this backdoor, you have no direct access to the camera.
Skeleton Backdoor	This backdoor offers no waterproof protection whatsoever but does enable you to record better quality audio when shooting video. It offers some protection to the camera against physical damage or dirt.
Touch BacPac Backdoor	Use this backdoor when you have the LCD Touch BacPac accessory connected to your camera. This backdoor grants you access to the touch screen while the camera is in use.
BacPac Backdoor	This backdoor accommodates the LCD Touch BacPac or Battery BacPac accessory but does not offer direct access to it while the camera is in use. In other words, you can see the viewfinder when using the LCD Touch BacPac display, but you cannot use its touch screen functionality. Full waterproof protection is offered.

Skeleton Housing

The Skeleton Housing gives you access to the camera's ports while the camera is in use.

Not to be confused with the Skelton Backdoor that you can use with the Standard or Dive Housing, the Skeleton Housing ($49.99) can help to protect the camera from physical damage, while granting you full access to the camera's ports and built-in microphone when the camera is in use.

This housing offers no waterproof protection whatsoever. Use this housing in calm shooting situations, when you want to capture better audio quality using the camera's built in microphone, or you'd like to connect an external microphone to the camera and need access to the mini-USB port.

Parents who want to shoot video of their child engaged in an outdoor sport (assuming it's not raining) can benefit from using this housing to protect the camera but record good quality sound. It's also a good choice to mount inside of a vehicle or when shooting indoors, for example.

Table 3.2 can help you select the most appropriate backdoor when using the Skeleton Housing, based on your shooting situation.

Table 3.2 Choose the Best Backdoor Option When Using a Skeleton Housing

Backdoor Type	When to Use It
Skeleton Backdoor	Use this backdoor with just the camera.
Skeleton BacPac Backdoor	This backdoor accommodates the LCD Touch BacPac or Battery BacPac accessory and grants access to the touch screen capabilities of the LCD Touch BacPac, in addition to using it as a viewfinder.

Dive Housing

GoPro's optional Dive Housing ($59.99) is the most durable housing offered. It's designed for use when scuba diving or when shooting in extreme conditions. The front of this housing is designed specifically to offer the best image sharpness possible, whether you shoot above or below the water.

If you shoot in or near water—at a beach, swimming pool, or on a boat, or use the camera while snorkeling, surfing, or kayaking—this is the best housing to use. (Although, the Standard Housing with a Standard Backdoor can also provide ample waterproof protection.)

You Wear Scuba Gear When Scuba Diving, So Should Your Camera

The Dive Housing when used with an optional colored lens filter and the Anti-Fog inserts is best suited for scuba diving. This housing makes the camera fully waterproof to a depth of 197 feet. The Dive Housing is constructed from thicker plastic and a more durable rubber waterproof seal.

Table 3.3 can help you select the most appropriate backdoor when using the Dive Housing, based on your shooting situation.

Table 3.3 Choose the Best Backdoor Option When Using a Dive Housing

Backdoor Type	When to Use It
Standard Dive Backdoor	This backdoor offers the best waterproof protection to the camera (to a depth of 197 feet). With this backdoor, you have no direct access to the camera.
BacPac Dive Backdoor	This backdoor accommodates the LCD Touch BacPac or Battery BacPac accessory but does not offer direct access to it while the camera is in use. In other words, you can see the viewfinder when using the LCD Touch BacPac display, but you cannot use its touch screen functionality.

Blackout Housing

The Blackout Housing functions exactly like a Standard Housing, but instead of being constructed from clear plastic, this housing encloses your camera within a black shell that makes it more difficult to see, especially in low light situations.

There may be times when you want to take photos or videos but remain incognito or undercover. As its name suggests, the Blackout Housing ($49.99) fully encases the camera within a protective, matte black finished housing, which gives it a low profile. This housing offers waterproof protection to a depth of 131 feet, but its main purpose is to encase the camera within a non-reflective housing that offers low visibility.

This housing comes with a Standard, Skeleton, and Touch Backdoor that is also black. When you use this housing, the operation of the camera's lens and Status Screen is unhindered, but the rest of the housing, including the buttons, are black. It's also possible to use the supplied concealment stickers to block glare and reflection caused by the Status Screen and LCD Touch BacPac screen (if it's attached to your camera).

The Frame Housing

The Frame Housing offers minimal protection to the camera but grants you access to its ports, as well as allowing you to connect a mount to the camera.

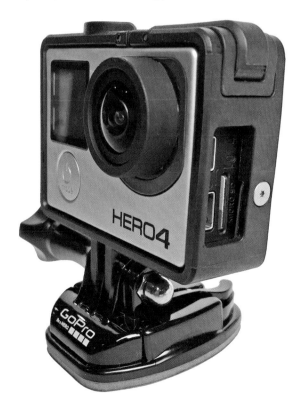

The Frame Housing ($39.99) is the least cumbersome housing option available. You should use it only in calm, dry, and clean shooting environments, to allow you to use a mount with the camera without fully encasing it within a housing.

Protect Your Camera's Lens When It's Not Enclosed in a Housing

If you opt to use the Frame Housing outdoors, consider attaching the supplied lens protector to the camera's lens to help keep it clean and prevent it from getting accidentally scratched or cracked.

When using the Frame Housing, you can capture the best quality audio using the built-in microphone, or you can attach an external microphone (sold separately) to the camera when you use GoPro's optional 3.5mm Mic Adapter ($19.99).

Using the supplied extendable support arm, the Frame Housing can accommodate the GoPro camera with either the LCD Touch BacPac or Battery BacPac attached to it. If neither of these accessories are used with the Frame Housing, be sure to insert the supplied Hero Port cap over the unused Hero Port to keep it clean.

Musicians, for example, often use the Frame Housing with a mount that allows them to attach the GoPro camera directly to their instrument, music stand, or microphone stand. Because the camera's lens and microphone are in no way hindered by a more elaborate housing, you can shoot clearer photos or videos with better quality sound.

Parents who want to take photos or videos of their child performing in a show, concert, or indoor dance recital, for example, typically can achieve the best results using this Frame Housing with their camera, with a traditional tripod to hold the camera still while shooting.

Frame Housing Redesign

Since first introducing this Frame Housing, GoPro has redesigned it to include an integrated latch and one-piece design. This new design makes it faster and easier to insert or remove the camera from this housing, even when the frame is attached to a mount.

Dual Hero System Housing

Designed mainly for serious videographers, this Dual Hero System Housing ($199.99) is designed to securely hold two separate GoPro cameras in place. Using this tandem method of shooting, you can create 3-D photos or video footage using the GoPro Studio software. This housing is fully waterproof (to a depth of 197 feet). At the time this book was written, only the GoPro Hero3+ Black Edition cameras could be accommodated by this housing. A version for the Hero4 was not yet released.

Third-Party Camera Housings

If you use any popular Internet search engine with the search phrase, "GoPro Camera Housings," you can discover many third-party companies that offer compatible housings designed for specific GoPro camera models.

The housing you use is designed to offer protection to your camera, which represents a several hundred dollar investment on your part. Thus, if you opt to use your camera with a housing that's designed and manufactured by a company other than GoPro, make sure it offers equivalent quality in its design, construction, and durability.

The construction quality of the housing's Quick Release Buckle and Thumb Screw are also important for keeping your camera securely in place when shooting. It's often a good strategy to use only a genuine GoPro housing with your camera.

However, there are literally hundreds of third-party camera mounts and accessories that are extremely well made and that can greatly expand the versatility of your camera's capabilities, plus save you money. These mounts are fully compatible with the popular GoPro camera housings. You'll learn more about some of these products in the next chapter.

It's Not All Good

Never Assume a Housing Is Waterproof!

Only the Standard Housing, Dive Housing, and Blackout Housing—when used with a Standard Backdoor or BacPac Backdoor—provide a waterproof environment for your camera, assuming the backdoor's seal is functioning properly.

When using the camera in or around water, always make sure you use an appropriate housing (and backdoor) with your camera. GoPro's warranty does not cover water damage resulting from user misuse, error, or the wrong choice of housing.

In addition, if you shoot in a hot and humid environment, you may notice that your camera lens sometimes fogs up when it's encased within a housing. This fog can ruin your photos or video footage. To prevent this, insert two optional Anti-Fog Inserts ($14.99) into the camera's housing.

The Anti-Fog Inserts fit snugly at the bottom of the camera within a Standard or Dive housing.

GoPro camera housings can be connected to many different specialized mounts, including one that allows you to easily attach the camera to any tripod or monopod.

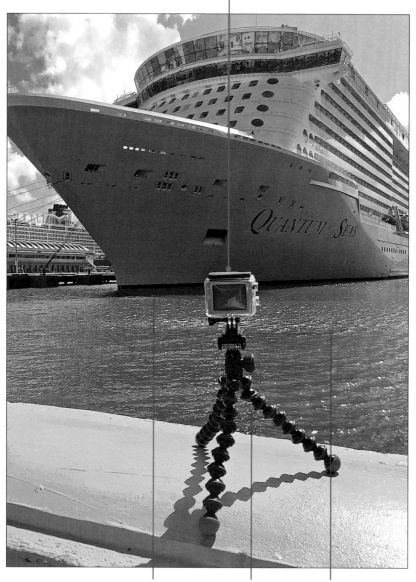

GoPro Hero4 Camera Joby Tripod Joby Tripod Mount

In this chapter, you learn about some of the popular and most versatile mounts available for your GoPro camera (when it's encased within a housing). Topics include the following:

→ Using GoPro's proprietary Quick Release Buckle and Thumb Screw to securely connect a camera housing to a mount

→ Overview of popular mounts and what they're best used for

→ Information about specialized mounts that can be used in specific shooting situations

→ How and where to find third-party mounts and save money in the process

Overview of GoPro Camera Mounts

One of the tricks for capturing the clearest and most vibrant photos or videos using your GoPro camera is to keep it as stable as possible when shooting. For example, you need to avoid excessive shaking, even if you're engaged in a high-action activity and shooting from a first-person perspective.

The best way to do this is to utilize an appropriate camera housing (covered in the previous chapter) and then attach that housing to a mount that's best suited for the shooting task at hand. Between GoPro and an ever-growing number of third-party companies, literally hundreds of optional mounts are available for your GoPro camera.

Some of these mounts are versatile and can serve you well in a wide range of shooting situations. For example, the optional GoPro Tripod Mount ($9.99) attaches to the Quick Release Buckle of any

housing and enables you to attach the camera (within its housing) to any standard tripod or monopod.

Beyond the mounts designed specifically for GoPro cameras, a wide range of full-size and portable tripods, monopods, camera handles, camera grips, and extension poles are available that can help you hold the camera steady and position the camera perfectly to capture the best possible shots.

>>> Go Further

FIND ONLINE SHOOTING TIPS RELATED TO USING SPECIALIZED MOUNTS

To help you set up your GoPro camera and equip yourself with the best housing and mounts for specialized shooting situations, the GoPro website offers its "Shop by Activity" page (http://shop.gopro.com/shopbyactivity). From this webpage, you can click an activity and discover the best GoPro equipment to use when engaged in shooting more than 20 popular activities.

Beyond what GoPro recommends for using official GoPro mounts, various third-party mounts offer even more options and flexibility. The websites from these third parties often offer useful tips for using their specialized mounts with a GoPro camera.

For example, if you plan to attach your camera to an Octomask when snorkeling or scuba diving, you can discover some awesome shooting tips from the Octomask website (www.octomask.com).

Preplan Your Shots and Choose the Best Equipment

Before buying a handful of mounts for your camera, consider the following:

- Who or what your intended subjects will be

- What activities you or your intended subjects will be engaged in while shooting or filming

- Whether you'll be shooting photos and/or video

- What type of shooting conditions you'll most likely encounter

- What shooting obstacles or challenges you'll potentially face

- Specifically how you want to frame your shots, including what shooting perspective or angles you'll want to use

- How you'll ultimately be utilizing or showcasing the photos and video after shooting

- Whether you'll be controlling the camera directly or controlling it remotely via the Smart Remote or the GoPro App

As you go into any shooting situation, always devise a plan, so you understand what you're trying to achieve in advance. By doing this, you can ensure you bring along the best camera housings, mounts, and accessories to achieve these goals and also to capture the highest quality photos or video possible.

When you understand what you're trying to achieve and have selected your subject, you'll typically have two types of decisions to make to select an appropriate mount.

- Determine if you will you be holding the camera in your hands while shooting; if yes will you need to attach the camera to yourself or your equipment (such as your bicycle, snowboard, surfboard, safety helmet, or vehicle dashboard) to capture shots from a first-person or third-person perspective? Or will you be acting exclusively as the photographer or videographer and shooting another subject from behind the camera?

- Consider what shooting angle or perspective you want to use. This determines how you mount the camera and at what angle (and height) it's mounted. As you'll discover shortly, even the slightest variation in camera angle can dramatically impact what you capture within your shots. After you determine how the camera will be mounted, you must use equipment that can hold your camera in place throughout the shooting process.

>>>Go Further

SUBTLE CHANGES IN SHOOTING ANGLE, HEIGHT, OR PERSPECTIVE CAN MAKE A HUGE DIFFERENCE

GoPro's Chesty, Helmet Front Mount, and Helmet Side Mount enable you to wear the GoPro camera (within a housing) either on your head or body, so the camera faces forward.

The difference in height between your chest and just above your forehead represents a vastly different shooting perspective and angle for your camera. The angle you choose impacts how your photos or videos ultimately look.

The same is true when you compare the more subtle difference between wearing the camera so that it's positioned in front versus to the side of your head. As a photographer or videographer, the mount you use determines your shooting angle and perspective. This is ultimately a creative decision; although, logistics may play a role in what equipment you need.

Attaching the Camera Housing to a Mount

You definitely want to protect the investment you've made in your camera, housing, and accessories by making sure you securely mount the camera to yourself or your equipment. This is especially important if you use your GoPro while engaging in a high-action activity.

All the official GoPro housings are equipped with the company's proprietary Quick Release Buckle and Thumb Screw, which securely attach the camera housing to a mount. You must always use the Thumb Screw that came with a particular mount to ensure a secure connection. Then, it's your responsibility to make sure you correctly and securely attach the mount to yourself or your other equipment.

Use the Quick Release Buckle and Thumb Screw

To use the Quick Release Buckle and Thumb Screw, place your camera within a housing, close it, and then follow these steps:

1. Select an appropriate GoPro mount and then remove the Thumb Screw from the mount by first turning the Thumb Screw to loosen it.

2. Line up the bottom of the housing with the mount.

3. Insert the Thumb Screw back into the Quick Release Buckle.

4. Adjust the camera/housing angle based on your shooting needs.

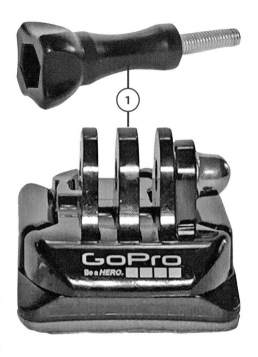

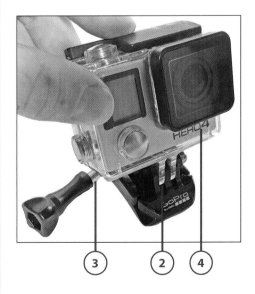

5. Tighten the Thumb Screw to securely connect the camera (within its housing) to your selected mount.

6. If you have an optional tether, attach it to the camera housing by removing the backdoor and looping the tether through the metal bar, which is part of the backdoor latch.

7. Using the adhesive, apply the other end of the tether to your equipment.

Adding a Tether

For added protection, in case the camera housing separates from the mount while engaged in a high-impact activity, attach one end of an optional GoPro tether to the camera's housing and the opposite end to your equipment. These tethers come with certain housings or can be purchased separately in packages of five for $19.99.

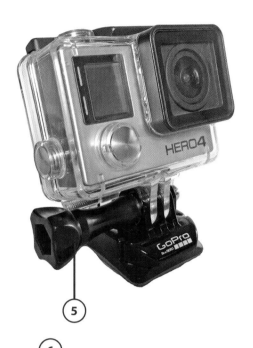

>>>Go Further

ATTACHING MOUNTS TO YOURSELF OR YOUR EQUIPMENT

After attaching a camera housing to a camera mount, it is then often necessary to attach the mount to something else, such as yourself, your equipment, or a tripod. You can do this in one of several ways, depending on which mount you use.

Some mounts have a clasp or suction cup that enables you to attach it to something else. Other mounts rely on an adhesive connection, whereas some screw into place. Make sure you follow the directions that came with your mount to ensure a secure connection between the mount and whatever you attach the mount to. Adhesives, in particular, must be used properly to avoid accidentally damaging your camera.

Use a Quick-Release Anti-Vibration Locking Plug

To reduce the impact vibration has on your photos or video, consider attaching an optional Quick-Release Anti-Vibration Locking Plug to the mount after it's attached to a housing. To use this accessory, follow these steps:

1. Connect the camera housing to the appropriate mount of your choice.

2. Attach the circular part of the white rubber Locking Plug over the end of the Thumb Screw.

3. Place the U-shaped portion of the Locking Plug into the open space within the Quick Release Locking Buckle on the mount, and press down so that it fits flush with the buckle.

When to Use the Plug

The Anti-Vibration Locking Plug comes with applicable mounts, or you can purchase it as part of GoPro's Replacement Parts package ($19.99). It works well when you mount a GoPro camera in a situation in which the vibration might impact your shots, such as on a vehicle dashboard, a motor boat, a jet ski, a motorcycle, an ATV, a dirt bike, or on an airplane.

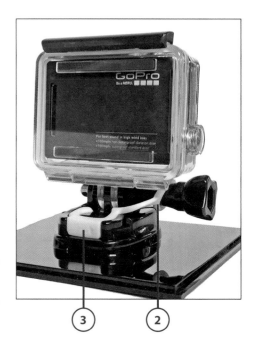

Overview of Popular GoPro Mounts

There are limitless combinations for using specific housings with specific mounts based on what you want to achieve. In some cases, which housing and which mount to use for a specific shooting task will be obvious. In other situations, you might need to use a bit of creativity and ingenuity to create a viable shooting solution.

Learning from Others

If you're faced with a challenging shooting situation and can't figure out the best GoPro-related housing, mount, and accessory combination to use, visit YouTube (www.YouTube.com) and see if people have posted a video showing how they devised a creative shooting solution that might also meet your needs. Within YouTube's Search field, enter a search phrase such as, "Using a GoPro camera with a skateboard," or "Using a GoPro camera to shoot underwater." You can find some helpful videos on the Que Publishing website at www.quepublishing.com/store/using-your-gopro-hero3-plus-learn-to-shoot-better-photos-9780789755964 and YouTube at www.youtube.com/watch?v=EcYZvRqPx3M.

Following is information about 22 popular mounts (each sold separately) offered by GoPro. The majority of these mounts are designed to work with all GoPro camera models, and you can use each with any GoPro camera housing because of the Quick Release Buckle and Thumb Screw.

- **Bodyboard Mount ($19.99):** Use this mount to attach your GoPro camera (within the Standard or Dive Housing) to the front of a body-board, soft-top surfboard, or foam surfboard to shoot yourself on the board (with the camera pointed backward), or point the camera forward to shoot from a first-person point of view perspective while using the board. This mount requires a screwdriver to attach it to your bodyboard.

- **Chesty Chest Harness ($39.99) or Junior Chesty ($29.99):** These versatile mounts are made from black nylon straps and are designed to be worn on your body so that the camera can be securely mounted, facing directly outward from the middle of your chest. The angle of the camera is not adjustable after it's connected to this mount. Thus, it enables you to capture photos or video of what's in front of the wearer, from a first-person perspective.

- **Curved and Flat Adhesive Mounts ($19.99):** These small mounts enable you to easily and semi-permanently attach your GoPro camera mount to almost any flat and smooth object or any slightly curved object. The mount remains affixed to the equipment, but you can remove the housing (and camera) easily at any time. These mounts use a strong, waterproof adhesive that bonds directly onto your equipment. To remove the mount, you need a hairdryer to first heat the adhesive and then pull it off.

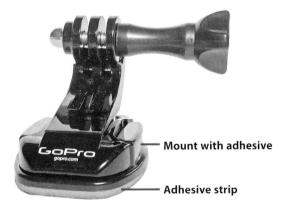

Mount with adhesive

Adhesive strip

- **Fetch ($59.99):** Have you ever wanted to see the world from your dog's point of view? Well, when you strap this padded and adjustable harness onto your pooch and then attach the camera, you can remotely control the camera and easily capture photos or videos as your dog roams freely.

- **Gooseneck ($19.99):** This mount is composed of an 8-inch adjustable and flexible arm that includes a GoPro Quick Release Buckle on one end. The opposite end can be used with an Adhesive Mount, Suction Cup Mount, or the Jaws: Flex Clamp to attach the camera (within a housing) to a wide range of objects. You can then manually adjust the camera's shooting angle and perspective. You can also join multiple Gooseneck accessories together to create a longer arm that's adjustable and flexible. Use this accessory to position your camera to shoot at unusual angles or around corners.

- **Handlebar/Seatpost/Pole Mount ($19.99):** This mount is designed to securely attach a camera housing to bicycle handlebars, seat posts, ski poles, or any other equipment that's shaped like a narrow bar or pole (between 0.75-inch and 1.4 inches in diameter). The supplied adapter also enables you to attach the mount to poles or bars between 0.43-inch and 0.7-inch in diameter. After you connect this mount to equipment, you can vertically adjust the camera's angle and then point the camera forward or backward, so you can capture yourself riding a bike, for example, or shoot outward and capture what's in front of you from a first-person perspective.

- **Handler ($29.99):** Instead of trying to hold the camera in your hands while shooting, attach the camera housing to this hand-held grip (which also floats). This grip makes it easier to hold the camera steady and at the perfect angle while shooting. Use the Handler with the LCD Touch BacPac to have access to a viewfinder while holding the camera. The Handler is waterproof to a depth of 33 feet and includes a grip and wrist strap so that it won't easily slip out of your hands.

Other Water-Friendly Mounts

GoPro's Handler mount is similar in design and function to several third-party mounts, including GoPole's brightly colored and waterproof Bobber ($29.99, www.gopole.com), which is described and shown in the later section "Popular Third-Party Mount Options."

- **Head Strap + QuickClip ($19.99):** This adjustable harness is made from black nylon straps and is designed to be worn on your head (like a miner's light) or worn over a baseball cap, for example. The camera can be mounted facing forward, so you can capture photos or video from a first-person perspective from just above your eye level. Using just the QuickClip (shown here), you can mount the camera directly onto the back of a baseball cap (which you can then wear backward to shoot what's in front of you). This is an example of a mount that you can use while engaging in a wide range of activities.

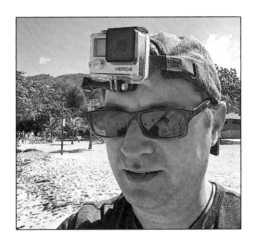

A MOUNT HELPS AVOID CAMERA SHAKING

Remember, the purpose of using a mount, instead of holding the camera in your hands, is to help you avoid excessive camera shaking or vibration, even if you and the camera are engaged in an activity. Some mounts are designed to free up your hands (so you don't need to use them to hold the camera) but don't do a great job keeping the camera steady when it's in motion. In some cases, such as when you use the Head Strap or QuickClip, the camera will be securely attached to your head and point outward, but it's then up to you to avoid excessive head shaking or movement while shooting. If you're constantly moving your head up and down or side-to-side while recording, this is detrimental to capturing in-focus images, especially in low light situations.

There's a difference between camera movement while filming and camera shaking or vibration. If you ski down a hill with the camera attached to you, that's camera movement. Your GoPro camera is designed for this. However, rapid shaking or vibration, caused by fast and jerky motions, or mounting the camera on equipment that has an engine or motor that generates a steady vibration, for example, could cause blurs in your images and video.

- **Helmet Front Mount ($14.99):** Attach this mount directly to the front of your safety helmet so that you can capture photos or video from a first person, almost eye-level perspective. Wear the camera like a miner's light. The mount attaches to any helmet using a semi-permanent adhesive. Use it with a safety helmet that's worn while biking or skiing, for example. It also works with a batting helmet or motorcycle helmet.

- **Helmet Side Mount ($14.99):** This mount works just like the Helmet Front Mount but enables you to mount the camera (within a housing) onto the side of a helmet with the camera facing directly forward or backward. You can then adjust the camera's vertical angle to achieve the perfect shot of the intended activity.

- **Instrument Mounts ($19.99):** These small, quick-release mounts utilize an easy-to-remove adhesive, so you can attach them directly to fragile or costly musical instruments, for example, without damaging the sensitive instrument. For added flexibility for camera positioning and shooting angles, use one of these mounts with the Gooseneck (sold separately). These mounts make it easy to connect the camera to many types of instruments, such as keyboards, guitars, drums, or even a music stand, turntable, or mixing board. Although the Instrument Mounts are reusable, the adhesives are designed for one-time use.

- **Jaws: Flex Clamp ($49.99):** This versatile clamp attaches to your camera's housing using the standard Quick Release Buckle and then can clamp onto a table or any equipment that's between 0.25-inches and 2-inches thick. For greater camera angle flexibility and options, use the Jaws Clamp with the adjustable gooseneck-like arm, which is included. Use this clamp/adjustable arm combo mount when engaged in a wide range of shooting situations to capture your subject from different angles.

- **Mic Stand Mount ($14.99):** As its name suggests, use this mount to attach your camera's housing directly to any standard microphone stand. You can then position the stand at any height or angle, plus adjust the mount's angle, to capture the perfect on-stage shots during a performance.

- **NVG Mount ($29.99):** Use this specialized mount to attach your GoPro camera housing to any helmet that's equipped with a standard night vision goggle (NVG) mounting plate. The low-profile mount keeps the camera close to the helmet and enables you to position the camera pointing directly forward to capture photos or video from a first-person, almost eye-level perspective.

- **Roll Bar Mount ($29.99):** This mount offers a similar design to the Handlebar/Seatpost/Pole Mount (sold separately), but can be used to attach the camera's housing to a vehicle roll bar, roof rack, or bike frame, or any tube or pole measuring between 1.4 inches and 2.5 inches in diameter. After the camera housing is mounted to something, you can adjust the vertical shooting angle of the camera via the Quick Release Buckle.

- **Sportsman Mount ($69.99):** Use this more specialized mount to attach your camera's housing directly to a rifle, handgun, paintball gun, crossbow, fishing rod, and such. It's made from a sturdy material with a matte-black, nonreflective finish. The versatility of this mount enables you to attach it to the top, side, or bottom of a pole-shaped piece of equipment between 0.4-inch and 0.9-inch in diameter. You can then adjust the camera to shoot at a customized angle. To reduce reflection caused by the camera, which can make it more noticeable, consider using this mount with the Blackout Housing (sold separately).

- **Suction Cup Mount ($39.99):** Use this versatile mount to temporarily (but strongly) adhere the camera housing to any flat and smooth service, such as a vehicle, boat, or any glass window. The industrial strength suction cup holds in place at speeds in excess of 150 mph. The design of this mount allows the camera to be positioned at a wide range of precise angles because of the accessories that come with it. This flexibility, combined with the fact that the mount can be placed on the roof, front, side, window, or bumper of a vehicle, for example, gives you many shooting options. Plus, unlike other mounts that use semi-permanent adhesive, this mount can quickly be removed or repositioned an unlimited number of times.

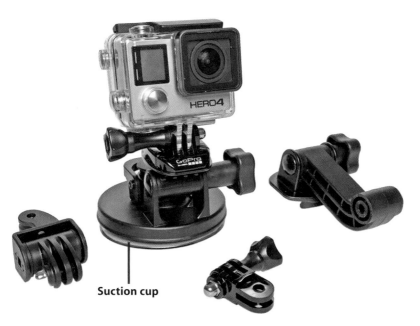

Suction cup

- **Surfboard Mount ($19.99):** Use this waterproof, adhesive mount to attach the camera housing directly to your surfboard, boat deck, kayak, or any other flat and smooth surface. For added security, this mount includes adhesive-based tethers that you can use to prevent camera loss in rough situations.

- **Three-Way ($69.99):** This is GoPro's answer to a portable, waterproof, and expandable arm that you can also use as a tripod (when expanded) or as a 7.5-inch handheld camera grip. Three-Way includes a 20-inch extension arm with a handle on one end and a Quick Release Buckle on the other. When extended, you can also open the legs of this mount, so it can stand on its own, like a mini-tripod.

- **Tripod Mount ($9.99):** This inexpensive mount is probably one of the most versatile because it enables you to attach the camera's housing to any standard tripod or monopod, made by any company, to keep the camera steady while shooting.

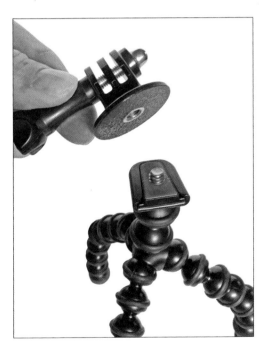

- **Vented Helmet Strap Mount ($14.99):** Use this strap-based mount to attach your camera's housing directly to a safety helmet that is vented. It works with safety helmets worn during a variety of activities, such as biking, skiing, or boating. The strap is fully adjustable and enables you to position the camera on your head, facing forward to capture photos or videos from a first-person, above eye-level perspective.

It's Not All Good

Convenience Isn't Necessarily the Best Option

Although the Wrist Mount ($49.99) might seem like it's one of the most versatile because you can wear the camera housing on your wrist and hold your arm at any height or angle to capture a shot, the actual functionality of this accessory isn't so comfortable—nor as versatile as it may initially seem.

For most shooting situations, you can use alternate ways to wear the GoPro camera (or mount it on equipment) that are more functional and more comfortable, and that enable you to keep your hands and arms free to engage in the activity.

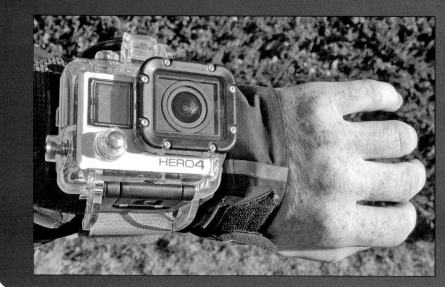

Finding and Purchasing Third-Party Mounts and Accessories

The GoPro website (www.gopro.com) exclusively sells GoPro products. However, many retailers that sell GoPro cameras, such as Best Buy, also sell GoPro-compatible mounts and accessories from third parties. However, the best place to find a wide selection of third-party mounts and accessories, and potentially save money, is online.

If you know exactly what you're looking for, you can visit the third-party company's website directly to learn more about its respective GoPro-compatible products or place an online order.

However, to learn more about a wide range of third-party mounts and accessories, access any Internet search engine, such as Google, Yahoo! or Bing!, and enter the search phrase, "GoPro Camera Mounts" or "GoPro Camera Accessories." You can also include a specific camera model within your search. For example, use the search phrase, "GoPro Hero4 Camera Mounts."

Some examples of useful third-party manufacturers include the following:

- **GoPole** (www.gopole.com): The GoPole company offers a line of optional grips, extension arms, and mini-tripods that go above and beyond what's possible using only GoPro's mounts and accessories.

- **Joby** (www.joby.com): This company is best known for its GorillaPod mini-tripods that have adjustable and flexible tripod legs. When used with a GoPro Tripod Mount, most of the company's products work nicely with any GoPro camera and housing. Joby also offers specialty mounts, such as the Action Clamp & Locking Arm ($39.95), that enable you to securely attach your camera housing to a wide range of objects or equipment, from tables or fences to skateboards or pipes.

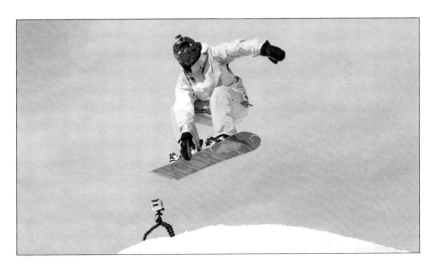

- **Octomask** (www.octomask.com): If you enjoy snorkeling or scuba diving, Octomask offers a growing line-up of specially designed dive masks that have a GoPro Quick Release Buckle built directly onto the masks. Thus, you can capture your underwater snorkeling or dive experience from a first-person, eye-level perspective and keep your hands totally free. These dive masks ($79.99 each) are extremely well made and were designed by professional divers.

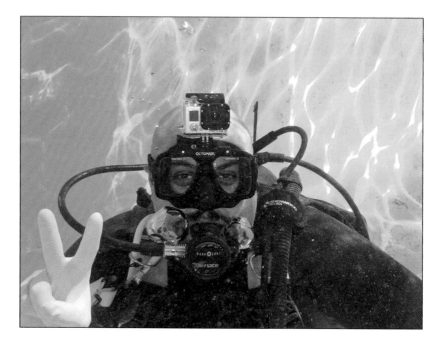

- **Peak Design Ltd.** (www.peakdesign.com): This company offers several mounts, including the Capture P.O.V. ($69.95). It can be attached to any strap or buckle that you wear or that's on your equipment (such as a ski boot). It then holds your camera housing securely in place.

- **PolarPro** (http://polarprofilters.com/shop/gopro-mounts): Instead of using the LCD Touch BacPac as a viewfinder and to adjust the camera's settings using its touch screen, PolarPro has developed a special mount for the GoPro that allows the camera housing to be attached directly to a custom iPhone 5/5S or iPhone 6 casing. Thus, you can use the iPhone and GoPro App as your viewfinder and to control the camera, and also use the iPhone as a camera grip.

Visit the PolarPro website to discover several dozen other specialized accessories for the various GoPro camera models, ranging from camera lens filters to extension arms. The GoPro Polarizing Filter ($29.99) attaches to the front of the camera's lens and automatically enhances the colors in your photos or videos when you shoot outdoors in sunlight.

LENS FILTERS ARE NEEDED ONLY IN CERTAIN SITUATIONS

Four main types of filters can be placed over your GoPro camera's lens to enhance your photos. These filters typically attach to the camera's housing using a mount or bracket that comes with the filter.

Use red or magenta filters exclusively for shooting underwater at depths greater than 10 to 12 feet. Use a red filter when the lake or ocean water naturally has a blue color. Use a magenta filter when the water has a greenish color. A colored filter removes this blue or green coloring and makes your underwater photos or video look more natural, plus the colors appear more vibrant.

Use an optional polarizing filter when shooting outdoors in sunny weather to make the colors in your photos or video appear brighter and more vibrant.

GoPro's Frame Housing comes with a glass lens filter that you can use simply to cover and protect the camera's lens when this housing is in use. This optional filter won't alter your photos or videos in any way, but it can help keep the camera's lens clean and prevent scratches.

Throughout this book, you'll see how many of these optional mounts with various GoPro housings can be used in a wide range of shooting situations to achieve professional-quality results.

The LCD Touch BacPac accessory for GoPro cameras provides a full-color viewfinder with touch screen technology that allows you to easily adjust the camera's settings.

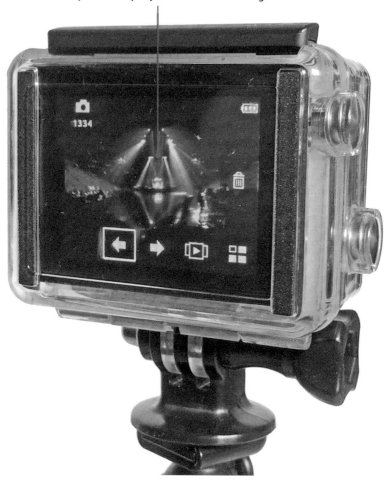

In this chapter, you learn about some of the extremely useful and popular accessories for use with the GoPro cameras. Topics include the following:

→ Remotely controlling your GoPro camera with a Smart Remote
→ Using the LCD Touch BacPac display
→ Giving your camera a power boost with the Battery BacPac

Must-Have GoPro Camera Accessories

In addition to using your GoPro camera with a housing and mount that's best suited to your shooting situation, GoPro offers several other extremely useful accessories that make the camera easier to use, give it added functionality, and enable you to capture better photos or videos.

Three of GoPro's most useful accessories, which fall into the "must have" category for many GoPro camera users, are the Smart Remote, the LCD Touch BacPac display, and the Battery BacPac.

Remotely Control Your Camera with the Smart Remote

The GoPro Hero3+ offers Wi-Fi capabilities, whereas the Hero4 can use Wi-Fi and Bluetooth to establish a wireless connection between the camera and certain accessories, including GoPro's handheld remote control for the camera, which comes bundled with certain camera configurations or is also sold separately ($79.99).

Additional Smart Remote Features

Originally, the wireless remote for the GoPro cameras was called the *Wi-Fi Remote*. However, with the release of the Hero4 camera, this useful remote control accessory was updated with enhanced capabilities and renamed. It's now called the *Smart Remote*.

Using the battery-powered Smart Remote, you can remotely control all the camera's options and adjust its settings from up to 600 feet. Like the camera, the Smart Remote is waterproof (but only to a depth of 33 feet), and it's designed to be used in a wide range of shooting situations. For more serious photographers or videographers, another useful feature of the Smart Remote is that this one remote control unit can be programmed to wirelessly control up to 50 different GoPro cameras, either separately or simultaneously.

The GoPro Smart Remote that's shown on the left (which works with the Hero3+ or Hero4) has a slightly different design than the original Wi-Fi Remote for the Hero3+ (shown on the right).

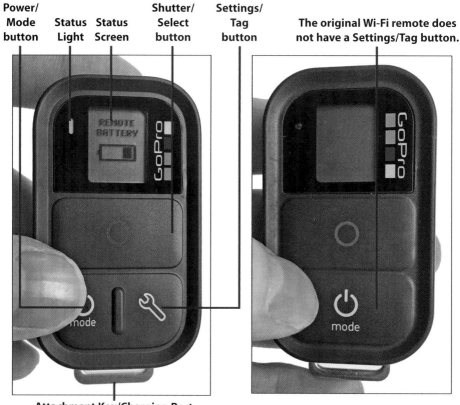

Power/
Mode
button

Status
Light

Status
Screen

Shutter/
Select
button

Settings/
Tag
button

The original Wi-Fi remote does
not have a Settings/Tag button.

Attachment Key/Charging Port

GoPro Smart Remote

GoPro Wi-Fi Remote

In addition to the large Power/Mode, Shutter/Select, and Settings/Tag buttons, which work exactly the same way as their counterparts that are built in to the GoPro camera body, the Smart Remote's built-in LCD Status Screen mirrors exactly what displays on the camera's Status Screen. The remote also has a Status Light built in that mirrors in real time what the Status Lights built into the camera display.

After you establish a wireless connection between the camera and the Smart Remote, you can

- Remotely turn on or off the camera.

- Adjust the camera's shooting mode and settings.

- Control the camera wirelessly when shooting photos or video.

- Use the Hero4's Tag feature to mark important moments as you shoot video, so you can find them faster during the editing process.

The Wi-Fi Remote Lacks the Settings/Tag Button

The older Wi-Fi Remote does not have a Settings/Tag button but functions similarly to the Smart Remote.

Charge the Smart Remote's Battery

The Smart Remote (and older Wi-Fi Remote) has a built-in rechargeable battery that powers the device. Prior to using the remote, you need to charge it:

1. Remove the Attachment Key from the remote, if applicable. To do this, move the release switch on the back of the remote from right to left, and then pull out the Attachment Key.

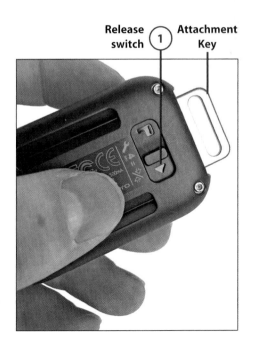

Release switch ① Attachment Key

2. Plug the larger end of the supplied Smart Remote USB Charging Cable into the bottom of the Smart Remote.

3. Plug the USB plug end of the cable into your computer's USB port, or plug the USB plug into an optional Wall Charger or Auto Charger.

The Smart Remote Has Its Own Rechargeable Battery

When the Smart Remote's battery is fully charged, a graphic of a fully charged battery displays on the remote's Status Screen.

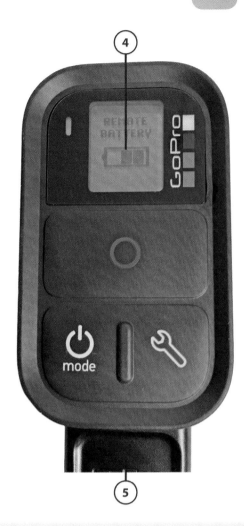

4. The Status Screen displays a battery-level graphic to indicate that it's charging. Allow the Smart Remote's battery to charge for at least 1 hour prior to initially using it.

5. Remove the USB Charging Cable from the Smart Remote, and if you choose, replace it with the Attachment Key.

>>>Go Further
USE THE SUPPLIED ATTACHMENT KEY TO KEEP THE SMART REMOTE HANDY

When in use, consider attaching the supplied Attachment Key to the bottom of the remote. This metallic key-shaped item fits into the remote's charging port. You can attach the opposite end of the key to a key ring, lanyard, tether, or some other type of holder to ensure it remains readily accessible while you shoot. Use the Attachment Ring (also supplied) for attaching the remote to other items. Also included with the Smart Remote is a wrist strap, so you can wear the unit like a wristwatch.

Pair the Smart Remote with Your Hero4 Camera

Prior to using the Smart Remote for the first time, you need to pair this accessory with your camera. This process needs to be done only once. After this, it works automatically from up to 600 feet away. Follow these steps to initially pair your Hero4 with a Smart Remote:

1. Turn on the GoPro camera by pressing the Power/Mode button.

2. Press the Power/Mode button repeatedly to cycle through the menu options until the Setup option displays on the Status Screen.

The Touch BacPac Displays Easier-to-Understand Camera Menus

When accessing any GoPro Camera menus or adjusting its settings is required, this is easier to accomplish using the optional LCD Touch BacPac display—more information will be displayed on this touch screen, and you can navigate through the camera's menus faster using your finger.

3. Press the Shutter/Select button to choose the Setup option.

4. When the Setup menu displays, press the Power/Mode button repeatedly to cycle through the menu options until the Wireless option displays on the Status Screen.

5. Press the Shutter/Select button to choose the Wireless option.

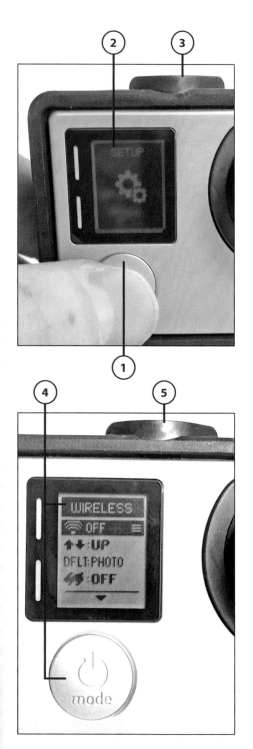

6. When the Wireless menu displays, press the Power/Mode button repeatedly to cycle through the menu options until the WiFi RC (or RC & App) option displays on the Status Screen.

7. Press the Shutter/Select button to choose this option.

8. If the camera does not automatically enter into pairing mode in search of the Smart Remote device, cycle to the New (or New RC) option, and select it to place the camera into pairing mode.

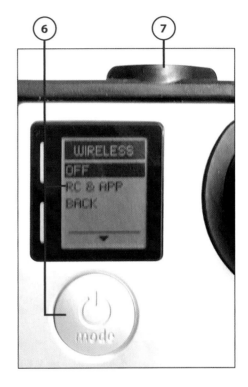

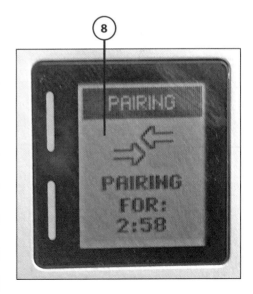

9. On the Smart Remote, press the Power/Mode button to turn it on. Assuming it has never been paired with a GoPro camera, the remote unit will enter into pairing mode.

10. If the Smart Remote has been paired with other GoPro cameras previously, press and hold down the Settings/Tag button for approximately 4 seconds to initiate the pairing process.

11. After the Smart Remote and Hero4 establish a wireless connection, a check mark graphic appears on both Status Screens. The Smart Remote now functions with the GoPro camera it's paired with.

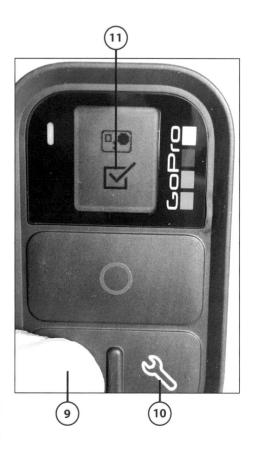

Directions for Hero3+ Users

You can find directions for how to pair the Hero3+ camera with the original Wi-Fi Remote or the Smart Remote on GoPro's website at http://gopro.com/support/articles/how-to-pair-your-hero3-wi-fi-remote.

Using the Smart Remote with Your Camera

After pairing your camera with the Smart Remote, turn on the Wireless option that's built in to the camera. At this point, you can operate the camera by pressing the buttons on the camera, or you can use the Smart Remote to handle any camera-related function remotely using the three buttons on the Smart Remote.

How to Turn on the Camera's Wireless Mode

To turn on the camera's Wireless function, turn on the camera, access the Setup menu, and from the Setup menu, select the Wireless option. From the Wireless menu, select the WiFi RC or RC & App option. When Wireless mode is turned on and active, the camera's blue Status Light flashes, even when the camera is turned off.

If you plan to mount your camera on equipment where it won't be easily accessible while you engage in a particular activity—or if you want to set up the camera on a tripod or mount but be standing away from the camera while you take pictures or film video—using the Smart Remote is a convenient and viable option.

Alternatively, if you're a smartphone or tablet user, you can install the free GoPro App onto your mobile device, pair your device with your camera, and then control the camera remotely via the GoPro App from your mobile device. Chapter 15, "Using the GoPro Mobile App," explains how to do this.

It's Not All Good

How Far the Wireless Signal Reaches

The distance from which you can wirelessly control the camera using the GoPro mobile app via your smartphone or tablet is much less than the 600-foot signal radius offered by the Smart Remote. However, the Smart Remote does not offer a viewfinder option. Therefore, which method you use to remotely control your camera is a matter of logistics and personal preference.

Control Your Camera with the Smart Remote

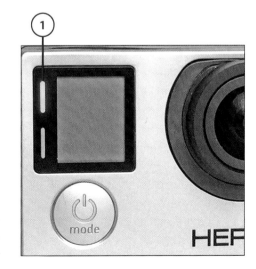

The Smart Remote buttons work just like the corresponding buttons on the camera's body. You can turn on the camera remotely and begin taking digital photos using the Photo-related settings you previously selected (or the default Photo-related settings) by following these steps:

1. Make sure the camera's Wireless mode is turned on. The blue Status Light should be flashing, even if the camera is turned off.

2. From the Smart Remote, press the Power/Mode button for 2 seconds to remotely turn on the camera. The Status Screen on the remote displays the camera's main menu.

3. Press the Power/Mode button on the Smart Remote repeatedly to cycle through the menu options until the Photo option appears.

4. Press the Shutter/Select button on the remote to choose this option.

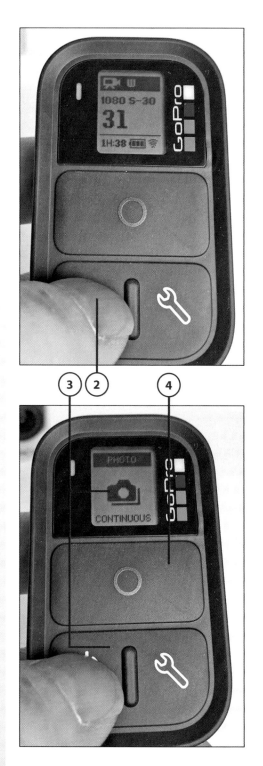

5. Set up the camera using a housing and mount, and frame your shot. Your GoPro camera is now turned on in Photo mode and ready to take pictures (not pictured).

6. Using the Smart Remote, press the Shutter/Select button to take individual photos. Or use the Smart Remote to adjust the Photo mode's settings before taking pictures.

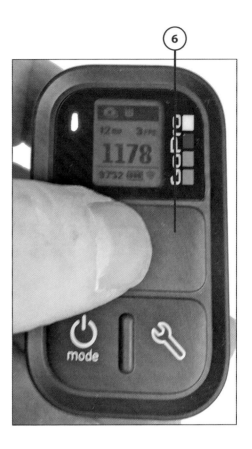

More About Adjusting the Camera's Settings

Chapter 8, "Shooting High-Resolution Photos," includes information on how to adjust the camera's photo-related settings and take pictures using your camera with or without the Smart Remote.

Chapter 10, "Shooting HD Video," covers how to adjust your camera's video-related settings, including its resolution and then shoot video using your camera with or without the Smart Remote.

Adjusting Settings with the Touch BacPac

A viewfinder is one of the features that virtually all point-and-shoot and digital SLR cameras offer. The GoPro cameras, however, do not have a built-in viewfinder. If you want to see what you're shooting in real time, you need to either invest in the optional LCD Touch BacPac display ($79.99), or use the GoPro mobile app with your smartphone or tablet.

See the World Through the Lens of Your Camera

It's a camera's viewfinder that shows you exactly what you're about to shoot and what your camera's lens has been set up and positioned to capture within your shots. Hence, if you're using your GoPro like a traditional camera, where you hold it in your hands, point it outward, and shoot a subject, the viewfinder is an essential tool for properly framing your shots, whether you are shooting photos or video.

The LCD Touch BacPac is a small, optional add-on accessory for the GoPro cameras that attaches to the back of the camera's body. It is powered by the camera's rechargeable battery. Thus, when you use this convenient accessory, your camera's battery life will be somewhat shorter.

In addition to serving as a full-color viewfinder while shooting, the LCD Touch BacPac has touch screen capabilities that enable you to view and navigate through all the camera's menus in a faster, straightforward, and efficient way. This method of adjusting the camera's settings can replace your need to use the camera's built-in Power/Mode and Shutter/Select buttons, as well as the camera's Status Screen.

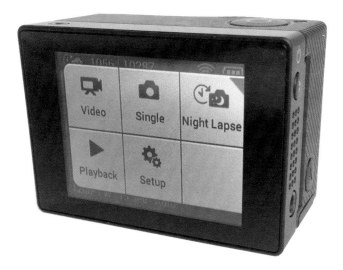

After you shoot photos or video, you can use the LCD Touch BacPac to play back your content without having to transfer your photos or videos from the camera's memory card to your computer or mobile device.

As you play back your video content on the LCD screen, you can hear the recorded audio either through the accessory's tiny built-in speaker, or you can plug standard headphones into the built-in 3.5mm headphone jack.

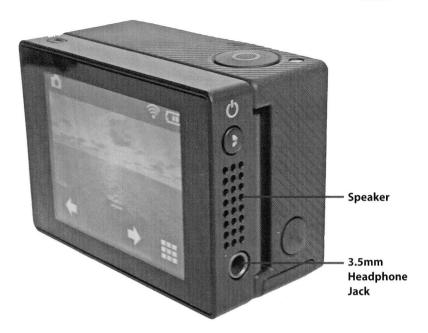

— **Speaker**

— **3.5mm Headphone Jack**

To attach the LCD Touch BacPac to the camera, turn off the camera and point it so that the camera's back faces you. Line up the hooked end of the accessory to the groove on the right side of the camera's back.

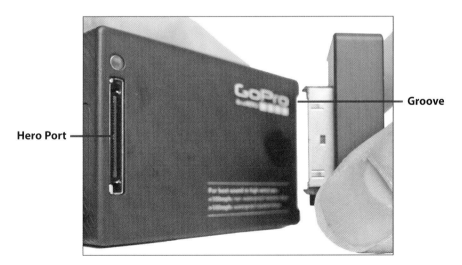

Hero Port —

— **Groove**

Gently press the BacPac connector on the accessory into the camera's Hero Port.

Hero4 Users Can Use Finger Swipes on the LCD Touch BacPac Display

In addition to allowing users to touch the screen to navigate through the menus and adjust camera settings, Hero4 users can also use finger swipe movements to perform certain tasks.

After the LCD Touch BacPac is connected to the camera, it automatically turns on whenever the camera is powered on. However, you can manually turn on or off this accessory by pressing its Playback button. If you're not using any of the functions offered by this accessory, turn it off to conserve battery power.

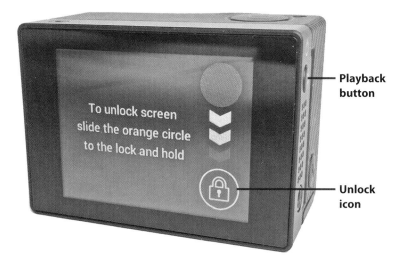

Playback button

Unlock icon

To unlock the touch screen, press your finger on the red dot and swipe downward to move the red dot over the lock icon. Hold your finger in place for several seconds after the red dot is dragged over the lock icon. An unlock animation displays, after which time the touch screen can then be used. Then, use finger taps or finger swipes on the touch screen to navigate through the camera's menu options and to adjust camera settings.

USE FINGER SWIPES TO NAVIGATE THROUGH MENUS

When using the LCD Touch BacPac with a Hero4, swipe across the touch screen from right to left with your finger to display the camera modes. You can also use these other finger swipe motions on the touch screen:

Swipe up/down: Scroll through a displayed listing of menu options.

Swipe upward from the bottom of the screen: Open and access the Settings menu for the camera's current shooting mode.

Tap: If you want to select a specific setting from a menu to turn it on or off, tap the screen when a particular menu option displays.

Swipe left/right (in Playback mode only): Scroll through and display thumbnails of stored images and videos.

Double-tap: When in Preview mode while shooting and using the camera as a viewfinder, this changes the Field of View.

Press and hold: This locks the touch screen when you hold your finger down on the screen for approximately 2 seconds.

Slide your finger downward: While maintaining constant contact with the touch screen, slide your finger from the top downward to unlock the display.

Instead of finger swipes, the Hero3+ recognizes only finger taps on the touchscreen to scroll through and access menus and to select various menu options.

Although you can preview and play back photos or videos on the LCD screen that's built into the LCD Touch BacPac, the photos and video display at a much lower resolution than the content was actually shot in.

After content has been shot, press the Playback button to view your photos or videos on the LCD screen. You can then scroll through image thumbnails. To play a video, tap its thumbnail or press the Playback button. Tap the Thumbnail icon to return to the thumbnail screen and preview your content, or tap the "X" icon to exit out of the Playback menu.

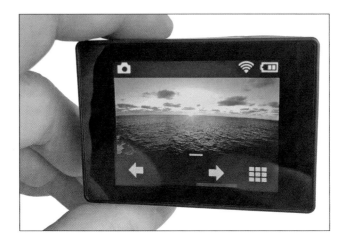

When using the LCD Touch BacPac with your camera and a Standard Housing or Dive Housing, you need to replace the backdoor of the housing and use a supplied Touch BacPac backdoor if you want to use the touch screen while the camera is encased within a housing. However, this Touch BacPac backdoor is only waterproof to a depth of 10 feet.

If you want to use the LCD Touch BacPac as just a viewfinder (with no access to the touch screen) while providing full waterproof protection to the camera and the display, use it with a Standard Housing or Dive Housing, and use a BacPac backdoor (which offers waterproof protection to a depth of 131 feet).

When filming video in a calm and dry environment, attach a Skeleton BacPac backdoor to most of the GoPro's housings to protect the camera, lens, and display from dirt or physical damage, plus record higher quality audio. No waterproof protection is offered with this option.

Use Your GoPro Like a Traditional Point-and-Shoot Camera

The LCD Touch BacPac is an extremely useful accessory if you want to use your GoPro camera more like a traditional point-and-shoot camera. However, if you plan to mount the camera on yourself or your equipment and then control it remotely using the Smart Remote or GoPro mobile app, the LCD Touch BacPac is unnecessary.

Give Your Camera a Power Boost with the Battery BacPac

Depending on which camera features and functions you use, in the best-case scenario, a fully charged GoPro battery will last only for 90 minutes of actual filming (often much less). Then, you need to either swap out the battery with a fully charged one, or stop using the camera to plug it in so that the battery that's within it can recharge.

If you work on projects that require a lot of continuous filming, or you take the camera on a vacation and want to shoot photos and videos throughout the day without needing to change batteries often, consider investing in the optional Battery BacPac ($49.99). Designed to be the same thickness as the LCD Touch BacPac, this is an external battery pack that attaches to the back of the camera. It greatly extends the overall battery life of the camera per charge.

It's Not All Good

Choose Between the LCD Touch BacPac and Battery BacPac

The drawback to the Battery BacPac is that when it's attached to the camera, you can't simultaneously use the LCD Touch BacPac display. Using this accessory, however, greatly reduces the number of times you need to shut down the camera and then remove it from its mount and housing to swap batteries.

The Battery BacPac comes with a USB charging cable that plugs into the USB port of a computer, or you can use an optional Wall Charger or Auto Charger. You can remove the Battery BacPac from the camera when it's charging, so you can continue shooting using either a second Battery BacPac or regular GoPro camera batteries.

When this accessory is connected to the camera, you must use a supplied BacPac backdoor with any of the GoPro housings because this battery pack increases the thickness of the camera body.

Learn to Extend the Battery Life of Your GoPro Camera

More information about using the GoPro's rechargeable batteries, how to extend the life of the batteries per charge, and how to save money on replacement GoPro-compatible batteries is covered in Chapter 7, "Keeping Your Batteries Charged."

All the photos and video you shoot with your GoPro camera are stored on the microSD memory card that's placed within the camera.

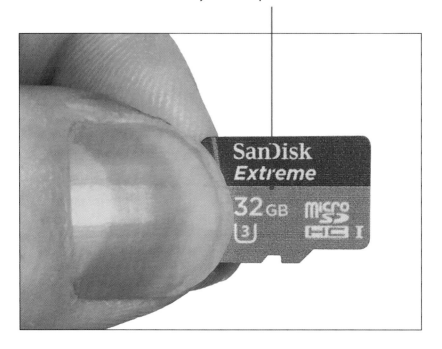

In this chapter, you learn all about microSD memory cards and how to use them with your GoPro camera. Topics include the following:

→ Selecting the best microSD memory cards for your needs
→ What you should know about memory card capacity and read/write speeds
→ Inserting the memory card into your camera and using it
→ How to format and manage your memory cards

Choosing the Best Memory Cards for Your GoPro Camera

As with any point-and-shoot, digital SLR or digital video camera, the photos and video you shoot are stored within a removable memory card that you insert into the camera prior to shooting.

Dozens of different memory card formats are available. Each memory card format comes in a variety of different capacities, and each offers a specific read/write speed. You need to choose the right memory card for your GoPro camera because this is one piece of required equipment that does not come bundled with the camera.

All the GoPro camera models use a tiny-sized microSD format memory card. This makes shopping for memory cards a bit less confusing. However, you still have some important decisions to make that relate to the card's read/write speed and storage capacity.

The microSD Memory Card Stores Your Images and Video

Your camera's memory card is meant to be a temporary storage solution for your photos or videos. Ultimately, you need to transfer your content from the camera's memory card to your computer, mobile device, and an online-based service to view, edit, archive, and potentially share your content. Then, you can reformat (erase) the memory card and reuse it.

Picking the Right Memory Card Speed Class

A memory card's *speed class* is rated and measured based on how quickly data can be transfered from your camera and stored onto the memory card while you shoot. This is the memory card's *write speed*.

To record high-definition or ultra high-definition (4K resolution) video, or high-resolution digital photos, a lot of information needs to be transferred between your camera and the memory card quickly while you actually shoot. Thus, for a microSD memory card to work with your GoPro camera, it must record (write) data fast enough to keep up with the camera.

Be sure to select a microSD memory card that has a Class 10 or UHS-1 rating, which displays on the memory card's packaging, and often on the memory card. The speed class of a Class 10 memory card can often be identified with the number 10 within a circle.

Class 10 or UHS-1 rating information

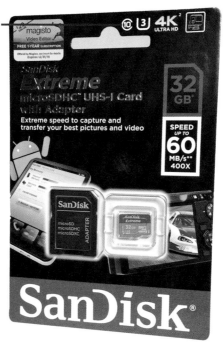

The UHS-1 Rating

For microSD memory cards, companies use different types of flash memory during the manufacturing process. The Class rating of a memory card refers to its write speed. The UHS Speed Class is another measure of a memory card's write speed. A microSD memory card with a UHS-1 rating has a minimum write speed of 10MB/second, which is needed to store HD or Ultra HD digital video files.

Meanwhile the *read speed* of a microSD memory card refers to how quickly data that's stored within the card (in this case, your photo or digital video files) can be transferred from the card to your computer. This also is measured in megabytes (MB) per second.

As you shop for microSD memory cards for your GoPro camera, choose the cards with the fastest read/write speed (that is Class 10 or UHS-1) rating you can afford. Traditionally, the higher the card's read/write speed, the higher the price of the card. However, due to intense competition among memory card manufacturers, this is not always the case.

Selecting a Memory Card's Storage Capacity

Every memory card has a maximum storage capacity, which can be 4, 8, 16, 32, or 64 gigabytes (GB). Obviously, the larger the storage capacity of the card, the more photos and video it can hold. Although microSD memory cards come in capacities larger than 64GB, this is the highest capacity your GoPro camera is currently compatible with.

A Memory Card's Capacity Is Important

One of the major contributing factors to a memory card's price is its capacity. So, in general, choose a card with the highest storage capacity and fastest read/write speed you can afford. If you plan to shoot HD or Ultra HD video, you need a microSD card with a 32GB or 64GB capacity because anything smaller fills up too quickly.

The number of photo files or the length of HD or Ultra HD video that can fit on a particular size memory card varies greatly based on many factors, including the resolution and frame rate at which you capture the video, or the resolution and field of view you use to capture digital images. If you

use certain camera features, such as Protune, this generates larger file sizes, which ultimately require more memory card storage space. In addition, file sizes associated with 4K video shot at 15fps on a Hero4, for example, are massive.

As you shoot photos and video, your camera's Status Screen displays how many additional photos, or how much more video the memory card can hold based on its current settings.

If you change any of the camera's settings, you increase or decrease the shooting resolution, which impacts the number of additional photos or how much additional video the memory card can hold. This same information displays on the Smart Remote's Status Screen or within the GoPro mobile app as you shoot.

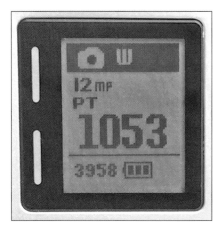 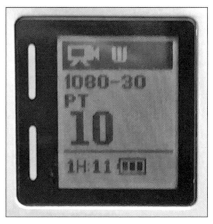

Shown on the left, the Hero4 is set to Photo mode. The memory card within the camera has 1,053 images already stored within it and the capacity to hold 3,958 additional images.

On the right, the Hero4 is set to Video mode. The memory card has 10 videos stored within it. Based on the camera's current settings, and what's already stored on the memory card, it can hold up to 1 hour and 11 minutes (01:11) of additional video content.

>>>Go Further

TRY TO AVOID DELETING PHOTOS OR VIDEOS WHILE ON THE GO

One of the biggest mistakes amateur photographers and videographers make is filling up their memory card with important photos or videos that they don't want to delete, but they don't keep a replacement memory card on-hand to keep shooting. Thus, they wind up missing important shooting opportunities. If you're experiencing a once-in-a-lifetime vacation or moment, not being able to take photos or videos can be upsetting. For this reason, it's always a good strategy to have at least one or two extra microSD memory cards on-hand whenever you shoot.

Don't get into the habit of deleting files from the memory card while on the go. If you preview your photos or videos using the screen of the LCD Touch BacPac accessory, or the screen of your smartphone or tablet, the resolution you're previewing that content at is much lower than you used for the shooting. Thus, you're better off making decisions about which files to keep and which to discard when viewing them on your computer monitor or HD television set at their full resolution.

Shopping for and Using microSD Memory Cards

You can purchase microSD memory cards that are compatible with your GoPro directly from GoPro's website (www.GoPro.com). However, GoPro has opted to offer only 32GB and 64GB memory cards manufactured by SanDisk and Lexar, for $49.99 (32GB) and $79.99 (64GB). These are excellent memory cards, but you do have other options, including finding these same memory cards at lower prices from consumer electronic stores, office supply super-stores, and any specialty camera store, including a wide range of online merchants.

Your must determine your needs and then shop for the best prices. However, you'll always pay a hefty premium if you're on vacation and wait to purchase a new memory card at or near a popular tourist destination.

Amazon.com offers microSD memory cards from many different manufacturers at competitive prices. However, you can also use a price comparison website, such as Nextag (www.nextag.com), and within the Search field, type exactly what you're looking for. Your search results will display dozens, possibly hundreds, of online merchants that offer microSD memory cards at the discounted prices they're offering them at, as well as merchants' reviews from customers.

What to Search for Online

Within the Search field of Amazon.com or Nextag.com, for example, use a search phrase such as, "microSD memory card, 32GB." If you're looking for memory cards from a specific manufacturer, also include this within your search. For example, enter, "SanDisk microSD memory card, 64GB" into the Search field.

Brand name memory cards often cost more than generic memory cards that are usually technologically identical to their brand name counterparts. As long as you use a microSD memory card that's Class 10 and UHS-1 rated, which have a 64GB (or less) capacity, it should work fine with your camera. However, GoPro recommends using a name brand memory card that has been tested for maximum reliability when shooting and engaging in high-vibration activities and when the camera is used in extremely hot, humid, or cold temperatures.

Insert a Memory Card into Your Camera

When you have a new microSD memory card, turn off your GoPro camera and remove it from its housing and mount. As you handle the camera, avoid directly touching the lens with your fingers or palms. You should insert or remove your camera's memory card indoors in a clean and dry environment. Follow these steps for inserting the memory card:

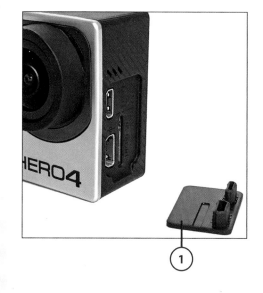

1. Remove the port door on the side of your camera. Be careful you don't accidentally lose this small plastic door.

2. Holding the memory card with your thumb and index finger, gently place it partway into the camera's microSD memory card slot, with the front of the memory card facing forward toward the front of the camera. If the memory card doesn't slide into the card slot easily, you may have it backward or upside down.

Safety Tip

When removing the memory card from its packaging, avoid touching the metallic connectors on the card with your fingers. It's essential that these connectors are kept clean.

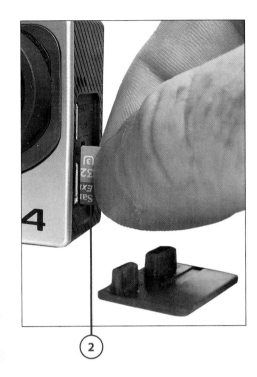

3. Using one finger, press the side of the card so that it gets fully inserted into the camera's memory card slot.

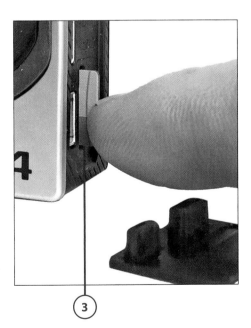

4. It should click into place and remain flush with the camera's card slot. Replace the port door on the camera.

Removing a Memory Card from the Camera

To later remove the memory card, simply place your finger against the end of the card and press gently inward to unlock the card from its locked position. Then gently remove the card with your fingers.

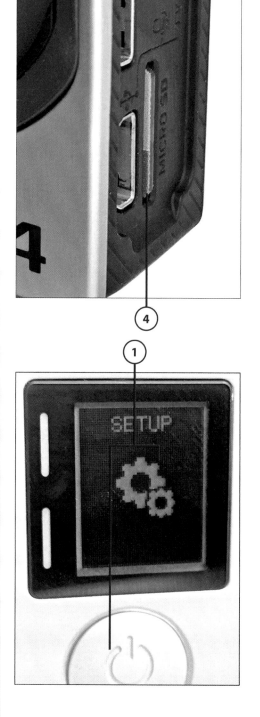

Format a microSD Memory Card Using a Hero4

Prior to initially using a new memory card, or after you transfer a memory card's content from the card to your computer, mobile device, or an online service, you need to format or reformat the memory card while it's installed within the camera. To format (or reformat) your Hero4's memory card, follow these steps:

1. With the memory card installed in the camera and the camera turned on, repeatedly press the Power/Mode button to scroll through the menu options until the Setup (gear-shaped icon) appears on the camera's Status Screen.

2. Press the Shutter/Select button to access the Setup menu.

3. Repeatedly press the Power/Mode button to scroll through the Setup menu options until the Trash icon appears on the camera's Status Screen. Press the Shutter/Select button to choose this option.

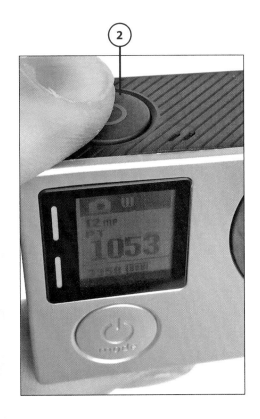

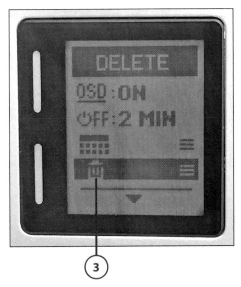

4. Press the Power/Mode button repeatedly until the ALL/Format option displays. Then press the Shutter/Select button to choose it.

5. Press the Power/Mode button repeatedly until the Delete option displays; then press the Shutter/Select button to choose it.

6. The camera's red Status Lights illuminate to indicate the formatting process is underway. Depending on the capacity of the memory card, formatting or reformatting takes between 5 and 15 seconds.

When the format is complete, the camera's memory card is now empty. When the camera is turned on, the file counter should say zero. Before attempting to shoot anything, snap one test photo and preview it to ensure the memory card functions properly.

Formatting a Memory Card Using a Hero3+

Formatting a memory card permanently deletes all content that's stored on it. You can find directions for formatting a microSD memory card using a Hero3+ on GoPro's website (http://gopro.com/support/articles/formatting-sd-card-with-hero3).

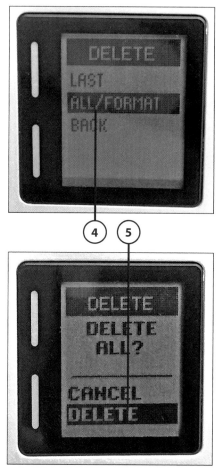

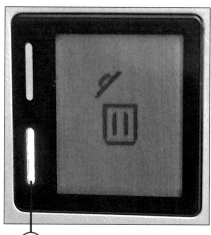

6 **Red Status Light**

STRATEGIES FOR PROTECTING YOUR MEMORY CARDS

It's a good idea to periodically reformat your memory card (after copying its contents to your computer, a mobile device, or an online-based service). microSD memory cards are designed to be reused thousands of times. You can increase the "life" of the card and prevent data corruption issues by properly caring for it.

Store the card in a clean, dry, and mild temperature climate when it's not in use, and refrain from touching the metal connectors on the card when inserting or removing it from the camera.

Do not expose the memory card directly to water, dirt, or extreme temperatures. When a memory card is not within the camera, store it within the casing that it came with.

Understanding Memory Card-Related Error Messages

Your GoPro camera can generate three error messages related to memory cards. If necessary, one of these messages will display on the camera's Status Screen.

- The NO SD message means there is no memory card present within the camera's microSD memory card slot. Simply insert a memory card into the camera to rectify this situation.

- The word Full will display if the memory card's capacity has been reached. At this point, you need to delete files or replace the memory card.

- The SD ERR message means some type of data-related error has occurred. Perhaps the data on the card has been corrupted. To fix this, you'll often need to reformat the card, which will delete all its contents.

What to Do

When you see an SD ERR message (which rarely, if ever happens), turn off the camera immediately and remove the memory card from the camera. By connecting the memory card to your computer (via a memory card reader) and using specialized data recovery software, you might retrieve any photos or videos already stored on the card before reformatting it. This is also something a professional data recovery service can do for you, but this is typically a costly option.

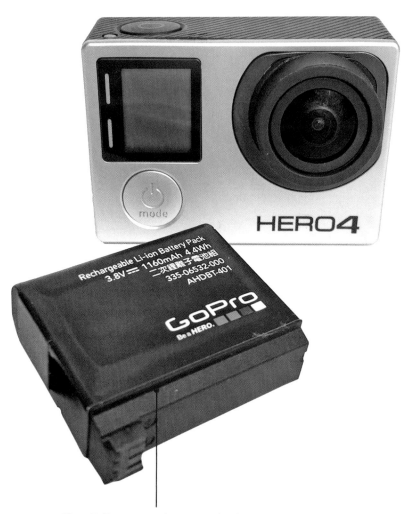

Your GoPro camera is powered using interchangeable and rechargeable batteries, like this one. (The Hero4 Battery is shown here.)

In this chapter, you learn how to use the interchangeable and rechargeable batteries that power your GoPro camera. Topics include the following:

→ Charging options for GoPro batteries
→ Using compatible, instead of genuine, GoPro batteries with your camera
→ Properly inserting a battery into the camera
→ Strategies for extending battery life

Keeping Your Batteries Charged

With the exception of the entry-level GoPro Hero camera, which has a single rechargeable (but not removable) battery actually built in to the camera's body, all the other GoPro camera models use interchangeable and rechargeable batteries. One battery comes with the camera, but you can purchase additional genuine GoPro batteries separately for $19.99 each.

Different Camera Models Use Different Batteries

The GoPro Hero3+ uses an 1180mAh lithium-ion rechargeable battery, which is slightly different than the 1160mAh lithium-ion rechargeable battery designed for the GoPro Hero4 camera. When purchasing extra batteries, be sure to select the appropriate battery for your camera.

You can recharge GoPro (or GoPro-compatible) batteries in two ways. First, with the battery installed within the camera, use the supplied USB cable to connect your camera directly to the USB port of your computer, or connect the opposite end of the USB cable to the optional GoPro Wall Charger ($39.99) or GoPro Auto Charger ($29.99) to access an external power source.

A second option is to remove the battery from your GoPro camera, and insert it into a GoPro Dual Battery Charger, which for the Hero4 is priced at $49.99 for the charger and one additional battery. The Dual Battery Charger for the Hero3+ is priced at $29.99 but does not include an extra battery. As their names suggest, either of these chargers enable two batteries to be charged simultaneously outside the camera.

You can plug the Hero4 version of the Dual Battery Charger unit into the USB port of a computer (using the supplied USB cable). You can also plug the opposite end of the cable into the optional GoPro Wall Charger or GoPro Auto Charger (sold separately). If you opt to use a compatible wall charger instead of the genuine GoPro version, be sure this charger is labeled Output 5V 1A to ensure compatibility. Plug the Hero3+ version of the Dual Battery Charger directly into an electrical outlet.

Although it will have a shorter life, you can use a battery within your camera that isn't fully charged, and this does not have a detrimental effect on the battery. Over time, you will notice that the battery will slowly fail to hold a full charge, or the life of the battery per charge will get shorter and shorter. At this point, consider replacing the battery with a new one.

It's Not All Good

Always Have Extra Batteries Available When Shooting

One of the few drawbacks to the GoPro cameras is the relatively short life per charge offered by these batteries, especially if you use the camera's higher-end features, or use the camera with the LCD Touch BacPac or certain other accessories, which consume additional power.

It's a good strategy to always have two or three extra fully charged batteries, as well as a charger, so as you drain individual batteries while filming, you can recharge them, while always having a charged battery available to insert into the camera to have a continuous supply of power.

>>>Go Further

THE STATUS LIGHT TELLS YOU WHEN THE BATTERY IS CHARGING

When you have a battery inserted into the camera, and you use the USB cable to plug it into an external power source, the battery within the camera recharges. While this is happening, the red Status Light on the camera remains illuminated. When this light turns off, this indicates the battery is fully charged.

Depending on which external battery charger you use, the status light on the charger may work the same way. However, some chargers display a solid red or flashing red light during the charging process. This light turns green or turns off altogether when the battery is fully charged.

Tracking Battery Life

Although multiple variables help to determine how long a battery lasts within your GoPro camera while shooting, Table 7.1 lists the average battery life you should expect based on which shooting mode you use with the GoPro Hero3+ Black Edition. This information is published on GoPro's website.

Table 7.1 Average Battery Life for Continuous Video Filming with the GoPro Hero3+ Black Edition

Video Mode		Estimated Time		
	Wi-Fi Turned Off (hr:min)	Wi-Fi Turned On and Using the Wi-Fi Remote (hr:min)	Wi-Fi Turned On and Using the GoPro Mobile App (hr:min)	Wi-Fi Turned Off and Using the LCD Touch BacPac Display (hr:min)
4K (15fps)	2:00	1:50	1:20	1:25
2.7K (30fps)	1:40	1:35	1:10	1:15
1440 (48fps)	1:50	1:40	1:10	1:20
1080p (60fps)	1:30	1:20	1:00	1:10
1080p (30fps)	2:00	1:50	1:20	1:25
720p (120fps)	1:55	1:45	1:15	1:20

Also, using information provided by GoPro's website, Table 7.2 offers similar information related to the GoPro Hero4 Black Edition. In addition to the shooting mode, camera features, and accessories you use, environmental factors (such as hot or cold weather) can negatively impact battery life. These charts assume you start shooting with a fully charged battery.

Table 7.2 Average Battery Life for Continuous Video Filming with the GoPro Hero4 Black Edition

Video Mode	Estimated Time			
	Wi-Fi Turned Off (hr:min)	Wi-Fi Turned On and Using the Smart Remote (hr:min)	Wi-Fi Turned On and Using the GoPro Mobile App (hr:min)	Wi-Fi Turned Off and Using the LCD Touch BacPac Display (hr:min)
4K (30fps)	1:05	0:55	0:50	0:50
2.7K (48fps)	1:05	1:00	0:55	0:55
2.7K (30fps)	1:10	1:05	0:55	0:55
1080p (120fps)	1:10	1:05	1:00	0:55
1080p (60fps)	1:20	1:15	1:10	1:10
1080p SuperView (30fps)	1:30	1:20	1:15	1:15
720p (129fps)	1:50	1:40	1:30	1:20

Saving Money Using Compatible GoPro Batteries

Many online merchants sell GoPro-compatible (generic) replacement batteries, which are fully compatible with specific GoPro camera models, but these batteries cost significantly less than the $19.99 that GoPro charges.

Shown here are two Wasabi Power replacement batteries and a compatible charger for the Hero4 camera.

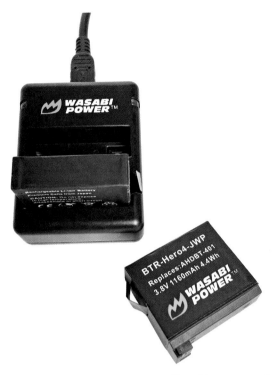

You can find these compatible batteries offered by companies such as Wasabi Power (www.amazon.com/wasabipower) and sold through Amazon.com.

To find less expensive generic batteries for your camera, visit the Nextag. com website, Amazon.com, or eBay.com, and enter the search phrase "GoPro Hero3+ replacement battery" or "GoPro Hero4 replacement battery."

YOU CAN SAVE A FORTUNE USING GOPRO-COMPATIBLE BATTERIES

The Wasabi Power Battery for GoPro Hero4, for example, is sold in a two-battery pack for $18.99 via Amazon.com, which is about one-half the price of genuine GoPro batteries. Priced at $32.99, Wasabi Power offers a Hero4-compatible battery package, which includes two Hero4-compatible batteries, a dual battery charger, a UBS cable for the charger, and a wall charger and auto charger for the battery charger.

Purchasing comparable genuine GoPro products may cost $49.99 for the GoPro Dual Battery Charger + Battery, plus $19.99 for an extra battery, $39.99 for the wall charger, and then an additional $29.99 for the car adapter, which is a total of $139.96.

Increasing Battery Life While Shooting

You can implement several strategies to extend the battery life per charge in your GoPro camera. Even if you opt to use these strategies, still seriously consider having one or two extra (fully charged) batteries on hand while shooting.

- Consider using the optional GoPro Battery BacPac while shooting. Refer to Chapter 5, "Must-Have GoPro Camera Accessories," for more information.

- Turn off the Wireless feature (Wi-Fi on the Hero3+, or Wi-Fi and Bluetooth on the Hero4) when you aren't using it.

- Set up the camera (from the Setup menu) to use only two of the camera's four red Status Lights.

- If you don't need it, turn off or remove the optional LCD Touch BacPac display.

- Set up the camera (from the Setup menu) to automatically shut down after just 1 minute of nonuse via the Auto Power Off setting.

- Make sure your camera has the latest version of the Camera Software installed. Almost every new version of this software that's been released by GoPro has helped the camera automatically conserve battery power or operate more efficiently.

- Shoot using the Protune features when they are needed because this feature consumes extra battery power.

- When shooting video, select the resolution and frame rate you actually need. Shooting at higher resolutions and frame rates depletes the battery faster.

- Set up the One Button mode (Hero3+) or QuickCapture option (Hero4) for the video shooting mode you use most often. This allows you to simply turn on the camera and start shooting at specific settings that you predefine. Over time, this can save battery life because you'll spend less time fumbling through menus and adjusting the camera settings.

- When recording video, try shooting shorter clips instead of leaving the camera running for extended periods. This strategy requires you to plan your shots better to save battery power and storage space on your memory card. You can save time during the editing process because you'll have less raw footage to sort through.

- Shooting in cold temperatures decreases battery life. To reduce this problem, try to keep the camera warm in between shots.

Insert a Battery into Your Hero4

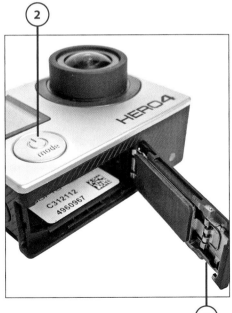

Follow these steps to insert a battery that's designed for the Hero4 camera into the camera body:

1. Remove the camera from its housing (and mount), if applicable (not pictured).

2. Turn off the camera.

3. Open the bottom door of the camera.

4. Insert the battery into the camera; then close the door. Attached to each GoPro battery is a paper-like tab. This tab is designed to help you easily remove the battery from the camera and should not be removed.

Hero3+ Differences

The process for inserting a compatible battery into a Hero3+ is similar to the Hero4. However, the door to the battery compartment is located on the back of the Hero3+.

Battery's tab

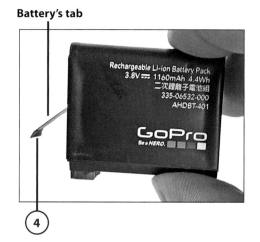

Discover how to shoot high-resolution digital photos using your GoPro camera, and learn how and when to use the camera's Photo, Continuous, Night, Burst, Time Lapse, and Night Lapse shooting modes.

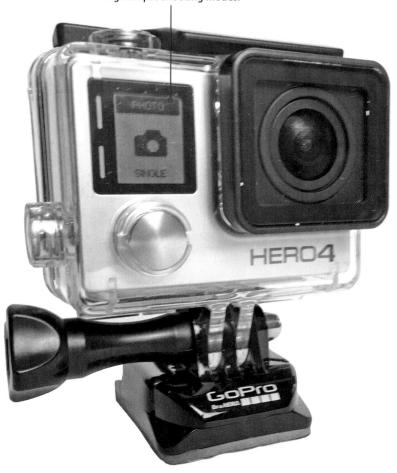

In this chapter, you learn about the features and functions built into the GoPro Hero4 camera (as well as some other GoPro camera models). Topics include the following:

→ Learning how and when to use each Photo or Multi-Photo-related feature built into your GoPro camera model

→ Learning the GoPro's menu structure so that you can quickly and accurately switch between shooting modes

→ Navigating through the picture-taking menus using the camera, LCD Touch BacPac, Smart Remote, or GoPro App

Shooting High-Resolution Photos

Earlier versions of the GoPro cameras were designed mainly for shooting HD video. However, the more recently released camera models, including the Hero3+ and Hero4, have a variety of built-in features and functions so that you can use the cameras to shoot high-resolution digital photos that fully utilize the camera's wide angle lens.

Because of its small size and durability (when used with an optional housing), the GoPro cameras also enable you to take high-resolution and extremely detailed photos in situations in which other point-and-shoot or digital SLR cameras aren't designed to go.

>>>Go Further
THE SKILL OF TAKING DIGITAL PICTURES

You can use all current GoPro camera models to take digital photos. However, each camera model offers a different selection of picture-taking features and functions, and you can shoot at different resolutions.

This chapter focuses on how to set up and use each of the GoPro Hero4's picture-taking features and functions. Some, but not all these features and functions are also built in to the GoPro Hero, Hero3, and Hero3+.

After you understand picture-taking features and functions and how to adjust your camera to use them (the "skill" aspect of digital photography), the next chapter can help you put these tools to work as you incorporate the creative aspects of digital photography and begin actually taking pictures. You can incorporate the "art form" aspect of digital photography into your picture taking.

Taking Pictures with Your GoPro

Each GoPro camera model offers a different selection of picture-taking features and functions, which you can use to shoot at different resolutions.

Because the top-of-the-line Hero4 Black includes all the picture-taking features and functions covered in this chapter, this is the camera model that is primarily discussed. However, Table 8.1 indicates other GoPro camera models that offer specific picture-taking features and functions.

Each of the GoPro cameras has several distinct shooting modes, which you can use to take digital photos (instead of shooting video). Each mode is designed to be used in a different shooting situation.

After you select a particular shooting mode, you can access the Settings menu to further fine-tune the camera settings you want to use.

First, take a closer look at each of the GoPro Hero4 Black's Photo and Multi-Shot-related shooting modes, as well as the options that can be adjusted when using each of them.

Table 8.1: Discover the Picture-Taking Features of Your GoPro Camera

Picture-Taking Feature	GoPro Hero	GoPro Hero3	GoPro Hero3+	GoPro Hero4 Silver	GoPro Hero4 Black
Maximum Resolution for Digital Photos	5MP	5MP	10MP	12MP	12MP
Burst Rates (Frames Per Second)	10/2	3/1	3/1, 5/1, 10/1	30/1, 30/2, 30/3, 10/1, 10/2, 10/3, 5/1, 3/1	30/6, 30/1, 30/2, 30/3, 10/1, 10/2, 10/3. 5/1, 3/1
Time Lapse Intervals	0.5 seconds	0.5, 1, 2, 5, 10, 30, or 60 second	0.5, 1, 2, 5, 10, 30 or 60 seconds	0.5, 1,2,5, 10, 30 or 60 seconds	0.5, 1,2, 5, 10, 30 or 60 seconds
Continuous Photo Rates (Frames per Second)	N/A	N/A	N/A	10/1, 5/1, 3/1	10/5, 5/1, 3/1
Wireless Mode & GoPro App Compatibility	N/A	Wi-Fi	Wi-Fi	Wi-Fi + Bluetooth	Wi-Fi + Bluetooth
Protune for Photos	N/A	N/A	N/A	Yes	Yes
Night Photo Mode	N/A	N/A	N/A	Yes	Yes
Night Lapse Mode	N/A	N/A	N/A	Yes	Yes
Simultaneous Video & Photo	N/A	N/A	N/A	Manual control, or photo every 5, 10, 30, or 60 seconds while shooting video	Manual control, or photo every 5, 10, 30, or 60 seconds while shooting video

Again, if you use a different GoPro camera model, not all these shooting modes or options are available, and the options that display (and in what order) within specific menus can vary.

Shoot Video and Photos Simultaneously

Some of the GoPro cameras, including the Hero4, enable you to shoot HD video and simultaneously take digital photos. How to utilize this Video+Photo feature is explained in Chapter 10, "Shooting HD Video." How to adjust the camera's Settings menu options is covered in Chapter 12, "Adjusting the Camera's Setup Menu Options."

Single Shooting Mode

If you plan to use your GoPro camera like a traditional point-and-shoot digital camera, the shooting mode you'll probably use most of the time (especially when shooting in well-lit areas) is Single shooting mode.

When you select this option, your GoPro camera can capture one image at a time, each time you press the camera's Shutter button. Ideally, you want to use this shooting mode with a viewfinder, so you can properly frame your shots and see exactly what you're shooting.

After you select the Singe shooting mode, when you access its Settings menu, you can adjust the following three options:

- **Megapixels:** This option enables you to alter the shooting resolution you use to take digital images. The Hero4 Black, for example, enables you to choose between 5MP Medium Field of View, 7MP Medium Field of View, 7MP Wide Field of View, and 12MP Wide Field of View. The resolution options offered by other GoPro camera models vary.

A Wider Field of View

When you choose a wide field of view, the camera captures more content within each frame, particuluraly on the right and left sides. This is ideal for first-person shots or landscape/cityscape shots.

- **Spot Meter:** Use this feature when you position the camera in a low-light area, but want to take pictures of a subject that's well lit. When turned on, the Spot Meter icon appears within the Status Screen of the camera, Smart Remote, GoPro App, or LCD Touch BacPac display. Examples related to when to best utilize this option are covered in the next chapter.

- **Protune:** Depending on your shooting situation, if you want to take manual control over camera settings that the camera normally adjusts, turn on the Protune feature. You can then manually adjust options related to White Balance, Color, ISO Limit, Sharpness, and EV Comp, as they relate specifically to the Single shooting mode. Information about how to use each of these options is covered in the later section "Knowing When To Use the Protune Feature."

Leave Protune Turned Off

In most situations, it's easier to leave Protune turned off and rely on the camera to automatically adjust these settings as you take pictures.

Continuous Shooting Mode

Upon activating the Continuous shooting mode, each time you press and hold down the Shutter button, you can take multiple images in quick succession. From the Settings menu, you can adjust how many photos to take per second when this feature is active.

Hero4 enables you to choose between capturing 3, 5, or 10 images per second when you press and hold down the Shutter button. This feature is ideal if you take pictures of a fast moving subject or need to capture a time-sensitive action (also see the next chapter).

Although you'll end up with many similar shots using this feature, you can always delete the unwanted shots. However, images you take even a fraction of a second apart can be vastly different when you compare them.

After you select the Continuous shooting mode, when you access its Settings menu, you can adjust the following four options:

- **Continuous Rate:** Enables you to determine how many images you can capture per second when you press and hold down the Shutter button (instead of pressing and releasing it to take a single photo when using the camera's Single shooting mode).

- **Megapixels:** Adjust the camera's shooting resolution and corresponding Field of View, based on which resolution you select.

- **Spot Meter:** Turn on or off the Spot Meter feature as it pertains exclusively to the Continuous shooting mode option.

- **Protune:** Turn on or off the Protune feature, and then adjust specific Protune-related settings, as pertains exclusively to the Continuous shooting mode option.

Night Shooting Mode

Anytime you take photos in low-light situations, such as outside at dusk, dawn, or nighttime, or indoors when the lights are dim, turn on the Night shooting mode. When turned on, your camera can capture more light and detail, with natural-looking colors (based on the shooting situation).

The GoPro cameras do not have a built-in flash, so unless you use a continuous and artificial light source when taking pictures, you need to rely on the present ambient light in your shooting area. Chapter 11, "Capturing Sound and Using Artificial Light While Shooting Video," discusses some of your artificial lighting options when shooting video, but you can use the same strategies and lighting products in many picture-taking situations.

When using artificial light, be careful not to drown out the natural lighting in the area where you take pictures, or the colors within your images could become faded, and your intended subjects could look over saturated with light (refer to Chapter 11).

Your GoPro camera is designed to take good-quality photos in many low-light situations however, without having to rely on additional lighting. When taking pictures in low-light situations, you must hold the camera still. Thus, you can typically achieve clearer and more in-focus results if you use a tripod or mount with the camera, and then control it remotely using the Smart Remote or GoPro App. Even pressing the Shutter button on the camera gently can cause unwanted camera movement.

Find more information about appropriate situations in which you can use this shooting mode in the next chapter. As a general rule, however, if you take pictures in low light or at night, turn on Night mode.

When Both the Camera and Your Subject Are in Low Light

Use the Night shooting mode when the camera and your subject are within an area with dim or minimal lighting. If the camera is in a low light area but the subject is well lit, instead of using Night mode, take advantage of the camera's Spot Meter feature with the Single shooting mode.

After selecting the Night shooting mode, when you access its Settings menu, you can adjust the following four options:

- **Shutter:** Each time you take a photo, you can determine how long the camera's shutter remains open. This impacts how much light the camera captures and uses for each shot. The Hero4 Black, for example, enables you to select between Auto, 2, 5, 10, 15, 20, or 30 seconds. When in doubt, use the Auto option. If you choose one of the other options, you need to figure out how much light the camera needs to capture your subject. The longer the shutter remains open, the more sensitive the camera becomes to any movement of the camera or your subject. This movement can result in blurs within your image. Or if the shutter is left open for too long, the shot might be overexposed.

- **Megapixels:** Adjust the camera's shooting resolution and corresponding Field of View based on which resolution you select.

- **Spot Meter:** Turn on or off the Spot Meter feature that pertains exclusively to the Night shooting mode option.

- **Protune:** Turn on or off the Protune feature, and then adjust specific Protune-related settings that pertain exclusively to the Night shooting mode option.

Burst Shooting Mode

Burst shooting mode works like Continuous shooting mode, but gives you more options for how many images are captured each time you press and hold down the Shutter button. Like Continuous shooting mode, Burst mode is ideal for taking pictures of fast-moving subjects or when you need precision timing to properly photograph (such as sporting events).

Using the Hero4, for example, you can set up the Burst shooting mode to capture 3, 5, or 10 images per second, 10 images every 2 seconds, 10 images every 3 seconds, 30 images per second, 30 images every 2 seconds, or 30 images every 3 seconds when you press the Shutter button and hold it down.

After you select Burst shooting mode, when you access its Settings menu, you can adjust the following four options:

- **Rate:** Select how many shots to capture per second when you press and hold down the Shutter button.

- **Megapixels:** Adjust the camera's shooting resolution and corresponding Field of View based on which resolution you select.

- **Spot Meter:** Turn on or off the Spot Meter feature that pertains exclusively to the Burst shooting mode option.

- **Protune:** Turn on or off the Protune feature, and then adjust specific Protune-related settings that pertain exclusively to the Burst shooting mode option.

Time Lapse Shooting Mode

Using this feature, when you press the Shutter button once, the camera automatically continues snapping photos at a predetermined time interval until you press the Shutter button a second time to stop the process. This feature is best used when the camera is securely attached to a tripod or mount, so that the camera does not move or shake; therefore, only the movement of your subject is captured in each time-lapsed photo.

The Hero4, for example, enables you to adjust the time between shots to be 0.5, 1, 2, 5, 10, 30, or 60 seconds. If you adjust the Interval option to be 10 seconds and then press the Shutter button, the camera snaps one photo every 10 seconds until you press the Shutter button again.

When you select the Time Lapse shooting mode and access its Settings menu, you can adjust the following four options:

- **Interval:** Determine the precise time interval that the camera automatically takes photos after you press the Shutter button.

- **Megapixels:** Adjust the camera's shooting resolution and corresponding Field of View based on which resolution you select.

- **Spot Meter:** Turn on or off the Spot Meter feature that pertains exclusively to the Time Lapse shooting mode option.

- **Protune:** Turn on or off the Protune feature, and then adjust specific Protune-related settings that pertain exclusively to the Time Lapse shooting mode option.

Night Lapse Shooting Mode

The Night Lapse shooting mode works the same as the Time Lapse shooting mode and you can use it in low-light situations (such as at night). Just like when using Night mode, the camera is extremely susceptible to movement or shaking, so you must use the camera with a tripod or mount to achieve the best results.

When you select the Night Lapse shooting mode and access its Settings menu, you can adjust the following five options:

- **Shutter:** Enables you to determine how long the camera's shutter remains open each time you take a photo. (See "Night Shooting Mode," earlier in this chapter.)

- **Interval:** Determines the precise time interval at which the camera automatically takes photos when you press the Shutter button. (See the previous section, "Time Lapse Shooting Mode.")

- **Megapixels:** Adjust the camera's shooting resolution and corresponding Field of View based on which resolution you select.

- **Spot Meter:** Turn on or off the Spot Meter feature that pertains exclusively to the Night Lapse shooting mode option.

- **Protune:** Turn on or off the Protune feature, and then adjust specific Protune-related settings that pertain exclusively to the Night Lapse shooting mode option.

Consider Battery Life When Using Time Lapse or Night Lapse

If you plan to take photos over an extended period of time using the Time Lapse or Night Lapse feature, be sure to start with a fully charged battery within the camera. How long the camera can continue taking pictures depends on how long the battery lasts.

Choose a longer time interval, such as every 5 minutes, if you plan to shoot over a period of several hours. This allows the battery to last longer because fewer photos will be taken, compared to if you set this feature to snap a photo every 10 seconds.

Knowing When to Use the Protune Feature

The Protune (PT) feature is designed for more advanced GoPro users. It enables you to have greater manual control over specific picture-taking settings. Originally, this option was available only when shooting HD video, but it is also now available when shooting digital photos if you use one of the more powerful GoPro camera models, such as the Hero4.

Using Protune, you can capture higher quality results because the camera utilizes less data compression on your images, plus it captures natural colors within your shots. These digital image files are then more compatible with higher-end photo editing software packages, which means you can take full advantage of the more advanced photo editing tools built in to software, such as Photoshop CC (Photoshop Creative Cloud) to digitally edit and enhance your images.

It's Not All Good

Protune Negatively Impacts Battery Life

With the Protune featured turned on, your camera requires additional power to function and take pictures, reducing battery life. The file sizes associated with your Protune images will also be larger, so they'll take up more space within your camera's memory card.

Regardless of which picture shooting mode you select, from that mode's Settings menu, you can turn on or off the Protune feature. When turned on, five additional menu options are available, and each is adjustable for that particular shooting mode. You can set the Protune-related settings differently for each shooting mode.

The adjustable Protune options include

- White Balance
- Color
- ISO Limit
- Sharpness
- EV Comp (Exposure Value Compensation)

When you turn off Protune, the camera automatically adjusts each of these settings, allowing the camera to serve more like a point-and-shoot digital camera set to Auto mode. This requires less decision making and tinkering with camera settings prior to shooting.

Adjusting White Balance

The White Balance setting enables the camera to adjust all the colors and tones displayed within an image based on what the camera perceives to be the color white in your shots.

When you set this option to Auto (which is the default), the camera automatically analyzes each shot as it's being taken and adjusts the color tone based on the conditions it senses.

- If you take photos in an area with natural, warm light, such as incandescent lighting (indoors), or during a sunrise or sunset, consider selecting the 3000K White Balance option to capture more authentic colors in your shots.

- If you shoot in areas lit by fluorescent lighting or in average daylight, select the 5500K White Balance option.

- When shooting in cool lighting (such as when outside in overcast conditions), use the 6500K White Balance option.

Hero4 Options Pertaining to White Balance
For picture taking, the available White Balance options include Auto, 3000K, 5500K, 6500K, and Native. If you plan to use higher-end photo editing software that offers White Balance controls to later edit or enhance your images, select the camera's Native White Balance option when taking pictures.

Adjusting Color

The Adjusting Color option enables you to manually select the color profile used by the camera when taking pictures. The default GoPro Color option uses the same color profile when the Protune feature is turned off. When you select the Flat option, this enables you to more easily edit the color in photos later using photo editing software to showcase truly natural or authentic-looking colors within an image.

Hero4 Options Pertaining to Color

For picture taking, the available Color options include GoPro Color or Flat. Choosing the Flat option allows the camera to capture more detail in shadows and highlights.

Adjusting ISO Limit

Use the Adjusting ISO Limit setting to manage the camera's sensitivity to light, especially when shooting in low-light situations. Based on which option you select, you can manage the brightness of an image and somewhat control the unwanted graininess (or noise) captured within an image by the camera due to poor lighting.

To achieve a brighter image when shooting in low light, select the default 800 ISO Limit option. The images, however, showcase more noise in your shots, which takes away from the detail, image sharpness, and vibrancy of color.

The 400 ISO Limit option results in a slightly darker image (when shooting in low light), but the image contains less noise than with the 800 ISO Limit option selected. As a result, images contain a bit more detail and sharpness.

If you shoot indoors with decent (but not bright) lighting, choose the 200 ISO Limit option. When shooting outdoors in daylight, the ISO 100 Limit option offers the least amount of image noise, resulting in a sharper, brighter, and more vibrant image.

Hero4 Options Pertaining to ISO Limit

For picture taking, the available ISO Limit options include 100, 200, 400, or 800.

Adjusting Sharpness

When manually adjusting an image's Sharpness while shooting, the Protune option for the various digital photo-related shooting modes offers three options: High (which is the default setting), Medium, and Low.

Choose the High setting to achieve ultra-sharp image quality in your photos. Choose the Medium setting to capture moderately sharp photos, or use the Low option to capture softer photos.

Hero4 Options Pertaining to Sharpness

For picture taking, the available Sharpness options include Low, Medium, or High. Most photo editing software applications (and some photo editing mobile apps) offer a tool for manually adjusting or fixing image Sharpness after the image is shot. Thus, you can skip tinkering with this camera feature while shooting and then adjust an image's Sharpness, if needed, while editing.

Adjusting EV Comp

Exposure Value Compensation (EV Comp) impacts the brightness of the photos as they're being taken. If you shoot in areas with contrasting lighting conditions, adjusting this setting can help you capture better quality images

Hero4 Options Pertaining to EV Comp

For picture taking, the available EV Comp options range from –2.0 to 2.0, with the default option being 0.0.

Reset the Protune Options

By selecting the Reset option related to a specific Protune menu, you can reset all the related options to their default settings. However, these changes apply only to the Protune options for that specific shooting mode.

Switching Between Shooting Modes

When you turn on the camera, you can switch between four shooting modes and then adjust shooting mode-specific settings, including

- From the camera directly

- Using the LCD Touch BacPac display

- Using the Smart Remote

- Using the GoPro App that runs on your smartphone or tablet

After you select a shooting mode and adjust its options, these selections remain active until you manually change them, or until you turn off the GoPro camera. Then, when you turn the camera on again, its Default shooting mode (and related settings) is automatically activated.

You can select the Default shooting mode from the camera's main Settings menu. See Chapter 12, "Adjusting the Camera's Setup Menu Options," for more information on how to set or change this option.

Switch Camera Modes Directly from the Camera

To switch between shooting modes and then adjust shooting mode-specific settings before taking pictures using the Hero4, follow these steps:

1. Turn on the camera by pressing and holding the Power/Mode button for approximately 2 seconds.

2. While looking at the camera's Status Screen, repeatedly press the Power/Mode button until the icon for either the Photo or Multi-Shot mode displays.

Photo Versus Multi-Shot Menu Options

The Single, Continuous, and Night shooting modes are available as primary shooting mode options found within the camera's Photo menu. The Burst, Time Lapse, and Night Lapse shooting modes are available as options from the camera's Multi-Shot menu.

② ① **Photo Mode icon**

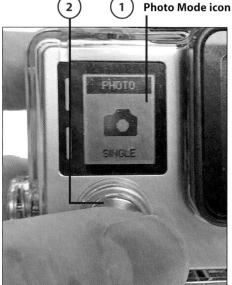

3. To select between Single, Continuous, or Night shooting mode, when the Photo icon appears on the Status Screen, press the Settings/Tag button on the side of the camera to access the Photos submenu.

Multi-Shot Settings

To instead select the Burst, Time Lapse, or Night Lapse shooting mode, when the Multi-Shot icon appears on the Status Screen, press the Settings/Tag button on the side of the Hero4 camera to access the Multi-Shot submenu.

4. The first option listed within the Mode submenu that displays on the Status Screen enables you to toggle between shooting modes. If you select the Photo mode, repeatedly press the Shutter/ Select button to switch between Single, Continuous, or Night mode until your wanted option displays. If you select the Multi-Shot mode, repeatedly press the Shutter/Select button to switch between the Burst, Time Lapse, and Night Lapse modes until your wanted option displays.

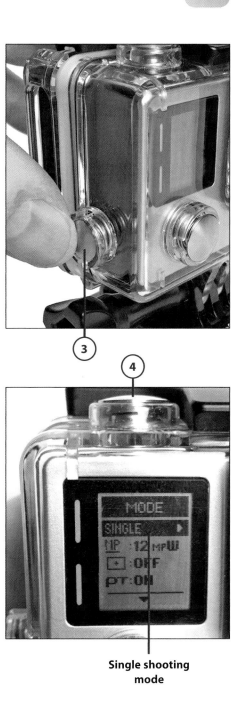

Single shooting mode

5. To select and activate the displayed shooting mode option, press the Settings/Tag button.

6. At this point, you can begin taking photos using the default (or preset) settings related to that shooting mode. Or from the Mode submenu that displays on the Status Screen, press the Power/ Mode button to highlight, select, and then adjust one or more shooting mode-specific settings.

7. Press the Shutter/Select button to select the highlighted option. Each time you press the Shutter/Select button, you toggle between available menu options. For example, if you select the Single shooting mode, select the MP option to adjust the Megapixel Resolution, and then press the Shutter/Select button repeatedly to toggle between 12MP Wide, 7MP Wide, 7MP Medium, or 5MP Medium.

8. When the desired settings-related option displays, press the Settings/Tab button to select it. Repeat steps 7 and 8 for each shooting mode-specific setting you want to alter prior to taking pictures.

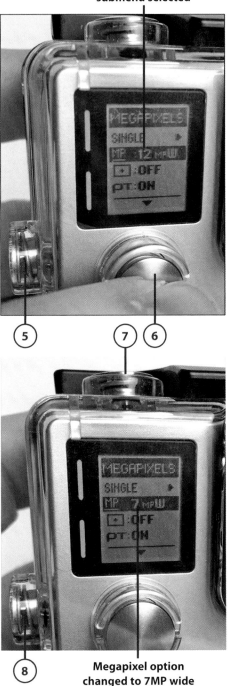

Megapixel (MP) submenu selected

(5) (7) (6)

(8) **Megapixel option changed to 7MP wide**

Switch Shooting Modes Using the LCD Touch BacPac Display

To select a specific shooting mode and adjust that shooting mode's settings using the LCD Touch BacPac, ensure the BacPac is properly attached to the camera, that it is turned on, and follow these steps:

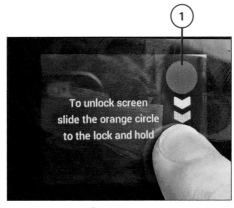

1. To access the camera's menu, tap the display and then unlock it by sliding down the orange circle.

2. When using the Hero4, place your finger on the right side of the display and swipe to the left to access the camera's main menu. (Alternatively, or when using a different GoPro camera model, press the Settings/Tab button or the Wi-Fi button on the side of the camera to access the menu.)

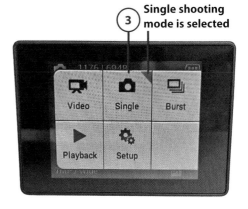

3. Tap the shooting mode you want to use. The currently selected and active shooting mode displays a red triangle in the top-right corner of the icon. You are automatically returned to the main viewfinder screen.

4. Place your finger at the bottom center of the touch display, and this time swipe upward. Using the Hero4, this reveals the Settings menu specifically for the selected and active shooting mode.

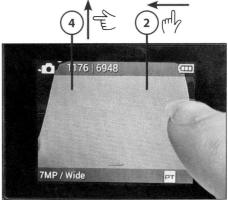

Simple Touches

As you already know, accessing the camera's menus and adjusting the various settings is much easier when using the LCD Touch BacPac display accessory. In addition to the menus being straightforward, because more information can display, you can use your finger to tap or swipe (using a Hero4) on the screen to access and select menu options.

5. From the Settings menu, if you previously selected the Photo mode, tap the Mode option to switch between Single, Continuous, and Night. If you previously selected the Multi-Shot option, tap the Mode option to switch between Burst, Time Lapse, or Night Lapse.

6. When the Mode submenu displays, tap the desired shooting mode. You may need to swipe your finger upward on the screen to first scroll through the menu options.

7. Tap the Megapixels option.

8. Some menus have a virtual on/off switch. Slide the switch left or right to toggle it on or off.

9. Some modes, like this one, have submenus for the mode. In this case, tap the option you want to alter. Another submenu with options specific to that feature or function appears. Again, tap your desired option to select it. Repeat Steps 8 and 9 until all the settings related to the selected shooting mode have been adjusted to meet your needs.

10. Tap the Exit (X) icon in the top-right corner of the display to save your changes and return to the viewfinder screen. You can now begin taking pictures.

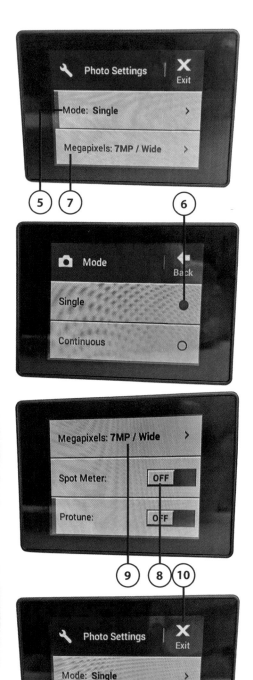

Switch Shooting Modes Using the GoPro Smart Remote

The information displayed on the Status Screen of the Smart Remote (or Wi-Fi Remote) is identical to what displays on the Status Screen of the camera. So, if you want to use the Smart Remote to remotely control your camera, first follow the directions offered in Chapter 5, "Must Have GoPro Camera Accessories," for pairing and activating the Smart Remote.

Then, refer to the "Switch Camera Modes Directly from the Camera" section earlier in this chapter to determine which buttons to press on the Smart Remote (instead of on the camera). To refresh your memory, the buttons on the Smart Remote are labeled here.

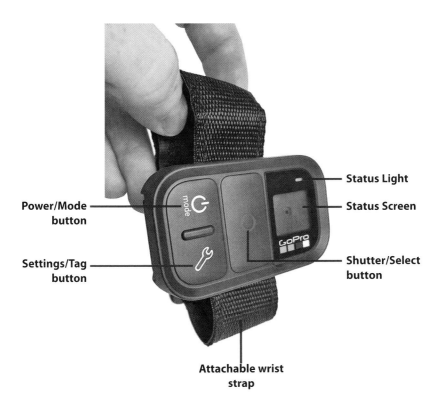

Status Light

Power/Mode button

Status Screen

Settings/Tag button

Shutter/Select button

Attachable wrist strap

Switch Shooting Modes Using the GoPro App

Due to the larger screen size and more straightforward menus, many GoPro camera users find that using the GoPro App on their smartphone or tablet to remotely set up and control the camera offers the easiest option. With the camera on and wireless enabled, follow these steps to select and activate a specific shooting mode, and then adjust the settings related to the selected shooting mode:

1. From your smartphone or tablet, access the Wi-Fi Settings feature and connect to the wireless network that your camera has created (not pictured). This is typically done from your mobile device's main Settings menu. On the iPhone or iPad, for example, launch Settings, and then tap the Wi-Fi option.

Pairing the App

To follow these steps, your camera and app must already be paired. Follow the directions in Chapter 15, "Using the GoPro Mobile App," to initially pair your smartphone or tablet with your camera.

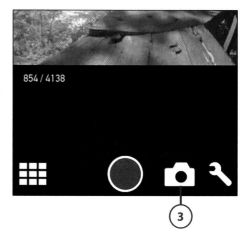

2. Launch the GoPro App on your mobile device, and tap the Connect & Control option.

3. Tap the shooting mode icon that's to the right of the red Shutter button to select a shooting mode.

4. Tap the Video, Photo, or Multi-Shot icon to select one of these three shooting modes and reveal its respective submenu. The selected option appears in blue.

5. After tapping the Photo icon, tap the Single, Continuous, or Night option, or after tapping the Multi-Shot icon, tap the Burst, Time Lapse, or Night Lapse option to select it.

6. After you select a specific shooting mode (Single, Continuous, Night, Burst, Time Lapse, or Night Lapse), tap the wrench-shaped Settings icon to adjust the available settings for the shooting mode you just selected.

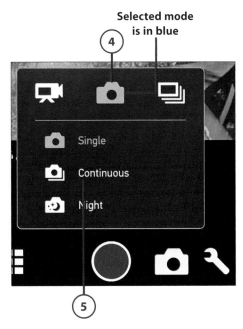

Selected mode is in blue

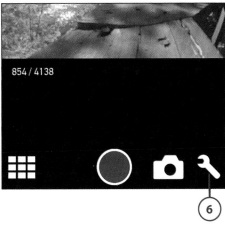

7. From the Settings menu, if you select the Single, Continuous, or Night shooting mode, scroll down to the options listed under the Photo Settings heading. If you select the Burst, Time Lapse, or Night Lapse mode, scroll down to the options listed below the Multi-Shot Settings heading.

8. Tap an option listed within the Settings menu to adjust that particular feature, such as Spot Meter. In some cases, a virtual switch displays to turn on or off a setting. Repeat this process until you've adjusted all the wanted shooting mode-specific settings.

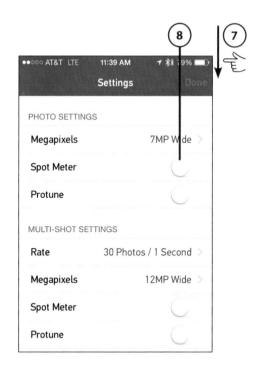

>>> Go Further

THE PROTUNE SUBMENU

After you turn on the virtual switch associated with the Protune option, with any of the shooting modes when using a Hero4, additional Protune-related menu options display on the Settings screen of the GoPro App.

As detailed in the earlier section, "Knowing When To Use the Protune Feature," Protune enables you to manually and separately adjust settings related to White Balance, Color, ISO Limit, Sharpness, and EV Comp for each specific shooting mode.

Discover easy strategies that can dramatically enhance the professional quality of your photos and make them more visually interesting.

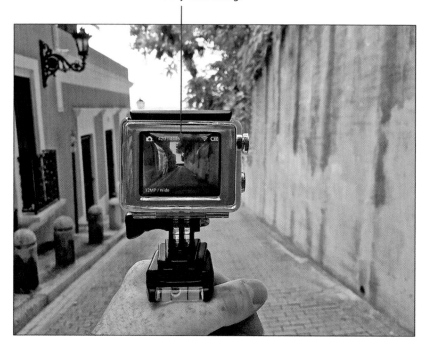

In this chapter, you discover 10 strategies for taking better digital pictures (as opposed to shooting video) using your GoPro camera. Topics include the following:

→ Selecting the best approach to take with your GoPro camera when taking pictures
→ How to best utilize light in your images
→ Using the Rule of Thirds to help frame your shots
→ Choosing the best shooting perspective to capture your subject

10 Strategies for Taking Professional-Quality Digital Pictures

You already know that your GoPro camera can shoot high-resolution photos. Actually, the Hero3+ and Hero4 can shoot digital images at up to 12MP resolution using a Wide Field of View.

In this chapter, you discover how to incorporate the technical knowledge you obtained from the previous chapter related to using the various Photo-related shooting modes, and combine it with your own creativity to consistently capture more visually interesting digital images.

Enhance Your Images with Software

Don't forget, using optional photo editing software on your computer or mobile device, you can quickly crop, edit, or enhance an image after it's been shot. Within just a few minutes, sometimes less, you can dramatically improve or alter the appearance of an image.

You can also apply many shooting strategies outlined in this chapter for taking digital pictures when using your GoPro camera to shoot HD video.

Preparation Is Essential

If you take pictures away from your home, such as when you're on vacation, or participate in a once-in-a-lifetime event, remember to bring along at least one or two extra fully charged batteries, plus an extra microSD memory card for your camera.

Without battery power, your camera is useless. In addition, if you fill your memory card to capacity, while awesome or once-in-a-lifetime photo opportunities still exist, you either need to erase content that's already stored on your camera's memory card or forego taking additional pictures while you're out and about.

Another important step that many people forego is to make sure the camera's lens is clean prior to shooting. This is particularly important if you shoot in or around water, snow, dust, or dirt.

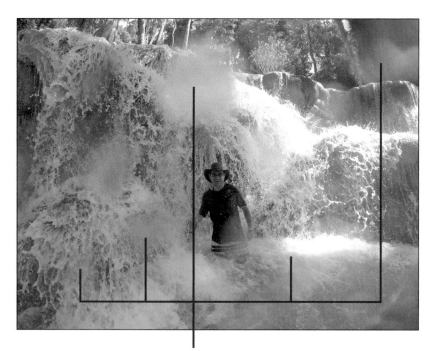

Water drops on the lens

Everyone has taken photos and gotten a finger in front of the lens. But even something as small as water drops or sand can get on your lens (or on the camera's housing in front of the lens) and ruin your photos. The easiest way to avoid this is to use some type of optional handle or grip with your camera.

You should also remember, when set to Wide Field of View, the camera's lens captures everything in front of the lens within a 170-degree radius. Thus, even if your fingers are positioned to the sides of the lens, they could appear in your images.

Avoid Excessive Shaking

Regardless of what you take pictures of with your GoPro camera, always be sure you hold the camera steady, and avoid excessive shaking when you press the Shutter button. This is particularly important when shooting photos or video in low-light situations.

The following 10 strategies can help you properly set up your camera and take advantage of its built-in features, as well as optional housings and accessories, to help you achieve the best possible results.

Choosing an Interesting Subject

As a photographer, your first big picture-taking decision involves deciding what or who your subject will be, and how you want to showcase that subject in your photos. When shooting with a GoPro camera, your subject can be yourself, or you can just as easily point the camera away from yourself and shoot subjects positioned in front of the camera.

In addition to people, however, a photo's subject can be an animal, object, popular tourist attraction, or a piece of architecture. Your goal as the photographer is to take people or objects that you encounter and capture those subjects within a digital image so that it's visually interesting.

When shooting people, for example, a variety of factors contribute to how your photos look, including

- The subjects' facial expression

- What they communicate through their eyes

- Their pose and body language

- Their outfit and general appearance

- What they're doing in the photo

- What's in the foreground, background, and to the sides of your subject within the frame

- As the photographer, your chosen shooting angle and perspective

- Whether you, as the photographer, opt to take a posed or candid shot of your subject (the difference will be explained shortly)

However, when your subject is an inanimate object and cannot showcase emotion, for example, then it's your responsibility as the photographer to capture that subject in creative ways.

This might mean shooting from an unusual angle or perspective, framing your subject in the shot using what's in the foreground, background, or to the sides of the subject, taking advantage of natural or artificial lighting, and utilizing some type of reflection in water, a window, or a mirror.

Break Your Existing Habits When Framing Your Shots

Most amateur photographers are indiscriminate when choosing their subject and then simply point the camera at their intended subject, center the subject within the viewfinder, and take a picture from a head-on perspective. These photos are boring to look at, and all the photographer's shots look basically the same even when the subjects are different.

Depending on your subject, you may discover that timing is essential to capture the perfect shot. So, when you know what you want to shoot, make sure that you're in the right place, at exactly the right time, with your camera set up to take pictures in that particular shooting situation.

Knowing what you want to accomplish in advance and then preplanning your shots as much as possible can help to ensure that you properly set up your GoPro camera and have the right housing, mount, and accessories on hand.

Following are picture-taking strategies that you can use to make your intended subjects appear in focus, vibrant, and visually interesting. Of course, these are only suggestions.

After you become better acquainted with your camera's various photo-related features and functions, use your own creativity when selecting your shooting strategies to acquire the best shots.

Shoot Action from a First- or Third-Person Perspective

One of the best uses of a GoPro camera, compared to a traditional point-and-shoot camera, is the ability to attach the camera directly to yourself or your equipment, so you can capture photos or videos of yourself engaged in an activity and shoot from a first- or third-person perspective.

First-person perspective means you mount the camera to yourself or your equipment and point it forward or backward. Thus, what's captured in photos is exactly what you see. However, you do not appear in the actual photos.

Using an optional extension pole, for example, or depending on how you mount your camera on your equipment, you can position the camera to capture yourself in the shots as you engage in an activity. This enables you to shoot from a third-person perspective.

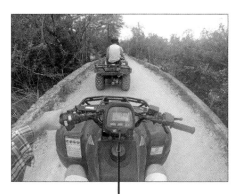

A first-person perspective shot created using the GoPro Head Strap Mount

A third-person perspective shot created using the Jaws: Flex Clamp Mount

If you opt to use your camera for this purpose, to achieve the best results, consider these strategies:

- **Choose the best shooting perspective.** If you mount the camera on your chest or head, for example, this slight height difference can impact how your photos ultimately look.

- **Make sure you can control your camera.** If you mount the camera on yourself and you plan to engage in an activity, you must be able to press the camera's Shutter button easily. Consider using the Smart Remote and wearing it on your wrist, for example. Another option is to have someone remotely control the camera that's mounted to you or your equipment.

This is easily done using the GoPro mobile app (via a smartphone or tablet) or the optional Smart Remote.

- **Frame your shots.** Based on how you mount the camera, this determines what appears in your photos. Changing the shooting resolution and switching between the Wide and Medium Field of View can impact how much of what's to the sides (and in the foreground) of your subject appears within your shots, and whether the fisheye effect impacts your shots.

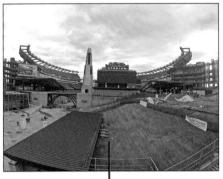 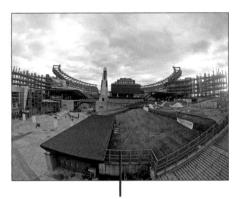

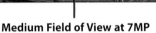

Medium Field of View at 7MP **Wide Field of View at 12MP**

Take Interesting Pictures of People

Because your camera has a Wide Field of View, if you move in too close to your subject, the fisheye effect typically appears in your photos. Thus, if you want to capture a close-up of your subject, you need to stand at least a few feet away, shooting at the highest resolution possible (12MP Wide if using a Hero4), and then cropping the image after the fact. Shooting at 7MP Medium reduces the fisheye effect but also results in a lower resolution image that showcases less detail.

Meanwhile, if you position the camera in landscape mode (horizontally), you can capture your intended subject in the shot but also capture a lot of background (what's behind and to the sides of your subject). This allows you to better showcase where the photo was taken.

However, if you want the main focus of your shot to be your subject and the background is less important, consider shooting with the camera positioned in portrait orientation (vertically), so less emphasis is put on what's in the background.

In general, when taking pictures of people, the primary focal point of the image, or what people viewing the image will pay the most attention to, is probably your subject's face.

If the subject is not looking directly into the camera, however, the focal point of the image becomes more about what the subject is doing in the photo.

Assuming you're not going for something more candid, which is more difficult but can capture more genuine emotions and natural actions, you can tell people where to look, how to pose, and what they should be doing when you press the Shutter button to snap a photo.

Capture the Perfect Selfie

Using a GoPro camera, the easiest way to take a selfie (taking a photo of yourself) is to use an optional extension pole.

Optional extension pole

1. Attach the camera to the pole mount.

2. Position the camera toward yourself and smile.

3. Snap a photo by pressing the camera's Shutter button, the Shutter button on the Smart Remote, or the Shutter icon within the GoPro App. When using a pole mount, controlling the camera with the Smart Remote is usually easiest.

Shooting Angle Matters

If you hold the camera facing toward you at about eye level, whatever is directly behind you will appear in your photo. If you hold the camera at a height above your head and shoot at a downward angle, the background in your image will be more of what's on the ground behind you. Likewise, if you hold the camera at waist level and shoot in an upward direction, your background will showcase more of what's above you.

>>>Go Further

SELFIES WITHOUT EXTENSIONS

If you don't have access to an extension pole, position the camera in front of you (using a mount or tripod), and then use the Smart Remote or GoPro App to snap a photo of yourself while you pose.

Another option is to hold the camera in your hand while extending your arm outward. When doing this, position the camera at a slight angle to put less emphasis on your extended arm within the photo.

Often, the most visually interesting selfies are shot from unusual angles or perspectives, instead of using a head-on shooting angle. You can also capture interesting selfies by standing in front of a mirror or body of water and by taking a picture of your reflection.

Photographing Animals and Pets

When taking photos of animals that are not in motion, you can typically achieve the most visually interesting results if the animal is looking directly into the camera as you snap the photo. In these situations, try to focus on, or frame your shots around, the animals' eyes because it's through their eyes that animals showcase emotion.

To capture an animal in motion, position yourself as the photographer so that the animal is moving into your shot or moving toward the camera. Taking photos of animals from unusual perspectives or while the animal is engaged in a funny or unusual activity often results in a visually interesting photo.

Capture a Fast-Moving Subject

If you use your GoPro like a traditional camera and take photographs of a subject that's in front of you (the photographer), there are a few tricks to getting great shots when your subject is in motion but you're not.

- Anticipate the movement of your subject, and plan accordingly for your shots. Ideally, you want to capture your subjects as they enter the frame of your shot, not exiting from it.

- If your subject isn't moving from right to left (or left to right) across the frame, try to capture the subject moving directly toward the camera, instead of away from it.

- Utilize the Burst mode that's built in to the camera if you need to capture a particular moment as your subject is moving. For example, as a basketball player is about to shoot a basket. Using the Burst mode, you can capture multiple shots in quick succession and capture the exact moment you need or want. You can always delete the extra shots later.

- Follow the moving subject by moving the camera at the same speed, and in the same direction, if possible. The subject will appear in focus, but the background will blur, which showcases motion.

Take Great Pictures of Your Child's Event

When you encounter a situation in which you, as the photographer, are in a low-light or a dark area but your subject is in front of you and well lit, be sure to turn on the camera's Spot Meter option prior to taking a photo.

Spot Meter works well if you're in the audience of a show or concert, for example, where the stage and the performers, which in this case are your subjects, are well lit.

When the Spot Meter feature is turned on, the Spot Meter icon appears on the camera and Smart Remote's Status Screen. A similar icon also displays within the GoPro App.

Spot Meter icon

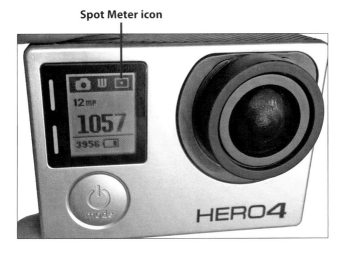

Shoot Visually Interesting Objects

The Wide Field of View offered by the GoPro cameras can capture massive buildings or large structures, which is relatively simple. However, instead of shooting a building, landmark, or piece of architecture from a head-on perspective, your photos can often look more interesting if you shoot them from an angle.

**Building shot from a
head-on perspective**

**Building shot
from an angle**

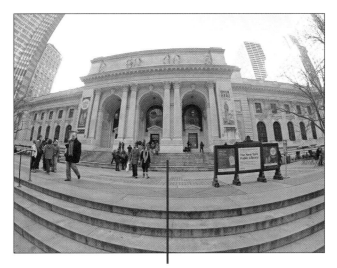

**Here, the photographer
crouched down and shot
at a slight upward angle.**

If your photos show a fisheye effect due to the camera's wide lens, move farther away from your subject, or fix this effect after you take the photo by using the GoFix or Lens Corrector app on your mobile device or the appropriate tool offered by your photo editing software.

More About the Fisheye Effect

You can find more information about the optional GoFix and Lens Corrector apps for the iPhone and iPad in Chapter 15, "Using the GoPro Mobile App."

Take Vivid Underwater Photos

Taking underwater photos with a GoPro camera is one of the situations for which this camera was specifically designed. However, before exposing your camera to water, make sure it's properly enclosed within either a Standard Housing (with a Standard Backdoor) or a Dive Housing (with a Standard Backdoor).

When snorkeling or swimming, your camera uses the ambient light from the sun that comes from the surface. If you take pictures of fish or coral, try to position yourself above your subject so that the sunlight from the surface shines from behind the camera and shines evenly onto your underwater subject.

If you try shooting from below your subject toward the surface, the light from the surface typically generates a silhouette effect around your subject, which greatly reduces the amount of detail you'll see.

When scuba diving or taking pictures at depths of more than a few feet underwater, consider using an optional colored filter over your camera's built-in lens. GoPro, as well as several other companies, offers red or magenta filters for color correction when shooting in the ocean or at depths of more than a few feet underwater. The optional filter you should use depends on the depth you shoot at and the water's natural color.

Choose the Right Underwater Lens Filter

GoPro's Red Dive Filter ($69.99) works best underwater when filming in blue salt water or clear fresh water, at a depth between 15 and 70 feet. GoPro's Magenta Dive Filter ($69.99) works better in greenish colored water, at a depth between 15 and 70 feet.

Polar Pro Filters (http://polarprofilters.com) offers a selection of optional lens filters designed for underwater photography. These filters work with GoPro's Dive Housing and are priced starting at $29.99.

Setting Your Camera to the Best Mode for Your Shooting Situation

To shoot digital images (instead of video), you can set your GoPro camera to Single, Continuous, Night, Burst, Time Lapse, or Night Lapse shooting mode when using a Hero4. You can also turn on or off the Spot Meter and Protune features, as well as adjust the Megapixel Resolution of your shots.

Based on the Resolution you select, you can sometimes choose between a Medium or Wide Field of View. Using these various photo-related settings and options, choose what's best for each particular shooting situation, based on what your subject is doing, the available light, and various other factors (including your own creativity).

Sometimes, Several Different Setting Configurations Work Equally Well

As the photographer, you'll often be confronted with shooting situations in which two or more different camera configurations will work fine. In these cases, it is a matter of making a creative decision to determine how you want your photos to ultimately look.

Take Advantage of Burst shooting mode

Burst shooting mode is best used when you shoot a fast-moving subject. Based on how you set up this feature, when you press and hold down the Shutter button, you can take 3, 5, or 10 photos per second. Using the Hero4 (with the February 2015 Camera Software update), it's also possible to shoot 30 frames in 6 seconds.

When using this Burst shooting mode feature, you can adjust the Megapixel Resolution, and if you use a Hero4, for example, also select between a Medium and Wide Field of View when shooting at 7MP resolution.

Why Burst Shooting Mode Is Ideal for Fast Action

If you know an action is about to happen, preset the camera to Burst mode, and then press the Shutter button 1 or 2 seconds before the wanted action starts, and hold it down until the action finishes.

Then, choose the single photo that best showcases the exact moment or action you want to depict. Photos taken even a fraction of a second apart often look noticeably different.

With the Burst shooting mode, you also have the option of turning on or off the Spot Meter and Protune feature.

Don't Forget About Your Hero4's Multi-Shot Options

The Multi-Shot options enable you to set up your camera to automatically snap photos at a particular time interval and determine how long the camera's lens shutter stays open for each shot. From the Settings menu, you can adjust the Megapixel Resolution, as well as turn on or off the Spot Meter and Protune feature.

When you tap on the Shutter option from the Settings menu, you can determine how long the camera's lens shutter remains open for each shot. This, in turn, determines how much light the camera can capture with your shot.

Your options include Auto, 2, 5, 10, 15, 20, or 30 seconds. The longer the camera's shutter remains open, the more susceptible the camera becomes to your subject's movement or camera movement. Even the slightest movement of the camera or your subject can potentially result in a blur appearing within your images.

Tips for Setting the Shutter Option

When using the Night or Night Lapse shooting modes, adjust the Shutter option to Auto to capture things such as sunrises or sunsets, or when taking photos outside at dawn or dusk.

When you shoot in low light but take pictures of things such as cars with their lights on, fireworks, or a neon sign, for example, try adjusting the Shutter to 2, 5, or 10 seconds, while holding the camera still by mounting it on a tripod.

Use a longer exposure, between 20 and 30 seconds, to take photos of the night sky, the moon, and stars, for example, where there is little light and motion. Again, a tripod or mount is required to hold the camera still.

By tapping the Interval option that displays on the Settings menu, under the Multi-Shot heading, you can adjust the time interval your camera automatically snaps a photo until you turn off this feature. For example, if you choose the 15 second option, your camera will snap one photo every 15 seconds, starting when you press the Shutter button and continuing until you press the Shutter button a second time.

Your available options from the Interval submenu include Continuous, 4, 5, 10, 15, 20, or 30 seconds, as well as 1, 2, 5, 30, or 60 minutes.

When Turning On Protune Can Benefit You

For taking digital photos with your Hero4 (or another GoPro camera that offers a Protune feature for taking digital photos), the Protune feature offers a handful of additional options that enable you to have more manual control over your camera's settings.

When you turn on the Protune feature that's related to Photo or Multi-Shot options, the Settings menu expands and offers a White Balance, Color, ISO

Limit, Sharpness, and EV Comp option, each of which has a submenu associated with it.

You can set up separate Protune-related settings for the Video, Photo, and Multi-Shot modes. Unless you need to customize Protune-related settings to capture the perfect shot, and you fully understand how adjusting one or more of these options can impact your shots, you should leave the Protune feature turned off and rely on your camera to automatically make adjustments as needed on your behalf.

Shooting Resolution Considerations

Your Hero4 camera can shoot at 5MP, 7MP, or 12MP resolution. A shot taken at 5MP resolution uses 5 million individual pixels within each digital image. This shooting resolution uses a preset Medium Field of View.

Shots taken at 5MP resolution also use the smallest file sizes but capture less detail, depth, and color vibrancy in your photos. Depending on what you shoot, if you compare the same subject shot at 5MP and 12MP resolution, you'll probably see a difference in the subtle detail captured within your image.

Resolution Matters When Editing Photos

By shooting at a higher resolution, you can make better use of your photo editing software to edit and enhance your images after they're shot. For example, if you opt to use the Crop tool to zoom in on a small subject within a photo, the cropped area you select will stay clear, detailed, and in focus. But at lower resolutions, the cropped portion of an image could become pixelated.

When using the Hero4, shooting at 7MP resolution offers decent detail, color vibrancy, and depth, plus enables you to choose between a Medium or Wide Field of View.

Shooting at 12MP resolution, using the default Wide Field of View, you can capture the highest quality digital images possible using your camera. Each digital photo requires significantly more storage space within your camera's memory card, and later on your computer's hard drive, or the internal storage of your mobile device.

Reducing Resolution After the Fact Is Easy

When you shoot at 12MP (Wide) resolution using the Hero4, when later using the photo editing software on your computer or mobile device, it's easy to reduce the image's resolution (and image quality).

However, you cannot easily increase the resolution of a shot after the fact. Thus, you can't shoot at 5MP resolution and then easily increase that photo's resolution to 12MP without using costly and typically difficult-to-use, professional-caliber photo editing software.

In general, always take photos at the highest resolution your camera offers, unless you have a specific reason to shoot at a lower resolution, and know you do not need the image quality of shooting at a higher resolution.

Using a Viewfinder with Your Camera When Taking Photos

As a photographer, framing your shots within a viewfinder enables you to see exactly what you're shooting in real time. Because your GoPro camera does not have a built-in viewfinder, you can either forgo planning and framing your shots altogether, or use one of the camera's viewfinder options.

For example, invest in the optional LCD Touch BacPac display to use this accessory's full-color viewfinder that fits onto the back of the camera. Yes; this does increase the thickness of the camera and drain the camera's battery life faster, but it also enables you to see exactly what you're shooting.

Another alternative is to use the GoPro App that runs on your smartphone or tablet as your viewfinder. This method works best if you have the camera attached to yourself or your equipment, and the back of the camera is otherwise blocked or inaccessible.

Using the GoPro App, you can frame your shot and then either control the camera's Shutter button from the camera or from the app, depending on your shooting situation. Even if you don't use a viewfinder while you shoot, having a viewfinder can help you initially position your camera when using a mount to ensure it's angled correctly based on the shooting situation and the results you want to achieve.

A Viewfinder Is Not Always Needed

If you have the GoPro mounted on your body or vehicle, for example, and the camera faces forward, what it captures when you press the Shutter button is whatever is in front of you. In this case, having access to a viewfinder isn't necessary.

Based on a particular shooting situation, choose which viewfinder option will work best, and which will allow you to frame your shots based on the situation.

Tilting the camera at a slight angle can impact the appearance of your image dramatically. Thus, it's often better to see a preview of exactly what you'll be shooting, instead of guessing, and then see what the camera actually captured within the frame after the fact, when it may be too late to do a reshoot.

Selecting the Most Appropriate Housing and Mount

To choose the best camera housing, follow these basic guidelines:

- If you shoot in or around water, encase your camera within a Standard or Dive Housing to ensure that it's waterproof and resistant to extreme temperatures.

- If you shoot in a clean, dry, and calm area, consider using the optional Frame Housing. This enables you to keep the camera's lens totally uncovered. However, this housing does come with a Protective Lens Filter to place directly over the lens for added protection against physical damage. Remember, the Frame Housing offers no waterproof protection whatsoever.

- If you want to make your camera as inconspicuous as possible, especially when shooting in low-light situations, consider using the Blackout Housing, instead of the Standard Housing.

Learn More About Housings and Mounts

Refer to Chapter 3, "Overview of GoPro Camera Housings," and Chapter 4, "Overview of GoPro Camera Mounts," respectively, for more information about the various optional camera housings and mounts available for your GoPro camera.

Paying Attention to Your Primary Light Source

As the photographer, you must always pay attention to your primary light source. When shooting outside, your light source is typically the sun. Inside, your primary light source might be a floor lamp, overhead lighting, candles, or flames from a fire in a fireplace.

Ideally, you want to position your primary light source behind you, the photographer, so that it's shining as evenly as possible onto your subject.

If the light is positioned in front of the camera, you have glare and possibly an overexposed image, and your subject may appear as a silhouette. Thus, the detail you see in your photos will be compromised.

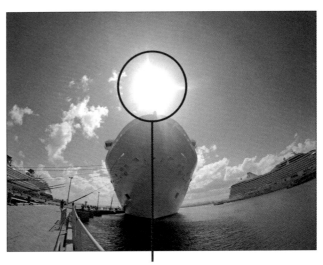

The sun, when positioned in front of the camera, results in a glare and a silhouette effect.

Meanwhile, if the primary light source shines unevenly on your subject, this can cause unwanted shadows on or around your intended subject. Shadows that appear in your photo can be annoying to look at and make your photos appear unprofessional.

Pay attention to how the primary light source casts light upon your subject, and if you notice unwanted shadows, reposition yourself (the photographer) and/or your subject to better use the light.

Using the Rule of Thirds When Framing Your Shots

Most amateur photographers tend to center their subject in the viewfinder and then shoot that subject from a head-on perspective. The Rule of Thirds is a basic photography strategy that encourages you, the photographer, to move your intended subject away from the center of the frame.

To use the Rule of Thirds, you need access to a viewfinder to frame your shots, which means using either the LCD Touch BacPac or the GoPro mobile app.

As you look at your viewfinder and frame your shot, imagine that a tic-tac-toe style grid is superimposed over your viewfinder. This grid shows nine boxes. The center box represents the center of the frame where you'd typically position your intended subject.

Rule of Thirds Grid

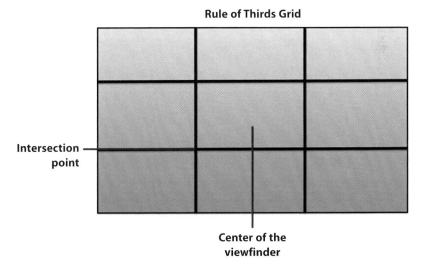

Reposition the camera so that your subject is lined up along one of the grid's horizontal or vertical lines, or the focal point of your subject is positioned

over one of the intersection points of the grid. In other words, move your subject away from that center square, as shown in the following examples.

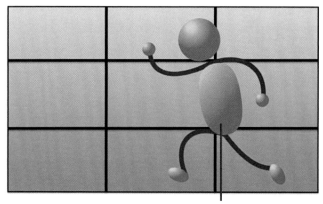

Subject is moving into the frame with its head at the top-right intersection point

Subject is looking at the camera, with its head lined up at the top-left intersection point

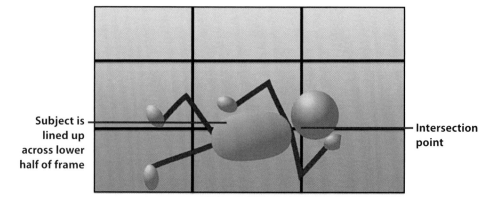

Subject is lined up across lower half of frame

Intersection point

When taking a picture of a person, center the subject's face at one of the intersection points of the grid. If you shoot a large object, you can line up the subject along one of the grid's horizontal or vertical lines.

Ultimately, you can capture more visually interesting photos if you position or mount the camera at an angle, from above, below, or to the side of your subject. Also consider shooting from a diagonal perspective. Keep the Rule of Thirds, the shooting perspective, and the position of your primary light source in mind as you frame your shots. Also use your creativity to choose an interesting shooting angle.

REMEMBER YOUR LOCATION

When choosing how you'll frame your shot, while taking the Rule of Thirds, your shooting perspective or angle, as well as the location of your primary light source into account, also consider what's in front of, behind, and to the sides of your subject, and use this scenery to your advantage.

For example, try to frame your subjects within their surroundings, or if you take pictures of people or animals, have the subject interact somehow with their surroundings.

Simply including objects in front of and behind your intended subject is one way to easily add a sense of depth to your photos and make them look more three-dimensional.

Choosing a Visually Interesting Shooting Perspective

If you will be mounting the camera to yourself or your equipment while taking pictures at the same time you're engaged in some type of activity, you can choose between shooting from a first- or third-person perspective. Alternatively, you can position the camera on a tripod or have someone else serve as the photographer and then use the camera just as you would any point-and-shoot camera.

Imagine you're on a bicycle. Using GoPro's optional Handlebar/Seatpost/Pole Mount ($19.99), you can easily and securely attach the camera to the handlebar of your bike. Then, if you position the camera facing forward, you can shoot from a first-person perspective. What you see in front of you will be in your shot, but you, as the photographer and bike rider, will not appear in the photos.

However, if you position the camera facing backward from the handlebars, you appear in your own photos, and what's in the background will be what's behind you as you're riding. Both are valid perspectives depending on the visual story you want to tell.

Yet another option is to mount the camera on the back or side of the bike, facing forward, so that it captures some of you (the rider), as well as what's ahead of you.

Properly Handling Low-Light Situations

The latest GoPro camera models, especially the GoPro Hero4, offer shooting modes that enable you to capture clear images, even in low-light situations. However, when shooting in low light, be sure to incorporate these shooting strategies:

- Turn on Night shooting mode. This enhances the clarity of photos by allowing more ambient light to be captured within each shot.

- Hold the camera still when pressing the Shutter button. (Consider using a tripod or mount. Even the slightest movement can cause blurs in low-light situations.)

Editing Your Digital Photos After They've Been Shot

After your images are shot using a GoPro camera and they're stored within the camera's microSD memory card, you can then transfer those images to your primary computer or mobile device. At this point, use photo editing software on your computer or a photo editing app on your mobile device to crop, rotate, edit, or enhance an image using editing tools and special effect filters.

Using the Crop tool, it's easy to reframe an image by getting rid of unwanted background, or by selecting your intended subject and using the Crop tool to simulate a camera's zoom feature.

You can also add one or more special effect filters to images to subtly or dramatically alter their appearance. Or you can use a series of individual editing tools to adjust specific aspects of a photo, such as its lighting, color, contrast, or saturation.

If you hold the camera at a weird angle while taking a photo, many photo editing applications enable you to easily straighten an image or rotate it clockwise or counterclockwise at a particular angle.

Photo editing software comes bundled with all Mac and Windows-based computers. However, there are many optional photo editing software packages available, such as Photoshop Elements (www.adobe.com/products/elements-family.html), Google Picasa (http://picasa.google.com), Corel Paint Shop Pro (www.corel.com), and Pixelmator (www.pixelmator.com).

There are also literally hundreds of photo editing applications available for the Apple iPhone and iPad, as well as all Android and Windows Mobile smartphones and tablets. Each of these photo editing software packages or mobile apps offer a different selection of photo editing and enhancement tools and features, so choose one that offers the toolset most useful based on your needs.

The GoPro was created so that you can shoot HD video virtually anywhere.

In this chapter, you learn about your GoPro camera's video shooting modes, resolutions, features, and functions. Topics include the following:

→ How and when to use each Video, Video+Photo, or Looping-related feature built in to your GoPro model

→ Determine the best video resolution to shoot in based on your situation or needs

→ Navigating through the video-related menus using the camera, LCD Touch BacPac, Smart Remote, or GoPro App

Shooting HD Video

If you want to shoot HD video in traditional shooting situations, you can choose from thousands of video cameras. Your smartphone or tablet probably has a decent quality HD video camera built in.

However, if you want to capture stunning, clear, and high-quality video in and around water, snow, or other harsh conditions; capture first-person shots by mounting the camera onto yourself or your equipment; or mount the camera in a tight space and at a specific angle to capture the perfect shot—your GoPro camera is designed to excel in these situations.

Especially when shooting with the Hero3+ or Hero4, your camera is chock full of video-related features and functions, and it gives you plenty of options for shooting resolution, frames per second, and field of view.

When you encase the camera within an appropriate housing and use a mount that's best suited for your shooting situation, you can quickly discover that when using your GoPro camera you are limited only by your imagination and not by the technology built in to the camera or its design.

Using Available HD Video Options

The GoPro Hero3+ and Hero4 cameras offer three main video-related shooting modes: Video, Video+Photo, and Looping. Each of these main options offers a variety of adjustable settings that enable you to customize that shooting mode to best meet your needs.

Thanks to GoPro's February 2015 Camera Software update, the GoPro Hero4 has a new shooting mode called Time Lapse Video. See the later section "Shooting Time Lapse Video" to discover how to use this new shooting mode.

Use video for shooting HD video in your choice of resolutions. Video+Photo enables you to shoot video and simultaneously take high-resolution digital photos with your camera. The Looping mode enables you to capture only highlights in a particular shooting situation, at an interval you preselect. Use this option to save storage space on your camera's microSD memory card because storing HD video files requires a significant amount of storage space.

>>>Go Further

THE SKILL AND ART FORM ASPECTS OF VIDEOGRAPHY

This chapter focuses on helping you understand how to use each of the camera's main shooting modes. In other words, the focus is on the skill aspect of videography using your GoPro.

Because shooting video typically requires you to also record audio, and using lighting is an essential element of good-quality video, the focus of Chapter 11, "Capturing Sound and Using Artificial Light While Shooting Video," is on these two important aspects of videography.

Chapter 13, "10 Strategies for Shooting Awesome HD Video," shows you how to put this knowledge to work and incorporate your own creativity, as well as proven video shooting strategies, to help you consistently shoot the highest-quality and most visually interesting videos possible using the GoPro camera and related equipment that's at your disposal.

After you capture your raw video footage, you need to edit it. You can do this using the free GoPro Studio software for the PC or Mac. (See Chapter 16, "Using the GoPro Studio Software," or you can use any third-party video editing software on your computer or mobile device.)

As you'll discover, the GoPro Studio software is fully compatible with some of your GoPro camera's unique features and functions. For example, you can easily remove the fisheye effect your camera captures, or you can import video shot at different resolutions or settings so that all footage looks consistent in your final video production.

In addition, during this editing process, you can do the following:

- Pick and choose the shots or scenes you want to incorporate into your video production.

- Edit or trim shots or scenes to showcase the best visuals and highlights.

- Rearrange the order of shots and scenes.

- Digitally enhance the footage with special effects.

- Incorporate animated transitions between shots or scenes.

- Add music and sound effects to your production.

- Record and add voice overs to your production.

- Edit and enhance the audio that was recorded with the video.

- Export and share your edited video with others in a variety of ways, such as creating DVDs or uploading the video to YouTube.

As you plan your video shots and the ultimate shooting video, you will most likely edit the raw footage before you show it to other people.

Don't worry; many powerful video editing programs and mobile apps are extremely easy to use and offer professional-quality features. As a result, you can often transform your raw video footage into an eye-popping visual experience for your viewers in a short amount of time.

Understand Your Goals When Shooting Video

Your goals when shooting video need to be capturing your subjects in the best way possible and using the most appropriate camera features, functions, and settings so that you have an overabundance of the best quality content possible when you begin the video editing process.

Shooting Video with Your GoPro

Each GoPro camera model offers a different selection of video-related features and functions and can shoot at a variety of different resolutions.

Because the top-of-the-line Hero4 Black includes all the video-related features and functions covered in this chapter, this is the camera model that is primarily discussed. However, Table 10.1 indicates which other GoPro camera models offer specific video-related features and functions.

Some GoPro Camera Models Offer Superview Resolutions

When you select a shooting resolution that includes Superview, this fully utilizes the built-in wide angle lens of your camera and enables you to capture a truly immersive field of view. More content can be captured around the edges of the frame, which enables you to showcase more detail when playing back video on a high definition, widescreen television or monitor.

Superview is ideal for capturing first-person perspective shots, but you can achieve better results when the camera is mounted to yourself or your equipment, or you use a tripod, because the camera becomes more sensitive to subtle shaking, vibration, or movement.

Table 10.1 Discover Which Video-Related Features Your GoPro Camera Offers

Video-Related Feature	GoPro Hero	GoPro Hero3	GoPro Hero3+	GoPro Hero4 Silver	GoPro Hero4 Black
Field of View	Ultra Wide	Ultra Wide	Ultra Wide, Medium or Narrow	Ultra Wide, Medium or Narrow	Ultra Wide, Medium or Narrow
Superview	Yes	No	No	Yes	Yes
Auto Low Light	Consumer Grade	Consumer Grade	Professional Grade	Professional Grade	Professional Grade
4K Resolution[*][^]	No	No	No	Yes	Yes
4K Superview Resolution[*][^]	No	No	No	No	Yes
Protune	Yes	Yes	Yes	Yes	Yes

Video-Related Feature	GoPro Hero	GoPro Hero3	GoPro Hero3+	GoPro Hero4 Silver	GoPro Hero4 Black
Photo+Video Mode	No	No	No	Manual control or photo every 5, 10, 30, or 60 seconds while shooting video	Manual control or photo every 5, 10, 30, or 60 seconds while shooting video
Protune Photo+Video	No	No	No	Yes	Yes
Time Lapse Video	No	No	No	Yes	Yes
Looping	No	Yes	Yes	Yes	Yes
Highlight and Tag	No	No	No	Yes	Yes
High Bitrate Video (H.264)	Up to 15Mb/s	Up to 15Mb/s	Up to 25Mb/s	Up to 45Mb/s	Up to 60Mb/s
Wireless Mode	No	Yes	Yes	Yes	Yes

** For each shooting resolution at which a GoPro camera model can capture video, you can choose between several Frames Per Second options. As you discover later in this chapter, this can be useful for editing your raw video and incorporating visual effects (such as slow motion) into your video productions.*

^ All GoPro cameras are capable of shooting at several different video resolutions, but only the Hero4 Black Edition can shoot at 4K and 4K Superview resolution.

It's Not All Good

Shooting Better Video Quality Requires More Battery Power

Especially when shooting extremely high-quality video using the Hero3+ and Hero4, you'll discover that this requires more battery power, and that the camera will actually heat up during the shooting process. This becomes even more of an issue if you use the LCD Touch BacPac or Battery BacPac with the camera, and it's fully encased within a Standard or Dive Housing, for example.

If you shoot in a hot climate at an extremely high resolution, the camera might overheat. When this occurs, a warning message appears on the Status Screen; the content you've recorded thus far is saved; and the camera automatically shuts down. At this point, you must allow the camera to cool down before you resume filming.

The GoPro cameras offer three main video-related shooting modes, each of which is useful for specific types of shooting situations. You will find, however, that you'll be using the Video shooting mode the majority of the time.

After you select a shooting mode, access the Settings menu for that shooting mode to adjust shooting mode-specific settings based on your intended shooting situation and what you plan to do with your video footage after it's been shot.

>>>>Go Further

YOUR GOPRO CAMERA OFFERS AN AUTO LOW LIGHT FUNCTION

All the GoPro camera models offer an Auto Low Light function that, when turned on, automatically activates when and if it's needed to help you capture the best quality video in a wide range of lighting situations. This feature helps the camera compensate in low light areas or when you move the camera (while shooting) between well-lit and poorly lit areas.

To enhance your videos, the camera automatically adjusts the frames per second rate to help it achieve the best possible exposure based on available lighting. This feature does not work, however, when shooting at 240 frames per second, or at 30 or less frames per second, and is only available when shooting at certain resolutions.

How well the Auto Low Light feature works depends on several factors, including which GoPro camera model you shoot with. This feature has been enhanced within the Hero3+ and Hero4 cameras.

If you know you'll be shooting in a low-light area, or moving between a well-lit and low-light area, from the selected Video shooting mode's Settings menu, turn on the virtual switch that's associated with the Auto Low Light option.

When using the LCD Touch BacPac display, the Settings menu for each video mode offers a virtual switch associated with the Low Light function. The option looks a bit different when using the GoPro App.

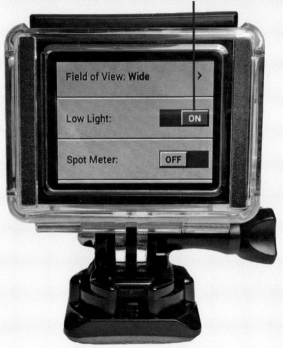

You need to choose the most appropriate shooting Resolution, Frames per Second rate, and Field of View when adjusting video mode-specific settings. These are three of the more important decisions you need to make based on your shooting situation, your creativity, and what you want to achieve.

Regardless of which shooting mode you select, you also can turn on or off the Spot Meter function, as well as turn on and adjust Protune-related settings.

To select the appropriate Resolution, FPS, and FOV, you can learn more about how to best make these decisions from Chapter 13, which covers the impact these settings have on your raw video, and how these settings impact your ability to edit and later showcase what you've shot.

More information about the camera's Protune functions as they relate to shooting HD video is covered later in the section "Enhancing Video Quality with Protune."

All Video-Related Functions Offer the Spot Meter and Protune Functions

After you select a Video shooting mode for your camera, you can adjust options related specifically to that shooting mode via the Settings menu.

At this point, you can also turn on or off the camera's Spot Meter and Protune functions, which are explained in greater detail in the later section "Video Shooting Mode." If you turn on the Protune function, a submenu of adjustable Protune-related functions will also be offered.

After you select a Video shooting mode and adjust its options, these selections remain active until you manually change them or until you turn off the GoPro camera. Then, when you turn the camera on again, its Default shooting mode and related settings are automatically activated.

You can select the Default shooting mode from the camera's main Settings menu. See Chapter 12, "Adjusting the Camera's Setup Menu Options," for more information on how to set or change this option.

Video Shooting Mode

The Video shooting mode enables you to capture HD video, complete with audio. Whether you hold the camera, have it mounted on yourself or your equipment, or position it on a mount or tripod, when you press the Shutter button, the camera begins recording and continues recording until you press the Shutter button a second time.

As you record, the red Status Lights on the camera flash, indicating that the recording process is underway. When you begin the video recording process, the camera also beeps once and then beeps three times when you stop recording.

After selecting the Video shooting mode, but prior to pressing the Shutter button to begin recording, you have the option of accessing the Video shooting mode's Settings menu, from which the following options are available:

- **Resolution:** Depending on which Hero camera you use, your choice of available resolution options will vary. The most comprehensive selection of resolution options is offered by the Hero4, which offers the following resolutions: WVGA, 720p Superview, 720p, 960p, 1080p, 1080p Superview, 1440p, 2.7K, 2.7K 4:3, 2.7K Superview, 3K, and 4K Superview.

- **Frames Per Second (FPS):** Based on which Resolution option you select, a different assortment of corresponding Frames Per Second options become available. For example, on the Hero4, if you select 1080p Superview, you can then choose between shooting at 24, 30, 48, 60, or 80 Frames Per Second.

- **Field of View (FOV):** Also based on which Resolution option you select, a different assortment of corresponding Field of View options become available. This helps to determine how much you'll take advantage of the camera's wide angle lens, and how much of what's in front of and to the sides of the camera's lens will be caught in the frame and recorded. Although some resolutions, such as 4K on the Hero4, offer only a Wide FOV option, the more common resolutions, such as 1080p on the Hero4, enable you to choose between a Narrow, Medium, or Wide Field of View.

- **Low Light:** When turned on using the virtual switch displayed with this option within the Settings menu, the camera automatically compensates for low light or changing light as you shoot video. This is a useful feature to use when shooting in the evening or at night, as well as indoors when minimal lighting is available. This option is only available when certain Resolution options are selected.

- **Spot Meter:** When turned on, this feature enables you to capture clearer and more in focus shots when the camera is positioned in a dark or low-light area, but the subject is in front of the camera in a well-lit area. For example, use this feature if you sit in the audience at a show or concert and film the performers on the stage, or if the camera is positioned inside of a vehicle, but you shoot a subject that's located outside of the vehicle in the sunlight.

- **Protune:** When turned on, this option enables you to manually adjust or fine-tune specific camera settings that are otherwise controlled automatically by the camera. Protune-related options include White Balance, Color, ISO Limit, Sharpness, and EV Comp.

Table 10.2 offers an overview of the Hero4's available shooting resolutions, as well as the corresponding Frames Per Second and Field of View options available. Again, the Resolution options available, as well as their related FPS and FOV options vary, based on which GoPro camera model you use.

Table 10.2 Hero4 Shooting Resolutions, FPS Options, and FOV Options

Video Resolution	Frames Per Second Options Offered	Field of View Options Offered
WVGA	240	Wide
720p	30, 60, 120, 240[*][^]	Narrow, Medium, Wide
720p Superview	60, 120	Wide
960p	60, 120	Wide
1080p	24, 30, 48, 60, 90, 120	Narrow, Medium, Wide
1080p Superview	24, 30, 48, 60, 80	Wide
1440p	24, 48, 60, 80	Wide
2.7K	24, 30, 48, 60[*]	Medium, Wide
2.7K Superview	30	Wide
2.7K 4:3	30	Wide
4K	24, 30	Wide
4K Superview	24	Wide

[*] Shooting 720p at 240 fps or 2.7K at 60 fps is only available on the Hero4 when the Camera Software has been updated with the February 2015 update from GoPro. These shooting resolutions are not currently available on other GoPro camera models.

[^] Shooting at 720p 240fps, only the Narrow FOV is available.

Video+Photo Shooting Mode

This shooting mode enables you to shoot HD video and simultaneously take digital images at a predetermined resolution and time interval. After you select the Video+Photo shooting mode, from the Settings menu, choose your video Resolution, FPS and FOV settings, and turn on/off the Spot Meter function. Protune is not available from this shooting mode.

In addition to the video-related settings, you need to select an Interval, which determines how frequently the camera takes a digital photo during the video filming process. Options include every 5, 10, 30, or 60 seconds.

Adjust the Photo Settings to select the wanted Resolution and corresponding Field of View for the digital images.

When you select Video+Photo, the Hero4's Video Resolution options are limited to 720p, 1080p, and 1440p. Based on which of these resolutions you

select, more limited FPS and FOV options are available (compared to when using the Video shooting mode).

Table 10.3 showcases what Video Resolutions, FPS and FOV options, as well as what Digital Photo Resolution options are available when the Video+Photo Shooting mode is selected on the Hero4.

After choosing the Video+Photo shooting mode and then adjusting its settings, press the Shutter button to begin filming HD video and capturing digital photos. The filming process continues until you press the Shutter button again.

Table 10.3 Video, FPS, FOV, and Photo Resolution Options Related to the Video+Photo Shooting Mode

Video Resolution	Frames Per Second Options Offered	Field of View Options Offered	Digital Photo Resolution Options
720p	30, 60	Narrow, Medium, Wide	5MP Medium, 7MP Medium, 7MP Wide, 12MP Wide
1080p	24, 30	Narrow, Medium, Wide	5MP Medium, 7MP Medium, 7MP Wide, 12MP Wide
1440p	24	Wide	5MP Medium, 7MP Medium, 7MP Wide, 12MP Wide

Looping Video Mode

This video option enables you to preselect a time interval, such as 5, 20, 60, or 120 minutes, and then have the camera capture and record video during that time period. When the selected time period ends, if you press the Shutter/Select button, the video recording is saved onto the microSD memory card and a new recording begins.

However, if you fail to press the Shutter/Select button at the end of the predetermined time period, the recording is not saved. The camera, however, begins the recording process again.

From the Interval submenu related to this Looping Video feature, in addition to the predetermined time periods (5, 20, 60, or 120 minutes), there's also an option called Max. When you select this Max option, the camera keeps recording HD video (using the settings you choose) until the microSD memory card reaches capacity. At this point, you can either save the footage or allow the camera to automatically erase the previously recorded footage and begin recording again until the camera's memory card is filled.

The Camera Records Separate Video Files

As the 5-, 20-, 60-, or 120-minute video files are recorded and saved to your camera's memory card, each time segment recording is saved as a separate file. This makes it easier to find and edit specific files. Or using photo editing software, such as GoPro Studio, multiple time segment recordings can be edited together into a longer video.

All the video resolution, FPS options, and FOV options available from your camera's Video shooting mode are also offered when you select the Video Looping mode on your compatible GoPro camera model (refer to Table 10.2).

Taking Advantage of Hero4's Hilight Tagging

One of the skills you need to fine-tune as you become a videographer using your GoPro camera is keeping track of what raw footage you might want to use later during the editing process. In many situations, you might shoot 5, 10, or even 20 times more video footage than you'll actually feature within your final video project.

As you're filming, one feature that can help you keep track of awesome scenes or shots is GoPro's Hilight Tagging feature. It's available exclusively on the Hero4 cameras.

When filming HD video, if you want to mark a specific moment or shot, so you can quickly find it later when editing, simply press the Settings/Tag button that's located on the side of the Hero4.

Later, you can view these tags as you play back video using the GoPro App on your mobile device or the GoPro Studio software on your computer. The tags, however, do not become part of your final video production that your audience sees.

Create a Tag from the Smart Remote

Instead of pressing the Setting/Tag button on the side of the camera while filming, you can also create tags directly from the Smart Remote:

1. Start a recording with your GoPro camera (not pictured).

2. Press the Settings/Tag button on the remote control unit to add a tag to the video file as it's being recorded.

Create a Tag from the GoPro App

You can also create tags directly from the GoPro App:

1. Start a recording with your GoPro camera (not pictured).

2. Open the GoPro App.

3. Press the bright yellow Tag button (displayed on the app screen to the right of the Shutter button).

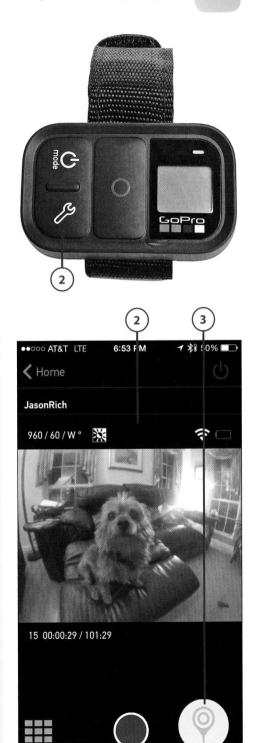

Shooting Time Lapse Video

One of the new features added to the GoPro Hero4's Camera Software update in February 2015 is a new shooting mode called Time Lapse Video. This video mode allows the camera to start and stop shooting video in short bursts, and at a pre-set time interval. This enables you to later edit and view the footage as a cohesive and seamless time lapse video clip, without having to stitch together a group of digital images.

After selecting the Time Lapse Video mode, access the mode's Settings menu to adjust the Interval, Resolution, FPS, FOV, and Spot Meter (On/Off) options. The Interval options available include every 5 seconds, 10 seconds, 30 seconds, or 60 seconds. The Auto Low Light option is not offered when shooting Time Lapse Video.

Time Lapse Video Settings menu in the GoPro app.

●●●○○ AT&T LTE	1:19 PM	✈ ❋❢ 90% ▬▭
	Settings	Done

VIDEO SETTINGS

Interval	5 Seconds ⟩
Resolution	1080 ⟩
Frames Per Second	24 ⟩
Field of View	Wide ⟩
Spot Meter	◯

Capture Time Lapse Video

To set up and begin shooting in Time Lapse Video mode directly from the camera, turn it on and follow these steps:

1. Press the Power/Mode button repeatedly until the Video mode icon appears on the Status Screen.

2. Press the Settings/Tag button to access the Video mode's Settings menu (not pictured).

3. Press the Shutter/Select button to toggle through the options, until the T Lapse Vid (Time Lapse Video) option is displayed.

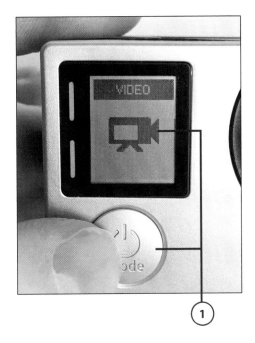

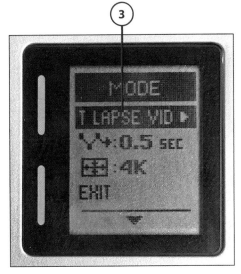

4. Press the Power/Mode button to scroll down within the Setup menu and adjust each Time Lapse Video-related option, one at a time. Options include Interval, Resolution, FPS, FOV, and Spot Meter (On/Off).

5. Once an option is highlighted, press the Shutter/Select button to toggle through the options, and then press the Power/Mode button to select the displayed setting and move to the next option within the menu.

6. When you're done adjusting the Time Lapse Video-related options, scroll down to the Exit option and select it. You're now ready to begin shooting Time Lapse Video using your GoPro Hero4.

Using the App

Of course, you can also adjust the camera's shooting mode via the Smart Remote or GoPro App.

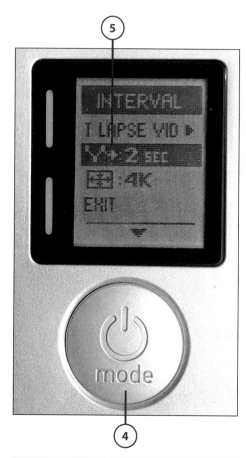

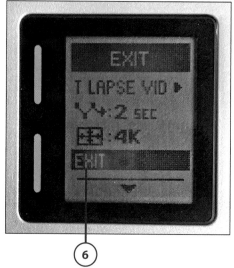

Time Lapse Video Shooting Strategies

When you're ready to start shooting Time Lapse Video, set up your camera using a tripod or stand so that it will remain very stable. There should be no camera movement whatsoever.

Press the Shutter button once to begin recording. The camera will begin shooting one video frame at a time at the pre-set time interval and continue doing this until you press the Shutter button again to stop recording.

The Time Lapse video is stored as a single video clip on your camera's microSD memory card. If you want access to individual Time Lapse images, use the Time Lapse mode in Photo mode, not the Time Lapse Video mode.

Keep in mind that when you play back the Time Lapse Video footage, the sequence is very short, even if you filmed over a several hour period. Thus, to give you the most flexibility when editing, allow the camera to shoot more additional time lapse sequences than you think you'll actually need. You can always delete the unwanted footage later.

Enhancing Video Quality with Protune

The Protune (PT) feature is designed for more advanced GoPro users. It enables you to have greater manual control over specific camera settings related to shooting video.

Using Protune, you can capture higher-quality results because the camera utilizes less data compression on your raw video footage, plus better captures natural colors within your shots. The raw digital video footage is then more compatible with higher-end and professional-level video editing software packages, which means you can take full advantage of the more advanced editing tools built in to that software.

Regardless of which video-related shooting mode you select, from that mode's Settings menu, you can turn on or off the Protune feature via a virtual on/off switch in the GoPro app.

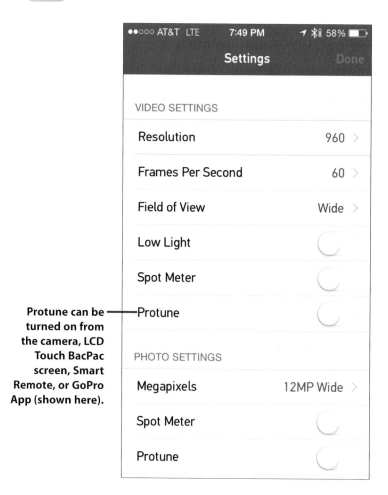

Protune can be turned on from the camera, LCD Touch BacPac screen, Smart Remote, or GoPro App (shown here).

When turned on, five additional menu options become available, and each can be adjusted for that particular Video shooting mode. You can set the Protune-related settings differently for each video and photo-related shooting mode.

The adjustable Protune options include

- White Balance

- Color

- ISO Limit

- Sharpness

- EV Comp (Exposure Value Compensation)

When Protune is turned off, the camera automatically adjusts each of these settings on your behalf. This requires less decision making and tinkering with camera settings on your part prior to shooting.

Adjusting White Balance

The White Balance setting allows the camera to adjust all the colors and tones displayed within each video frame, based on what the camera perceives to be the color white in each frame.

When this option is set to Auto (which is the default), the camera automatically analyzes each video frame as it's being shot and adjusts the color tone based on the conditions it senses.

- If you shoot video in an area with natural, warm light, such as incandescent lighting (indoors), or during a sunrise or sunset, consider selecting the 3000K White Balance option to capture more authentic colors.

- If you shoot in areas lit by fluorescent lighting or in average daylight, select the 5500K White Balance option.

- When shooting in cool lighting (such as when outside in overcast conditions), use the 6500K White Balance option.

- If you plan to use higher-end video editing software that offers White Balance controls to later edit or enhance your raw footage, select the camera's Native White Balance option when actually shooting video.

Adjusting Color

The Adjusting Color option enables you to manually select the color profile used by the camera when shooting video. The default GoPro Color option uses the same color profile as when the Protune feature is turned off. When you select the Flat option, this enables you to easily edit the color in your video later, using video editing software, to showcase truly natural or authentic looking colors within an image.

Adjusting ISO Limit

Use the ISO Limit setting to manage the camera's sensitivity to light, especially when shooting in low-light situations. Based on which option you select, you can manage the brightness of your video footage and somewhat control the unwanted graininess (or noise) captured within the footage by the camera due to poor lighting.

To achieve brighter footage when shooting in low light, select the default 800 ISO Limit option. The video, however, showcases more noise, which takes away from the detail, image sharpness, and vibrancy of color that's depicted.

The 400 ISO Limit option results in slightly darker footage (when shooting in low light), but the video contains less noise than with the 800 ISO Limit option selected. As a result, your video showcases a bit more detail and sharpness.

If you shoot indoors with decent (but not bright) lighting, choose the 200 ISO Limit option. When shooting outdoors in daylight, the 100 ISO Limit option generates the least amount of noise, resulting in a sharper, brighter, and more vibrant footage.

Adjusting Sharpness

To manually adjust Sharpness while shooting video, the Protune option offers three options: High (which is the default setting), Medium, and Low.

Choose the High setting to achieve ultra-sharp image quality in your videos. Choose the Medium setting to capture what GoPro calls "moderately sharp" video footage, or use the Low option to capture softer video footage that showcases a bit less detail.

Adjusting EV Comp

EV Comp, which stands for Exposure Value Compensation, also impacts the brightness of video as it's being taken. If you shoot in areas with contrasting lighting conditions, adjusting this setting can help you capture better quality video overall. The available EV Comp options range from −2.0 to 2.0, with the default option being 0.0.

Reset the Protune Options

By selecting the Reset option related to a specific Protune menu, you can reset all the related options to their default settings. However, the changes to their default settings will apply only to the Protune options for that specific shooting mode.

>>>Go Further

QUIKCAPTURE SHOOTING

If you have a favorite or most commonly used Video shooting mode (and related settings), you can set up the camera's QuikCapture feature so that as soon as the camera is turned on, it immediately begins shooting video using the default or wanted (preset) settings for the selected Video shooting mode.

Then to activate it, instead of pressing and holding the Power/Mode button on the camera to turn on the camera, press and hold the Shutter/Select button for approximately 2 seconds to turn the camera on and immediately begin shooting. (Refer to Chapter 12 for more information on how to set or change the QuikCapture setting.)

Switching Between Video-Related Shooting Modes

When the camera is turned on, you can switch between Video shooting modes in four ways and then adjust shooting mode-specific settings, including

- From the camera directly

- Using the LCD Touch BacPac display

- Using the Smart Remote

- Using the GoPro App that's running on your smartphone or tablet

Adjusting the Orientation

After selecting a Video shooting mode and adjusting the mode-specific Settings, you might also want to access the camera's Setup menu and adjust the Orientation Up/Down feature if you plan to hold or mount the camera sideways or upside down.

If you know the camera will be mounted upside down while shooting, turning on the Orientation Up/Down feature allows the camera to automatically rotate the video you shoot, which can save you a step during the editing process.

Thanks to the February 2015 Camera Software update, the Hero4 will automatically rotate your video footage as needed during the shooting process, so you don't need to worry about this Orientation Up/Down option. It still applies to other Hero camera models, however.

For directions on how to turn on/off this Orientation Up/Down feature, see Chapter 12.

Switch Video-Related Shooting Modes Directly from the Camera

To switch between video-related shooting modes and then adjust shooting mode-specific settings before taking pictures using the Hero4, follow these steps:

1. Turn on the camera by pressing and holding the Power/Mode button for approximately 2 seconds.

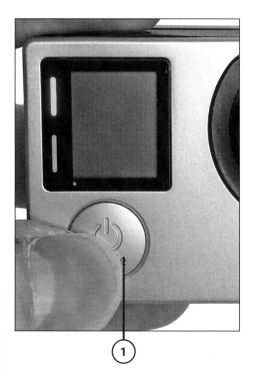

2. While looking at the camera's Status Screen, repeatedly press the Power/Mode button until the icon for either Video mode displays. Stop pressing the Power/Mode button when the Video icon is visible to turn on the Video mode.

3. When the camera is in Video mode, to select between the Video, Time Lapse Video (Hero4 only), Video+Photo, or Looping Video mode, press the Settings/Tag button on the side of the camera to access the Video's Mode submenu.

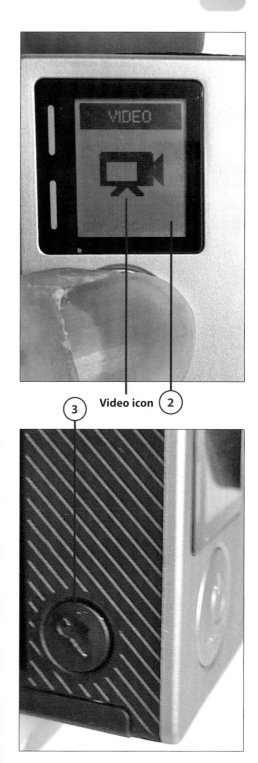

③ **Video icon** ②

4. The first option listed within the Mode submenu that displays on the Status Screen enables you to toggle between shooting modes. Repeatedly press the Shutter/ Select button to switch between Video, Video+Photo, or Looping Video mode until your wanted option displays. When using the Hero4 with the February 2015 Camera Software update, the Time Lapse Video option will also be listed here.

5. The shooting mode that's highlighted and displayed near the top of the Mode menu is the one that's selected and currently active. Below this menu option are the currently selected Settings-related options for that shooting mode.

6. Press the Power/Mode button to highlight, select, and then adjust one or more shooting mode-specific settings (one at a time).

Video Mode selected ④

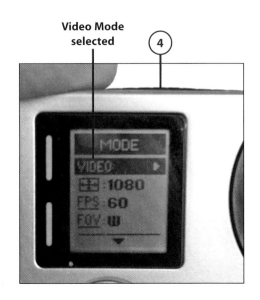

⑤

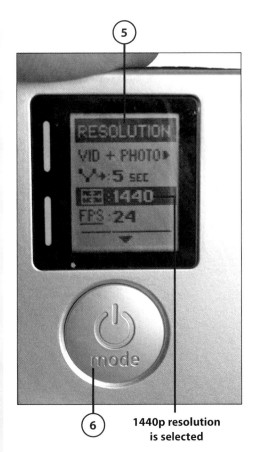

1440p resolution is selected

7. After a submenu option is highlighted (by pressing the Power/Mode button), press the Shutter/Select button to select the highlighted option's submenu or toggle between available options.

8. After the desired settings-related option displays, press the Power/Mode button to select it. Repeat Steps 5 through 7 for each shooting mode-specific setting you want to alter prior to shooting.

720p resolution is selected

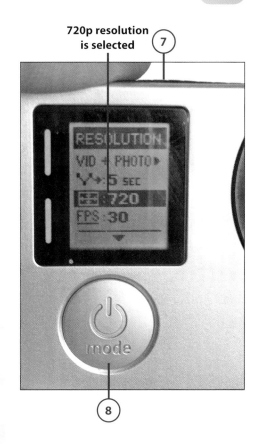

Switch Video Shooting Modes Using the LCD Touch BacPac Display

To select a specific Video shooting mode and adjust that shooting mode's settings using the LCD Touch BacPac, attach the BacPac to the camera and, with the camera turned on, follow these steps:

1. Tap the BacPac display and unlock it by swiping down.

2. When using the Hero4, place your finger on the right side of the display and swipe to the left to access the camera's main menu. (Alternatively, or when using a different GoPro camera model, press the Settings/Tab button or the Wi-Fi button on the side of the camera to access the menu.)

3. Tap the Video mode option displayed in the top-left corner of the menu. The currently selected and active shooting mode displays a red triangle in the top-right corner of the icon. You will automatically return to the main viewfinder screen.

4. After you select the main Video mode option, to switch between Video shooting modes, place your finger at the bottom center of the touch display, and this time swipe upward. Using the Hero4 this displays the Settings menu specifically for the active shooting mode.

5. Tap the Mode option to select a specific Video shooting mode (Video, Video+Photo, or Looping Video).

6. When the Mode submenu displays, tap your wanted shooting mode. You may need to swipe your finger upward on the screen to first scroll through the menu options.

7. Tap Back to return to the Settings menu. Repeat Steps 5 through 7 until all the settings related to the selected shooting mode are adjusted to meet your needs.

8. From the Video Settings menu, tap the Exit (X) icon that's displayed in the top-right corner of the display to save your changes and return to the viewfinder screen. You're now ready to begin shooting.

Video is the selected and active shooting mode.

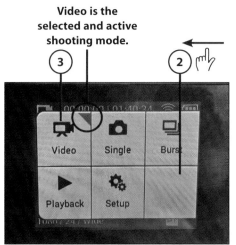

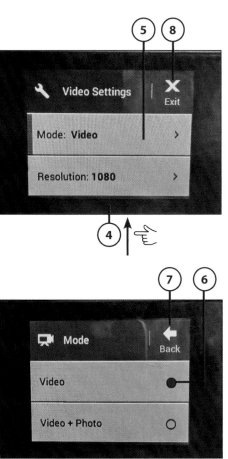

Other Options

You can adjust the following options from the Settings menu: Resolution, Frames Per Second, Field of View, Low Light, Spot Meter, and Protune.

Submenus and Controls

Upon tapping many options available in the Settings menu, you may see another submenu, where options specific to that feature or function display. In some cases, a virtual on/off switch is an option instead of a submenu. Regardless, tap the option you want to select it.

Switch Between Video Shooting Modes Using the GoPro Smart Remote

The information displayed on the Status Screen of the Smart Remote (or Wi-Fi Remote) is identical to what's displayed on the Status Screen of the camera. If you want to use the Smart Remote to remotely control your camera, first follow the directions offered within Chapter 5, "Must Have GoPro Camera Accessories," for pairing and activating the Smart Remote.

Then, refer to the "Switch Video-Related Shooting Modes Directly from the Camera" section earlier in this chapter to determine which buttons to press on the Smart Remote (instead of on the camera).

Switch Shooting Modes Using the GoPro App

To select and activate a specific Video shooting mode using the GoPro App, and then adjust the settings related to the selected shooting mode, follow these steps.

1. From your smartphone or tablet, access the Wi-Fi feature and connect to the wireless network that your camera has created. On the iPhone or iPad, for example, this is done from within Settings (accessible from the Home screen), not from within the GoPro App.

Pairing the App

To follow these steps, your camera and app must already be paired. Follow the directions in Chapter 15, "Using the GoPro Mobile App," to initially pair your smartphone or tablet with your camera.

2. Launch the GoPro App on your mobile device, and tap the Connect & Control option.

3. To select the main Video shooting mode, tap the shooting mode icon that displays to the right of the red Shutter button on the app's Viewfinder screen.

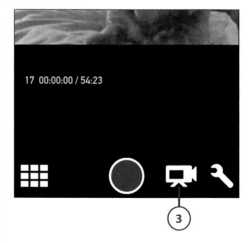

4. Tap the video camera-shaped icon so that it becomes highlighted in blue.

5. Tap the Video, Video+Photo, or Time Lapse Video option to select the desired video-related shooting mode. Your selected option also is highlighted in blue.

6. Tap on the wrench-shaped Settings icon to adjust the available settings for the specific shooting mode you've just selected. Displayed near the top of the Settings menu is the Video Settings heading. Below it are the options you can adjust for the selected Video shooting mode.

7. Tap the Resolution setting.

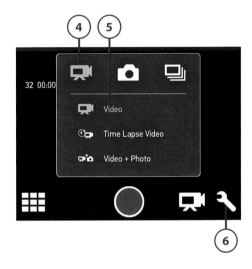

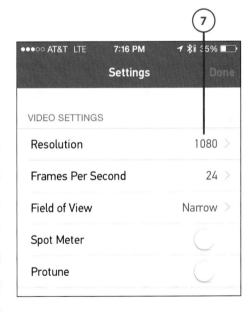

8. Select a resolution. Repeat this process until you've adjusted all the wanted Video shooting mode-specific settings.

Changing Other Settings

One at a time, tap an option listed within the Settings menu to adjust that particular feature. In some cases, such as with resolution, there is a submenu from which you can select an option. In other cases, you can adjust a virtual switch to turn on or off a setting.

The Protune Submenu

After you turn on the virtual switch associated with the Protune option, with any of the Video shooting modes when using a Hero4, additional Protune-related menu options display on the Settings screen of the GoPro App.

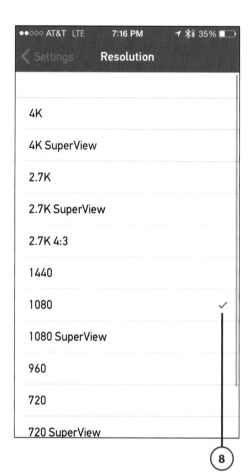

Optional Lume Cube
Video Light

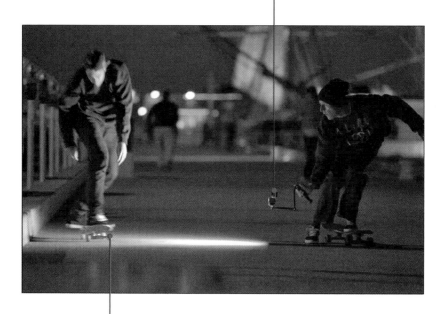

Capturing high-quality sound and
properly lighting your videos is
relatively easy when you use the right
equipment with your GoPro camera.

In this chapter, you learn how to properly record sound and use artificial lights when shooting video with your GoPro camera. Topics include the following:

→ Recording sound using the camera's built-in microphone

→ Using an optional and external microphone with your camera

→ Tips for using a constant artificial light source when shooting video

Capturing Sound and Using Artificial Light While Shooting Video

When shooting HD video, your GoPro camera can record decent quality sound using its built-in microphone. However, how well this microphone works depends directly on which optional housing you use with the camera.

If you require higher-quality audio than what's possible using the built-in microphone, invest in the optional GoPro 3.5mm Mic Adapter ($19.99), and then connect a third-party microphone directly to the camera.

Another option is to use the GoPro Studio software, or other video editing software, to later add background music, sound effects, and voiceovers to your video project. You can also use some video editing software to clean up the audio quality that was recorded during the filming process.

Although including high-quality and clear audio within your video productions greatly enhances their professional quality and makes them more enjoyable to watch, another video production element you sometimes need to consider is lighting.

All GoPro cameras are designed to work well in a wide range of lighting situations. However, you may encounter shooting situations in which the ambient light in your shooting area is not adequate to capture decent quality video. In this case, using an optional, external, and continuous light source may be a viable option to enhance the visual quality of your video.

This chapter deals with overcoming issues related to sound and lighting that you may encounter when shooting video with your GoPro camera.

Using Your Camera's Built-in Microphone to Record Audio

The microphone that's built in to your GoPro camera may be extremely small, but it can capture decent quality sound when you simultaneously record video.

Built-in microphone

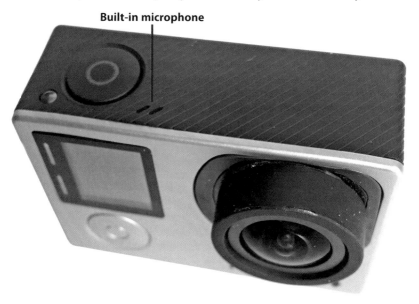

Following are five strategies to use to capture and record the highest-quality audio possible based on your shooting situation:

Sound versus Waterproofing

The majority of these sound recording strategies involve using an optional camera housing that offers no waterproof protection for your camera whatsoever. When you use a housing, it's to protect the camera from physical damage, dirt, or dust, or in the case of the Frame Housing, to use an optional mount with the camera.

- Unless you shoot in or around water, instead of using a Standard back-door with your camera's Standard or Blackout Housing, consider using a supplied Skeleton Backdoor. When the camera is not completely sealed within an airtight and waterproof housing, the camera's built-in micro-phone can pick up and record better-quality audio yet still keep the cam-era protected.

It's Not All Good

Full Enclosures Compromise Sound

The Standard, Dive, or Blackout Housing, when used with a Standard or Dive Backdoor, fully encase the camera. This muffles sound as it's recorded.

- When shooting video involves some camera movement, consider using the Standard Housing with a Skeleton Backdoor. This blocks much of the wind noise created with the motion, offers some protection for your cam-era, but still allows the camera's microphone to capture sound in the area.

- If you shoot in a clean, dry, and calm area, and keep the camera reason-ably still (no movement, if possible), consider using only the Skeleton or Frame Housing. This allows the camera's built-in microphone to record the clearest sound possible because little or nothing stands between the microphone and the sound source.

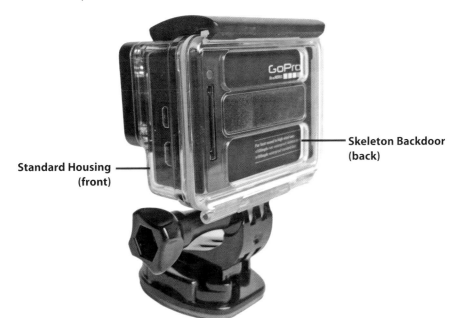

Standard Housing (front)

Skeleton Backdoor (back)

- Connect an external microphone to your GoPro camera via the optional 3.5mm Mic Adapter, but be sure to select the most-suitable microphone for the type of audio that's being recorded. (See "Connecting an External Microphone to Your Camera" later in this chapter.)

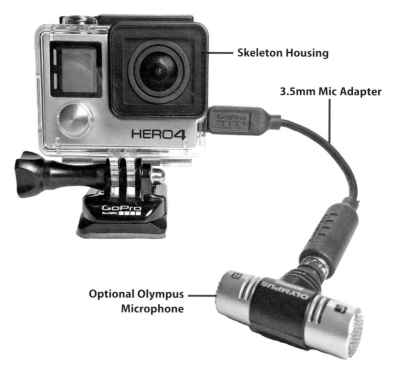

Skeleton Housing

3.5mm Mic Adapter

Optional Olympus Microphone

- Plan on adding voiceovers, music, and sound effects to your video during the editing process and not using the audio recorded by the camera in your final video production. This is often a viable solution for video shot with the camera fully encased in a Standard or Dive Housing, including video shot underwater.

It's Not All Good

Beware of Unwanted Noise

Whether you use the camera's built-in microphone or an external microphone, be aware of all sounds in the area as you film. The noise an air conditioner generates, traffic, airplanes flying overhead, phones ringing, appliances running nearby, an engine, or people talking in the vicinity are picked up and recorded by the microphone.

The microphone that's built in to the GoPro cameras is sensitive. If you hold the camera in your hands while filming, the microphone can pick up and record the sounds of your fingers moving around on the camera and your palm rubbing against the camera and its housing. In this situation, refrain from even subtle finger or hand movements when they're in contact with the camera.

When planning your shots, consider what sounds you want people to hear, and take steps to eliminate sounds or noises that you do not want recorded. Although some video editing software offers tools for removing or muffling unwanted background noise, separating unwanted noise from the audio you intend to record is not always possible after an audio recording has been made.

Connecting an External Microphone to Your Camera

Instead of relying on your GoPro camera's built-in microphone, consider connecting the optional 3.5mm Mic Adapter to the camera and then plugging an external microphone into the adapter.

Optional and external microphones that utilize a 3.5mm plug are available from consumer electronics stores (such as Best Buy), music specialty stores (such as Guitar Center), photo/video specialty stores, as well as a wide range of online-based merchants. (Just search for "GoPro Microphone.")

What you'll quickly discover, however, is that an external microphone can cost less than $25.00, but go up in price to several hundred dollars. Plus, microphones designed for specialized uses are available that can record audio in mono or stereo.

For example, if you want to record a person talking, a lavaliere microphone (that clips onto a shirt collar or lapel) might be suitable. Also handheld and wireless microphones designed for recording voice are available with some specializing in recording music.

If you're a musician, consider using a specialized microphone that attaches directly to your instrument. With a small amount of research, you can also find microphones designed only to pick up and record audio that's within close proximity to the microphone, whereas some microphones are

extremely sensitive and can pick up and record even subtle sounds that originate from far away.

Based on what type of audio you want to record with your video, choose an appropriate microphone type, and select the highest-quality microphone you can afford for that purpose.

Choosing a Microphone

Following is information about several third-party microphones that are designed for use with a GoPro camera. Some require the optional 3.5mm Mic Adapter to connect to the camera, whereas others come with a proprietary connector that plugs into the camera's mini-USB port.

- **GoPro Microphone Kit - Promic** ($49.99, http://polarprofilters.com/shop/gopro-microphone-external-mount): Available from Polar Pro, this microphone is a good-quality external microphone that plugs into the side mini-USB port of the GoPro camera without requiring the optional 3.5mm Mic Adapter. This stereo microphone is designed for use with the Frame Housing and comes with a wind screen to help reduce unwanted wind noise created by camera movement.

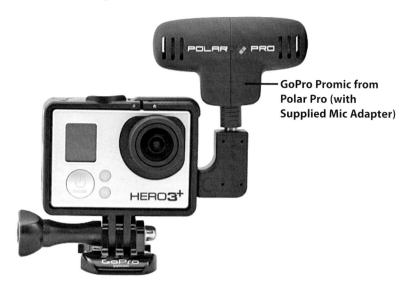

GoPro Promic from Polar Pro (with Supplied Mic Adapter)

Stop Noise Caused by Wind

When shooting outside, whatever microphone you use can pick up wind noise. To reduce or eliminate this unwanted noise, consider using an optional wind screen with your microphone. The Skeleton Housing serves as a wind screen for the built-in microphone. Other microphones have an optional sponge or foam-based wind screen that fits over them.

- **MicW iGoMic Stereo Microphone for GoPro** ($159.00, www.mic-w.com/product.php?id=113): You can use this tiny but powerful stereo microphone to record music or ambient sound in a wide range of shooting situations. This microphone comes with its own cable that connects to the GoPro camera's mini-USB port.

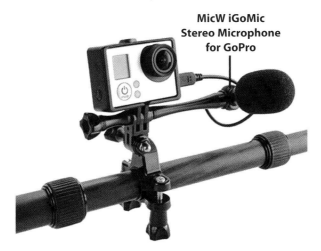

**MicW iGoMic
Stereo Microphone
for GoPro**

- **Sena Bluetooth Audio Pack for GoPro** ($99.00 - $219.00, www.sena.com/product/cameras/bluetoothaudiopackforgopro): Using this specially designed Bluetooth wireless microphone and audio system (that connects to the back of the GoPro camera), videographers can record their voices in CD quality, as they're shooting, whether they're holding the camera, they have the camera mounted to them, or they're up to 100 meters away from the camera. This microphone system eliminates the need for any cables, yet offers the capability to record extremely high-quality audio. In addition to this system, the microphone or mic headset is sold separately.

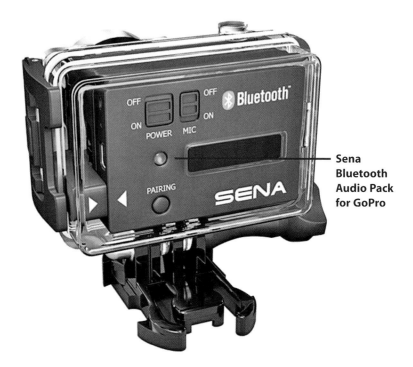

Sena
Bluetooth
Audio Pack
for GoPro

- **Movo GM100 Lavalier Lapel Clip-on Omnidirectional Condenser Microphone for GoPro** ($17.95, www.amazon.com/Movo-GM100-Omnidirectional-Condenser-Microphone/dp/B00N0EA3NC): This microphone and the **Audio-Technica ATR-3350 Lavalier Omnidirectional Condenser Microphone** ($27.95, www.amazon.com/Audio-Technica-ATR-3350-Omnidirectional-Condenser-Microphone/dp/B002HJ9PTO), offer a low-cost, external microphone option for recording a person speaking. These small microphones are designed to be clipped to someone's lapel or collar. The optional GoPro 3.5mm Mic Adapter is required to connect either microphone to the camera.

Adding Sound Effects and Music to Your Video Projects

After you record and transfer video to your computer using video editing software such as the free GoPro Studio software for a PC or Mac (see Chapter 16, "Using the GoPro Studio Software"), you can edit your video, and at the same time, include music, sound effects, and voiceovers to the production.

Music and sound effects can set the tone of your video (or a scene within your video), and if used correctly, can help capture and maintain the attention of your audience.

If you create a video production purely for personal use, you can use any music from your digital music library (or music that you acquire) as background music within your video production. However, if the video will be used for professional purposes, distributed publicly, or broadcast in any way, you either need written permission to use copyrighted music, or you need to acquire royalty and license-free music and sound effects to use within your video productions.

Music copyright issues apply to videos you plan to publish on YouTube as well. For more information about copyright issues related to publishing video content on YouTube, visit www.youtube.com/yt/copyright.

There is a wide range of online-based music and sound effect libraries from which you can acquire music for little or no cost that you can use within any video production without having to worry about copyright infringement or other legal issues.

These music libraries offer hundreds, or in some cases thousands, of music tracks (with or without vocals), that are divided up by music genre. Some of these music production libraries include

- **123RF:** www.123rf.com

- **IB Audio:** www.ibaudio.com

- **Music Case:** www.themusicase.com

- **Premium Beat:** www.premiumbeat.com

- **Royalty Free Music:** www.royaltyfreemusic.com

- **SmartSound:** www.smartsound.com/royalty-free-music

Find More Music Online

To find a vast selection of royalty-free music that's available for free or for a small fee from other sources, visit any Internet search engine, such as Google, Yahoo, or Bing!, and within the Search field, enter the phrase, **Royalty free music**, or **Royalty free background music**. To find sound effects, enter the phrase, **Free sound effects**, for example.

After you acquire the digital music file, you can easily import it into your video editing software and incorporate it into your video project as you see fit. Of course, you want to choose music that is appropriate for your production and intended audience. Like so many other aspects of shooting and editing video, the music and sound effects you use are a matter of personal taste.

Using External Lighting Options

Because your GoPro camera has technology built in to it that enables you to shoot good-quality photos or video in low-light situations, you'll probably find that whatever light does exist in your intended shooting situation will work. For certain situations, however, additional lighting may be required to achieve the high-quality video you want or need for a project. For example, scuba divers who tend to shoot video at depths below 15 feet often use a battery-powered and waterproof external light source with their GoPro.

TecDiveGear.com (www.tecdivegear.com) offers several custom GoPro lighting solutions for scuba divers, including the GoPro Hero HD Camera Video Lighting Set ($599.00), which includes two lights and a proprietary camera/lighting mount.

In addition, the Qudos Action Waterproof Video Light for GoPro Hero (http://usd.knog.com.au/video-lights/qudos-action.html), which is available from Amazon.com, is priced at $119.00. You can use it on land or underwater to shed up to 400 lumens of light onto your subject while filming. This small, battery-powered light also comes with a proprietary mount that can accommodate a GoPro camera and the light.

Qudos Action Waterproof Video Light for GoPro Hero

You should consider several additional things when you start adding artificial light to a shooting situation:

- Adding unwanted shadows to what you shoot.

- Drowning out the natural colors in settings by using harsh, bright, white lights.

- Overexposing your video footage or shedding too much light onto your subjects, so they look washed out.

- Capturing inconsistent lighting within your video if you or your subjects are moving around while you shoot.

Depending on the type of artificial lighting you use, many of these obstacles can be overcome, but you need to address them during the shooting process. For example, if you start seeing unwanted shadows in your shots, you can move the position of the lights, change your shooting angle or perspective, or instruct your subjects to move into better lighting.

If you notice the natural colors in your shooting area are drowned out, try using a less bright light or moving the lights farther away from your subjects. This strategy can also help you prevent overexposing your video with too much light.

TRY THIS BEFORE TINKERING WITH EXTERNAL LIGHTING

Before you start adding artificial light to a shooting situation, try adjusting your camera's settings. For example, make sure the camera's Auto Low Light feature is enabled. Auto Low Light allows the camera to automatically adjust to low-light situations or when you move the camera between varied lighting situations.

This feature is not available when shooting video at 240 frames per second or when shooting at 30 or less frames per second.

As you discovered in Chapter 10, "Shooting HD Video," while you're shooting video, the camera's Protune and Spot Meter features are also available and you can use either or both in low-light situations.

Choosing the Best Continuous Lighting Solution

When shooting video in low light, if you add artificial light to the shooting situation, you need to choose an appropriate continuous light source. You can attach small, battery-powered LED lights to a GoPro mount (for your camera), which can light up a small radius directly in front of your camera.

These small, typically LED lighting solutions are relatively inexpensive (between $50.00 and $200.00) and offer portability and mobility while you shoot. To find them, use the search phrase **GoPro light** within any Internet search engine or while visiting Amazon.com or eBay.com, for example.

One versatile, small, waterproof, mountable, and battery-powered lighting solution was designed by independent inventors and funded via Kickstarter. com in December 2014. Each Lume Cube Video Light for GoPro ($79.99 each, www.lumecube.com) generates 1,500 lumens of light per 1.5-inch light cube, and multiple light cubes can be used in any given shooting situation.

You can place these tiny light cubes exactly where they're needed. You can control the intensity of the lights remotely via a smartphone or tablet while you shoot video with the GoPro.

Lume Cube Video Lights for GoPro with custom mounts

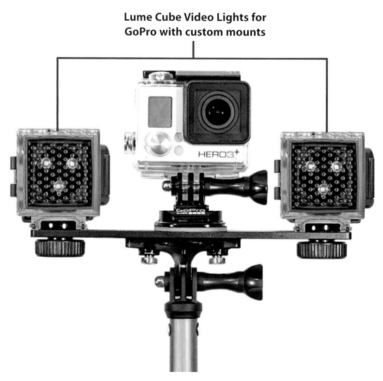

Larger and more powerful lighting solutions require their own stands (and typically need to be plugged into an electrical outlet) and can be placed, as needed, within and around your shooting area.

These more advanced and costly lighting kits and solutions are sold by photo and video specialty stores and online merchants (including B&H Photo, Video and Pro Audio, as well as Adorama) and are also manufactured and distributed by companies such as

- **Barndoor Lighting Outfitters**: www.filmandvideolighting.com/litepanelsled.html

- **Calibex**: www.calibex.com/Video-Lighting-Kits/shop-html

- **VideoLighting.com**: http://videolighting.com

- **Genaray**: www.genaray.com

Video Lighting Kits and Solutions Are Available from Amazon.com

Amazon.com offers a vast selection of low-, mid-, and higher-end video lighting kits and solutions, often at discounted prices. To discover what's available, visit www.amazon.com, and within the search field, use the phrase **GoPro lighting** or **video lighting kit**.

Discover what options
are available from your
camera's Setup menu.

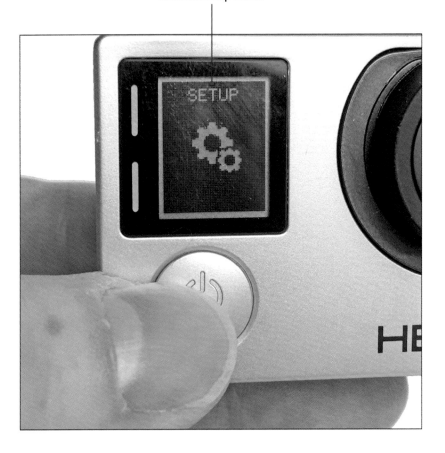

In this chapter, you learn about the options available from your camera's Setup menu. Topics include the following:

→ Learn which specific Setup menu options to change to meet your needs

→ How to navigate your way around the Setup menu

→ How to set the Default shooting mode for your camera

Adjusting the Camera's Setup Menu Options

You already know that each shooting mode that your camera offers has its own Settings options that enable you to customize that mode to best accommodate each shooting situation you encounter. However, your camera also has a main Setup menu, from which you can adjust options that relate to the overall operation of the camera. Each of these Setup options relate to all shooting modes.

Factory Defaults

Each Setup menu option has a default factory setting. After you adjust a Setup option, that change remains active until you manually alter it again or use the Reset command on your camera to return all Setup options to their factory default settings.

In this chapter you learn how to adjust each Setup-related setting directly from the camera, using the Smart Remote, using the LCD Touch BacPac display, or using the GoPro App with your smartphone or tablet.

Getting Acquainted with the Setup Menu Options

The following options are available from the Hero4's Setup menu:

Menu Options Vary

The available Setup menu options will vary based on which GoPro camera model you use and which version of the Camera Software is installed on your camera.

- **Orientation Up/Down** If you opt to mount the camera sideways or upside down while shooting, you must rotate your images or video footage during the editing process unless you first adjust this Orientation setting. When the Up option is selected, the camera assumes all filming will be done with the camera positioned right side up. When the Down option is selected, the camera assumes it will be mounted upside down when filming and will automatically rotate the image(s) and video on your behalf. This saves you a step during the editing process. If you're using the Hero4 with the February 2015 Camera Software update, the orientation is now automatically adjusted by the camera, so this feature is not needed.

- **Default Mode:** Select which shooting mode is automatically active each time you turn on the camera. Shooting options include Video, Video+Photo, or Video Looping. If you're using a Hero4 with the February 2915 Camera Software update, instead of Video Looping, a Time Lapse Video option is available. Options related to shooting digital images include Single, Continuous, Night, Burst, Time Lapse, or Night Lapse. In addition to choosing a shooting mode, you can then customize the Settings options for that mode, which will also become active each time you turn on the camera. For the Default mode, choose the shooting mode and related options that you will use most frequently.

Change Shooting Modes After You Turn on the Camera

Regardless of how you set the Default mode, when the camera is turned on, you always have the option to change the shooting mode before you begin shooting. Directly from the camera, repeatedly press the Power/Mode button to toggle between shooting modes.

- **QuikCapture:** When you turn on this feature, each time you power on your camera, it immediately begins shooting video or taking Time Lapse photos based on how you set up this feature. After you set up your camera, to use this feature, start with the camera turned off. Then, instead of turning it on by pressing and holding the Power/Mode button for 2 seconds, press and hold the Shutter/Select button for 2 seconds. The camera then starts filming video or taking Time Lapse photos immediately and keeps doing this until you press the Shutter/Select button again. (When you control the camera with the Smart Remote or GoPro App, QuikCapture is automatically disabled.)

- **LED Blink:** Your GoPro camera has four red LED Status Lights (located on the top, bottom, front, and back of the camera's body) and uses all of them by default, so you can see them from any angle while the camera is in use. This Setup option enables you to instruct the camera to use all four lights, just two lights (the ones on the top and bottom of the camera), or none of the Status Lights as you use the camera.

Reasons to Turn Off the LED Status Lights

The LED Blink option you select is a matter of personal preference. If you can't see the camera while filming, or you want to keep the camera as inconspicuous as possible, turn off all LED Status Lights. These lights use very little battery power, so turning them off does not significantly extend your battery life.

- **Beeps:** With the Status Lights, your camera beeps when it's turned on or off, or when certain functions are used. This option enables you to adjust the volume of these beeps. The default option is 100% (the loudest possible). Other options include 70% or Off. When turned off, the camera won't make sounds with its normal operation.

- **Video Format:** This option enables you to control frame rates when playing back video on a television set or monitor. Use the NTSC setting if you're within North America or the PAL settings if you're outside of North America.

- **On Screen Display (OSD):** This option has an on or off setting. When turned on, related icons and filenames appear on the screen as you play back video or view photos. When turned off, only the content displays. This option applies only when you view content on the LCD Touch BacPac display or when your camera is connected directly to a television set or monitor as you use the Playback feature.

- **Auto Off:** Determine if and when your camera will automatically turn itself off (to conserve battery life) after a predefined period of inactivity. Your submenu options include Never, 1, 2, 3, or 5 minutes. If you select Never, the camera remains on until the battery dies or you manually turn it off. When you select one of the other options, the camera powers itself off if that length of time goes without any buttons on the camera being pressed, or without the camera recording or shooting.

- **Set Date and Time:** Anytime you wirelessly connect your camera to the GoPro App or connect your camera to the GoPro Studio software running on your computer (using the supplied USB cable), the date and time within the camera will automatically be set or adjusted. Using this option, however, you can manually set the date and time.

Make Sure the Date and Time Are Correctly Set

Each time you take a photo or shoot video using your camera, the time and date that content was created is automatically recorded and saved. Thus, it's important that you have the correct time and date set within your camera. If you travel between time zones, and don't connect your camera to the GoPro App or GoPro Studio software, be sure to manually adjust the date and time as needed.

- **Delete Last File:** This command is used to manage content stored within your camera's microSD memory card and does not relate directly to the camera's operation. When you select and activate this option, the last photo or video you shot with your camera will be deleted from the SD memory card.

- **Delete All Files From SD Card:** This command is also used to manage content stored within your camera's microSD memory card and does not relate directly to the camera's operation. By selecting this option, all the content currently stored within your camera's SD memory card will be deleted.

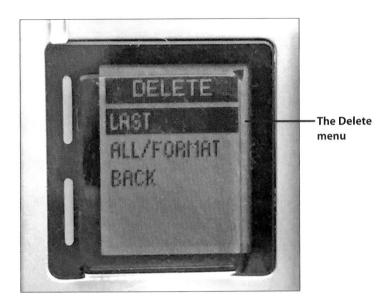

The Delete menu

Delete Confirmation

Upon confirming the All/Format option, this reformats your camera's memory card. Do not use this feature unless you're 100 percent sure you've transferred to your computer or mobile device the photos and video files that you want to keep. When the content is deleted from the memory card, it is gone forever.

In some cases, you can hire a data recovery service to retrieve accidentally deleted files from the camera's memory card, but this typically costs at least several hundred dollars and is not always successful.

- **Name:** When you first set up the Smart Remote or GoPro App with your camera, you are asked to name your camera and create a password for it. The name given to your camera is also used as the Network Name your camera creates when establishing a wireless connection, and the password is used, so only you can access this network using the GoPro App (running on your smartphone or tablet). To change the Camera/

Network Name and related password, select this Setup menu option, and then tap on the Apply Changes button after you update the Camera/Network Name and Password.

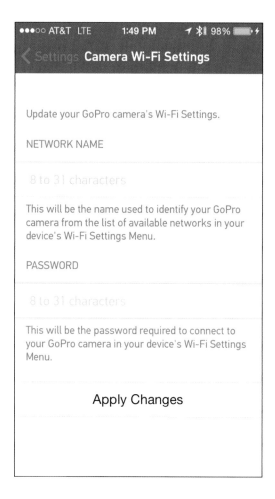

- **Version:** This is a non-interactive option that simply displays which version of the GoPro Camera Software is currently running on your camera.

- **Locate Camera:** This option has an on/off option and is used with the Smart Remote or GoPro App. When turned on, it activates the camera's LCD Status Lights and Beeping feature, which enables you to easily locate the camera (assuming it's turned on). This feature can be used to help locate your camera if you're within relatively close proximity to it.

- **Use with Current Wi-Fi Remote/Use with Smart Remote:** When the camera's Wireless feature is turned on, the camera can be set up to establish a wireless connection with a Smart Remote and the GoPro App (running on your smartphone or tablet), but only one of these options can be used at any given time. If the camera has already been set up to work with your Smart Remote, select the default Use with Current Wi-Fi Remote option. However, if you want to set up the camera to work with a different Wi-Fi Remote (or Smart Remote) select this Setup menu option, and then follow the directions in Chapter 5, "Must Have GoPro Camera Accessories," to pair the camera with the new remote control accessory.

- **Battery Level:** This feature simply displays the camera's current battery level.

- **SD Card Capacity:** Select this option to review details about your camera's SD memory card. Information that displays includes the number of videos currently stored on the camera, the amount of additional video that can be shot and stored on the memory card (based on its available capacity and the camera's current shooting mode and settings), the number of digital photos stored on the current memory card, and the number of additional photos the memory card can hold (based on its available capacity and the camera's shooting mode and settings).

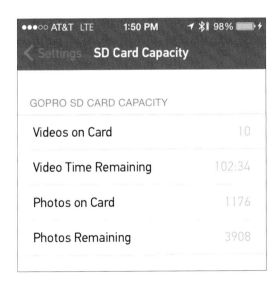

>>>Go Further

THE LCD TOUCH BACPAC SETTINGS

The following additional options are available only on the LCD Touch BacPac:

- **Sleep:** Separate from the Auto Off camera setting, this option enables you to save battery life by having just the LCD Touch BacPac display turn itself off after a predetermined period of inactivity. Options include Never, 1, 2, or 3 minutes.

- **Lock:** The LCD Touch BacPac has a built-in lock that prevents users from accidentally touching or swiping the display to activate or change various features and functions. When this feature is turned on, the Lock engages and does not allow taps or swipes until it's unlocked. When turned off, the Lock feature deactivates altogether.

- **Brightness:** Manually adjust the brightness of the LCD Touch BacPac display. Options include High, Medium, or Low. The selected option does not impact the Brightness of actual video or photo files taken with your camera. It impacts only the brightness of the display.

- **Touch Display On/Off:** When this feature is turned on, the LCD Touch BacPac display turns on automatically when it's connected to the camera and the camera is turned on. When the feature is turned off, the display must be turned on manually by pressing the Playback button on the side of the display.

Resetting Your Camera

Your camera has a built-in Reset command. When you execute this option, all Setup options are returned to their default factory settings. However, the date and time as well as the name and password you assigned to the camera when setting up the Wireless mode remain intact.

The Camera Reset command is not currently available via the GoPro App. To access it, you need to access the Setup menu directly from the camera, via the Smart Remote, or using the LCD Touch BacPac display.

If for some reason your camera becomes unresponsive, one option to try before using the Reset command is to press and hold the Power/Mode button for 8 seconds. Using this option, your camera's personalized Setup settings remain intact.

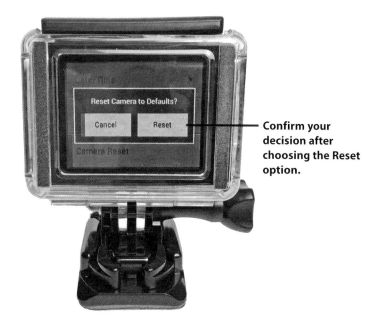

Confirm your decision after choosing the Reset option.

Accessing the Setup Menu

You can access your GoPro camera's Setup menu in four possible ways. You can do this from the camera directly, using the LCD Touch BacPac display, using the Smart Remote, or using the GoPro App (that runs on your smartphone or tablet).

Access the Setup Menu Directly from the Camera

To access and adjust the Setup menu directly from the camera, follow these steps:

1. When the camera is turned on, while looking at the Status Screen, repeatedly press the Power/Mode button until the gear-shaped Setup menu icon displays.

2. Press the Shutter/Select button to access the Setup menu.

3. When the Setup menu displays within the Status Screen, repeatedly press the Power/Mode button to scroll down within the menu and highlight each feature.

4. When the feature you want to adjust is highlighted, press the Shutter/Select button.

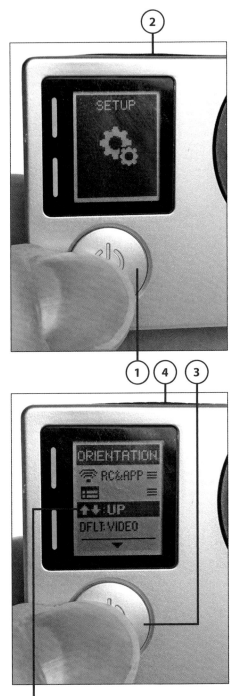

The Orientation Up/Down option is highlighted, and the Up option is selected.

5. Press the Power/Mode button to toggle through the submenu options.

6. Press the Shutter/Select button to activate a highlighted and selected option.

7. To exit out of the Setup menu, scroll down to the bottom of the menu, and select the Exit option.

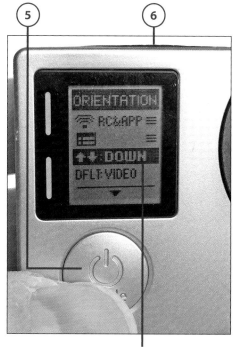

The Orientation Up/Down option is highlighted, and the Down option is selected.

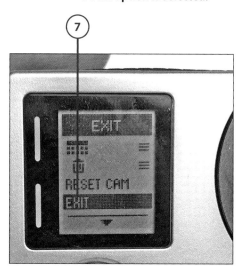

Access the Setup Menu Using the LCD Touch BacPac Display

To access and adjust the Setup menu using the LCD Touch BacPac display using a Hero4 with the BacPac attached and powered on, follow these steps:

1. Unlock the screen by placing your finger on the red dot and dragging it downward until it covers the lock icon. Hold your finger in place until the screen unlocks.

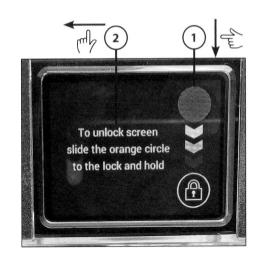

Swiping

The LCD Touch BacPac for the Hero3 or Hero3+ is not compatible with finger swipes on the display. Instead, use the buttons on the camera to access menus, and then tap the screen to select menu options.

2. Place your finger at the right-edge of the display and swipe to the left. This opens the menu screen.

3. Tap on the Setup option.

4. Swipe up to scroll downward to see options not visible on the screen.

5. Tap on the Setup menu option you want to adjust.

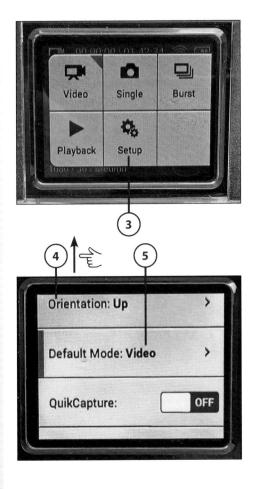

6. When the selected option's submenu appears, tap on the wanted setting.

7. Tap on the Back icon (displayed in the top-right corner of the screen) to return to the main Setup menu. Repeat steps 4 through 7 for each Setup option you want to adjust.

8. To exit out of the Setup menu, tap on the Exit X icon that displays in the top-right corner of the screen (not pictured).

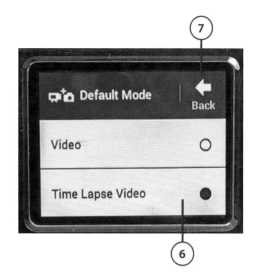

Access the Setup Menu Using the Smart Remote

As you know from previous chapters, the information displayed on the Smart Remote's Status Screen is identical to what's displayed on the camera's own Status Screen.

To use the Smart Remote to access the Setup menu, first establish a wireless connection between the camera and the Smart Remote. To do this, refer to Chapter 5.

While controlling the camera via the Smart Remote, press the Power/Mode button on the remote to toggle between the various shooting modes until the gear-shaped Setup icon displays. Then, follow the directions offered within the previous section (titled "Access the Setup Menu Directly from the Camera"); however, instead of pressing buttons on the camera, press the buttons on the Smart Remote.

Access the Setup Menu Using the GoPro App

To access and adjust the Setup menu using the GoPro App that's running on your smartphone or tablet and paired with your camera, follow these steps:

1. With the app open, tap the wrench-shaped Settings icon that displays in the lower-right corner.

Pairing Your Camera

Establish a connection between your GoPro camera and the GoPro App. (Refer to Chapter 15 for information on how to pair these devices and establish the wireless connection.)

2. From the Settings menu, scroll downward. The options listed under the Setup heading all correspond to the options available from the camera's Setup menu.

3. Tap on the Settings menu option you want to adjust to access its submenu.

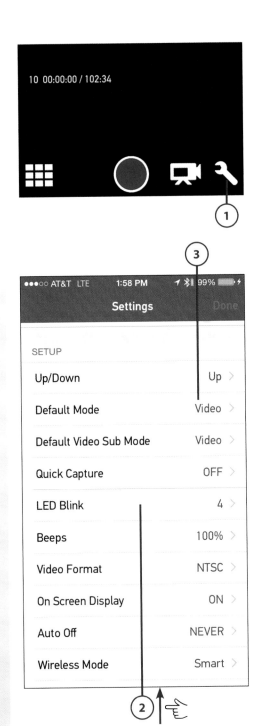

4. Tap on the new setting you want to use.

5. If you're not automatically returned to the Setup menu, tap the Settings option in the top-left corner of the screen. Repeat Steps 2 through 5 to adjust other Setup menu options, one at a time.

6. Tap the Done option in the top-right corner of the Setup menu screen to return to the viewfinder screen and save your changes.

Discover strategies that can help
you shoot more visually interesting
HD video with your GoPro camera.

In this chapter, you learn how to combine your knowledge of operating the GoPro camera with your own creativity, plus use strategies to shoot better videos in a wide range of situations. Topics include the following:

→ Choosing the best Resolution, FPS, and FOV for a particular shooting situation based on how you'll ultimately be showcasing your video

→ Using the light within your shooting area to its utmost advantage, and compensating in low-light situations

→ Deciding on the best mount to use to help you shoot video from the perfect angle based on the shooting situation and your needs

→ Making sure you have the right equipment on-hand to achieve your filming objectives

13

10 Strategies for Shooting Awesome HD Video

A lot of similarities exist between using your GoPro camera for shooting high-resolution digital images and using it to shoot HD video. Many of the strategies you read about in Chapter 9, "10 Strategies for Taking Professional-Quality Digital Photos," also apply when shooting video.

However, when shooting video, instead of pressing the shutter button and holding the camera steady for a fraction of a second to capture a single image, it's essential that the camera is steady for longer periods and that, when moving the camera as you film, you use only slow and steady movements.

In many video shooting situations, in addition to focusing on how to capture the best visuals, you also need to ensure you are able to record the best-quality audio. So, you need to think about a lot of issues to prepare for shooting HD video, which might present more opportunity for things to go wrong.

By following the 10 video shooting strategies offered in this chapter, combining them with the rest of the knowledge you acquire from this book, and tapping your own creativity, you can ultimately shoot high-quality HD video that you'll be proud to share with your audience (after it's edited, of course).

>>>Go Further

REMEMBER TWO WORDS

Regardless of what or where you shoot, or what filming strategies you use, always keep two words in mind when planning and executing your shots that require movement: *smooth* and *steady*.

Hold your camera as steady as possible, in your hands using a grip, or with a mount, and keep all movements as smooth as possible. Refrain from using quick or jerky camera movements, and take proactive steps to eliminate constant camera vibration. (Use a rubber Anti-Vibration Locking Plug with your mount, for example.)

Excessive shaking, jerky camera movements, or vibration causes the unwanted seasick effect, which makes your video difficult for your audience to watch without feeling motion sickness. This is one shooting mistake that you cannot easily compensate for or fix during the editing process.

Preplanning Is Essential

Before you start shooting, think about what you want to accomplish, and create a plan. If you can envision your edited video in your mind prior to shooting, you can take a more organized approach during the shooting process and be less prone to forget to shoot essential content. Write down your ideas, storyboard, or shot list.

Even though you want to preplan your shots as much as possible, always be open to spontaneous, creative inspiration that often strikes while you actually film.

As you plan your video, consider

- What will be the topic of your video? If you want to tell a story, outline the story. Create a storyboard or shot plan that lists the key scenes or shots that you don't want to miss shooting.

- How you want to showcase your main subjects.

- What shooting conditions you'll encounter, and what challenges you should be prepared for.

- The types of shots you want to capture, and from what shooting perspectives.

- Whether you want to capture the same shots repeatedly from different perspectives using the same camera, or if you can set up and control multiple cameras at once to capture the same action. Having multiple choices for each scene or shot makes editing your video easier, plus it makes the final video project more enjoyable to watch.

- How you'll record quality audio with the video, if necessary.

- The anticipated length of your final edited video.

You Don't Need to Shoot in Order

Using any video editing software or a mobile app, you can reorder the sequence of your content. Thus, if you're filming a video that's designed to tell a story, you don't have to shoot that story in order.

You need to create a storyboard or shot list, so you know exactly what you need to shoot and don't forget anything important.

Having the Right Equipment at Your Disposal

After you plan your video in advance, gather together all the camera equipment you need to actually record each shot or scene you envision. You already know the importance of bringing along extra fully charged batteries and microSD memory cards. This can't be overstated enough because running out of power or not having enough storage space are the two most common problems amateur GoPro videographers encounter.

Gather Your Equipment

Plan to bring along the right equipment by following these steps:

1. Having considered in advance the shooting conditions you'll encounter, make sure you bring along the appropriate camera housings.

2. Choose the best housing backdoor option for each shooting situation. Don't forget to consider the protection of the camera, as well as the audio quality you need to record.

1 **Standard Housing with Standard Backdoor**

2 **Touch Backdoor for use with the LCD Touch BacPac Display**

3. Select the best mounts so that you can position the camera at exactly the right height and angle to capture each shot that you want or need, and hold the camera firmly in place.

4. When deciding which mounts to use, think about how you'll actually control the camera—by pressing buttons on the camera, using the Smart Remote, or via the GoPro App and your mobile device. Make sure you bring along the Smart Remote with its various accessories or your smartphone (or tablet).

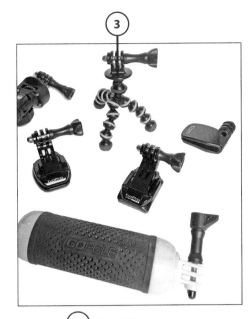

Smart Remote

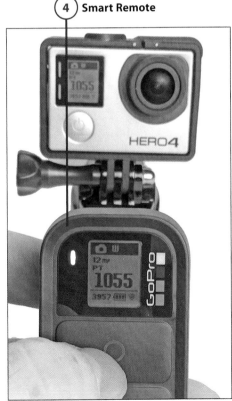

5. Don't forget the ancillary GoPro accessories that you also need, such as the LCD Touch BacPac, Anti-Fog Inserts, camera tether, lens filters, 3.5mm Mic Adapter, external microphone, Anti-Vibration Locking Plugs, extra adhesive strips for specific mounts, and/or microfiber lens cleaning cloth.

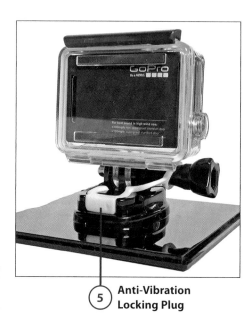

⑤ **Anti-Vibration Locking Plug**

Choosing the Best Shooting Resolution

Each GoPro camera model can shoot HD video at a variety of different resolutions. To recap, the resolution you select determines how many pixels are used to record each frame of your video. This impacts things such as the image clarity, vividness of color, and level of detail in your shots.

The resolution you should choose depends on

- The shooting situation

- How the content will be presented and shared later

- What you shoot (your subject matter) and the shooting perspective you use

- How you mount the camera

- How much content you want to appear within the frame

- The impact the fisheye effect will have on your shots, and whether this is acceptable

Choosing 1080p

For the vast majority of your shooting needs as an amateur videographer, who will ultimately watch your videos at home on your 1080p HD television set or computer monitor, plan to use the 1080p, 24FPS, Ultra Wide, or Medium FOV settings, or the 1080p Superview 24 FPS, Ultra Wide Resolution settings.

The higher the resolution you choose, the larger your video files will be, and the more memory card storage space you need. You must ensure that your computer ultimately can edit video shot at the camera's higher resolutions because this requires more processing power, RAM, hard drive space, and a higher-end graphics card. (Refer to the Minimum System Requirements for the video editing software you'll be using, and ideally, make sure your computer exceeds those requirements.)

The following list offers suggestions for choosing the optimal resolution on a GoPro Hero4 Black, based on what you want to achieve in a specific shooting situation:

- **WVGA**: The camera's lowest shooting resolution results in Standard resolution (non-HD) footage. The file size associated with this resolution is much smaller. At this Resolution, you can opt to shoot at up to 240 FPS, which is ideal for capturing ultra-slow motion footage.

- **720p:** This enables you to capture HD video but at a lower resolution. It's ideal when holding the camera in your hands and shooting content that will be shown using an ultra-slow motion effect.

- **720p Superview:** This offers the same benefits at 720p, but enables you to utilize the GoPro camera's ultra wide angle lens to capture more immersive first-person footage. Consider this resolution when you mount the camera onto yourself to shoot a high-action scene that you'll later showcase in slow motion, and watch on your TV in Wide viewing mode.

- **960p:** This is excellent for capturing first-person perspective shots when the camera is mounted on yourself and you plan to shoot a high-action sequence that you want to showcase in slow motion. Compared to 720p, however, 960p includes more detail within your shots because more pixels are recorded within each frame.

- **1080p:** The most commonly used shooting resolution (at 24 or 30 FPS) because it's compatible with all 1080p HD flat screen TVs, most computer monitors, as well as online-based video sharing services (such as YouTube). Because you record a lot of detail within each frame,

the camera becomes more susceptible to vibration and quick jerky movement, making it a good idea to use a tripod or mount.

- **1080p Superview:** This resolution option is ideal for shooting first-person perspective video that truly utilizes the GoPro camera's ultra wide angle lens. You'll get content that's more immersive and good quality. During playback, it's equivalent to using the Wide option, instead of the Standard option, when viewing a Hollywood blockbuster on your HDTV.

- **1440p:** Use this resolution to capture smooth, high-action footage. You can achieve the best results when your camera is mounted and held steady.

- **2.7K:** This resolution can generate cinema-quality results and is overkill for most consumer-oriented video projects. You get high-quality video but at a resolution most TVs and computer monitors can't display.

- **2.7K 4:3:** The added benefit to this resolution (compared to 2.7K) is that it offers a larger viewing area and captures more content within each frame. During playback, it's equivalent to using the Wide option, instead of Standard option, when viewing a Hollywood blockbuster on your HDTV.

- **2.7K Superview:** Again, this video option is more suited to professional videographers who want to capture cinematic quality content. 2.7K Superview captures a wider Field of View than the 2.7K option.

- **4K:** This is another of the GoPro camera's "professional" shooting modes. Use it when your camera will be filming from a fixed position and mounted on a tripod. You'll get incredibly high-resolution content, even in low-light situations. However, you must have a compatible TV or monitor to later view this content.

- **4K Superview**: Use this resolution option to capture the most detailed and immersive footage possible from a first-person perspective. During playback, it's equivalent to using the Wide option, instead of the Standard option, when viewing a Hollywood blockbuster on your HDTV.

When selecting a shooting resolution, you need to select a Frames Per Second rate, and in some cases, a Field of View setting.

Learn How to Adjust Your Camera's Settings

Refer to Chapter 10, "Shooting HD Video," for step-by-step directions that explain how to adjust your camera's shooting Resolution, Field of View, and Frames Per Second rate when the camera is in Video, Video+Photo, Time Lapse Video (if applicable), or Looping Video mode.

Selecting the Best Frames Per Second (FPS) Rate

The Frames Per Second (FPS) option enables you to determine how many individual frames of video your camera can record each second. Most TV shows and movies are shot at 24 frames per second when standard playback is used. However, if you plan on incorporating special effects into your video, or playing the content back at faster or slower speeds, you need to use a higher FPS rate.

For example, if you want to shoot a high-action scene but play it back in your edited video in slow motion, to achieve the best results and see the most detail during that slow motion sequence, shoot it at the highest FPS rate possible. Slower frame rates, however, are better suited for time lapse videography.

If you know the video you'll be shooting will be used for normal speed playback, use between 24 and 30 frames per second. When you increase the FPS rate, this increases the amount of storage space needed for your video files.

Deciding Which Field of View (FOV) Option to Use

By default, your GoPro camera is designed to shoot video using an Ultra Wide Field of View. This is ideal for shooting extremely immersive video from a first-person perspective. However, there will be shooting situations in which capturing so much content within your frame won't be advantageous.

To see the difference between the Narrow, Medium, and Wide Field of View option when shooting at 1080p, take a look at these examples from a video that was shot using the GoPro Hero4 Black.

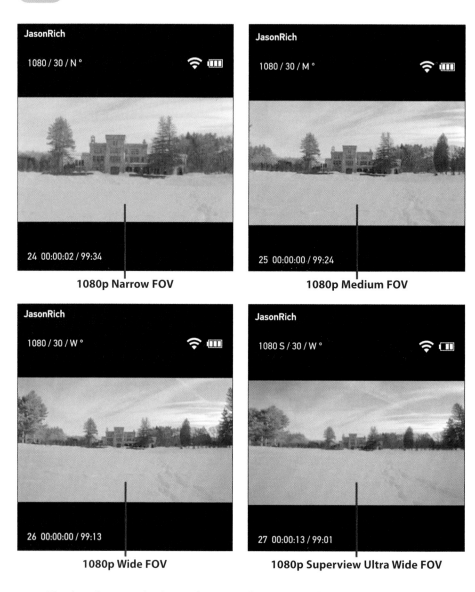

1080p Narrow FOV

1080p Medium FOV

1080p Wide FOV

1080p Superview Ultra Wide FOV

The fourth example shows the same shot captured using the 1080p Superview setting. For each of these examples, the position of the camera remained fixed, and no other settings were altered. Notice how much scenery is included on the left and right edges of the frame when looking at each FOV setting.

In some cases, the FOV you choose is a creative decision. However, you can also decrease the FOV if you want to diminish or eliminate the fisheye effect captured by your camera.

Restricted Views

Shooting with the GoPro Hero4 currently gives you the most options for Resolution, FPS, and FOV settings. However, when using the Hero3+ or Hero4 Black, only when shooting at 720p or 1080p can you choose between Narrow, Medium, or Ultra Wide Field of View.

The 2.7K Resolution option enables you to choose only between a Medium or Ultra Wide Field of View, whereas all the other available Resolution options require you to shoot HD video using an Ultra Wide Field of View exclusively.

Deciding the Best Way to Shoot Your Subject

Many amateur videographers tend to position their intended subject in the center of the frame and then shoot that subject from a head-on perspective. However, if you watch any television show or movie shot by a professional cinematographer you'll notice that this approach is seldom, if ever, used.

Instead, find an interesting shooting angle or perspective from which you capture your subject within each shot. This might mean shooting from above the subject (in a slight downward direction), from below your subject (in a slight upward direction), from the side of your subject, or from a slight diagonal.

There Are No Rules!

You do not always need to shoot from a head-on perspective, and your subject does not need to be positioned in the center of the frame.

When choosing how to mount the camera, you can decide the height the camera will shoot from, and in most cases, also adjust the shooting angle after the camera is mounted. Even a slight change in camera height or angle can dramatically alter how you capture a scene.

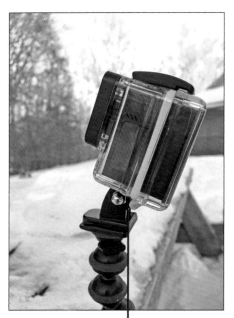

**Position the camera
facing slightly upward.**

**Position the camera facing
slightly downward.**

If you opt to hold the camera, you, of course, have unlimited options for how you position the camera and then move it around while shooting. However, for the best results when shooting HD video, do not hold the camera directly in your hands.

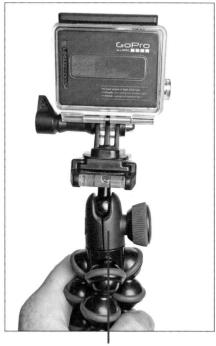

One option is to use an optional camera handle, such as GoPole's Bobber.

Use an adjustable, portable tripod, such as Joby's Action Tripod with GoPro Mount, as a handle.

Why Use a Handle or Grip?

Using an optional handle or grip, instead of holding the GoPro camera directly in your hands, helps to ensure you keep your hands and fingers out of the frame when shooting, plus you can hold the camera steadier. This results in smoother footage.

Depending on what you want to accomplish, and which mount you use, it might make sense to position the GoPro camera upside down when shooting. If you opt to do this, from the camera's Settings menu, turn on the Orientation Up/Down feature, so the camera automatically rotates your footage as it's recorded. This saves you a step in the editing process. The Hero4 camera, with the February 2015 Camera Software update installed, now automatically adjusts orientation.

>>>Go Further

SHOOT FROM DIFFERENT PERSPECTIVES

To edit your videos, you'll always have a much easier time if you start with plenty of content to choose from. To make your videos more interesting to watch, when possible, shoot the same shots or scenes multiple times but from different angles or perspectives. Then, during the editing process, mix and match which takes you use. This is particularly useful when shooting otherwise boring "talking head" or non-action-based shots, but this strategy can also make your intense action scenes look even more spectacular.

Using Lighting to Your Advantage

To recap an important concept from Chapter 8, "Shooting High-Resolution Photos," to frame your shots, always pay attention to the position of your primary light source. This is just as important when shooting video.

In general, as the videographer, you want to position your primary light source behind you, and try to ensure that it's shining evenly onto your subject. If light shines directly into the camera's lens, you could get unwanted glares, or the footage could easily become overexposed because the camera's lens takes in too much direct light. The exception to this is when you shoot a sunrise or sunset, or want to create a glare or silhouette effect within your shot for creative purposes.

When the primary light source isn't shining evenly onto your subject, this also often generates unwanted shadows. As the videographer, pay attention to shadows, and make sure they're not ruining your shots. Shadows can distract your audience and take away from the professional look for your production.

As you learned in the previous chapter, your GoPro camera can handle low-light situations well because of the Auto Low Light and Spot Meter options that you can turn on after selecting the Video, Video+Photo, or Looping Video shooting mode.

AUTO LOW LIGHT AND SPOT METER

Use your camera's Auto Low Light option when you shoot in a low-light area, outside in the evening or at night, or indoors when the lighting is dim. Turn on this feature also if you move between well-lit and low-light areas while filming. When turned on, the camera automatically compensates for the low or changing light by adjusting the FPS shooting rate to achieve a better exposure.

In situations in which the camera is positioned in a dark or low-light area, but your subject (that's in front of the camera) is constantly well lit, instead of using the Auto Low Light feature, turn on the Spot Meter feature. For example, use this feature if the camera is mounted inside your vehicle, but you shoot through a window, and your subject is outside and well lit.

Handling Camera Movement

Anytime you shoot video and the camera is in motion—whether you hold it in your hands using a handle or grip, or have the camera mounted to yourself or your equipment—you always want to ensure that you hold the camera as steady as possible. Avoid excessive shaking or quick jerky movements.

When panning with the camera or somehow holding it, always use slow and steady movements. When the camera is mounted in equipment, make sure it is held securely in place, so it can't move around or shake excessively while it's in motion.

Instead of holding the camera in your hands and moving, for more professional results and to capture smoother movement, consider using the optional Tiffen Steadicam Curve.

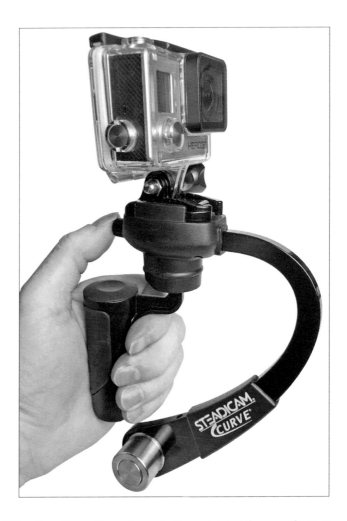

The Tiffen Steadicam Curve is perfectly weighted for specific GoPro camera models and automatically helps to compensate for sudden or jerky movements when the camera is in motion. This GoPro accessory is a scaled-down version of Steadicams used by professional cinematographers equipped with high-end cameras.

Because this accessory requires the videographer to be holding the Steadicam and the camera, it's best suited for when the videographer is shooting other subjects and not actually engaged in the activity. When the videographer is engaged in an activity, he should use a hands-free mount that allows the camera to be attached to his body or equipment.

More About the Steadicam Curve

Additional information about the Tiffen Steadicam Curve is included in Chapter 4, "Overview of GoPro Camera Mounts." You can also discover useful information about this accessory from the company's website (http://tiffen.com/steadicam/steadicam-curve).

To watch sample videos created using the Steadicam Curve and see firsthand the difference this accessory can make when trying to shoot smoother videos while holding the camera, visit www.tiffen.com/curve_videostest.html.

Tagging Your Best Shots as You Shoot

The GoPro Hero4 has a built-in Tag feature you can use while shooting video. As you actually film, if there's a shot or scene that you think is fantastic and you want to find it quickly during the editing process, simply press the Tag button on the side of the camera.

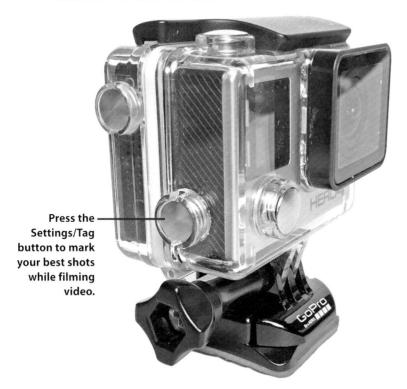

Press the Settings/Tag button to mark your best shots while filming video.

When editing your video using the GoPro Studio software, you can see the tags within your raw footage and find them easily; although, they won't appear in your final edited video.

Shooting Plenty of Raw Footage

As the videographer, you always want to shoot more raw video footage than you actually plan to use or could possibly need. During the video editing process, you trim down scenes or shots, plus cut out content. Whenever possible, you also want to have multiple options (or takes) for each key shot or scene to choose from.

When time and conditions permit, try to shoot the same shots or scenes from different angles or perspectives, so you have multiple takes. During the filming process, you should shoot two, three, or even five times the amount of content you'll actually use. This way, you can later choose only the best shots to showcase in your edited video project, and you always have options while editing.

Always Be Prepared!

Knowing you'll be shooting a lot of extra content, be prepared. Have extra microSD memory cards and fully charged camera batteries on hand.

>>>Go Further

SHOOT YOUR GOPRO VIDEOS IN 3-D

When you use two GoPro cameras together, you can shoot 3-D video and then edit that 3-D content using the GoPro Studio software. In addition to simultaneously using two GoPro cameras compatible with this feature, you need the optional GoPro Dual Hero System ($199.99), which is available from GoPro's website. It includes a proprietary dual camera housing.

To control both cameras simultaneously, use the 3D Sync Cable (which comes with the Dual Hero System). Both cameras must use identical camera settings (Resolution, FPS, FOV, and Spot Meter) when filming 3-D effects, and you need to edit the raw video using the GoPro Studio software on your PC or Mac.

You can ultimately view the edited 3-D content on any standard HD television set (using red/blue glasses), a 3-D HD television set (with or without glasses, depending on the television), your computer monitor (using red/blue glasses), or online (using red/blue glasses).

For more information on shooting in 3-D, check out GoPro's free video tutorial for how to shoot 3-D at http://gopro.com/support/articles/how-to-start-recording-in-the-3d-hero-system.

Learn to troubleshoot camera-related problems and shooting mistakes, and where to go for help when things go wrong.

In this chapter, you discover how to overcome common problems and mistakes when shooting photos or video. Topics include the following:

→ How to troubleshoot common camera-related problems
→ Overcome common shooting mistakes
→ Where to turn for additional help and inspiration

Troubleshooting Camera-Related Problems and Overcoming Common Shooting Mistakes

Before shooting, always try to invest a few minutes to preplan your shots and determine what you want to accomplish. With this insight, you can equip your camera with the appropriate housing, mount, and accessories. This also helps you to frame your shots; deciding what, where, and when to shoot; and what shooting approach to take.

Even if you set up all your equipment correctly, have everything you need on-hand, understand exactly how to operate your camera, and have goals in mind for what you want to accomplish, occasionally

things may go wrong either with the camera or with related camera equipment (such as the battery, memory card, or another accessory).

Meanwhile, how your photos or videos ultimately turn out may not be as you envisioned because of an error on your part. You might have chosen the wrong camera settings or adopted the wrong shooting strategy for a particular situation.

This chapter can help you become familiar with the most common technical problems that can occur with your camera, and teach you how to avoid or fix them. In addition, you can become aware of common shooting mistakes that could potentially ruin your photos or videos, and prevent you from achieving the results you want.

Troubleshooting Camera-Related Problems

If something goes wrong with the GoPro camera or one of your mounts, houses, or accessories, this section should help you fix the issue.

The Camera Won't Turn On

The most common cause of this issue is either that you forgot to put a fully charged battery into the camera, the battery that's in the camera has died, or the battery no longer holds a charge. If the camera goes unused for an extended period, for example, the battery will drain, especially if you left the camera's Wireless mode turned on.

The easiest fix (which is the most obvious one) is to plug in the camera (with the dead battery) to an external power source using the supplied USB cable and allow it to charge, or insert a different fully charged battery into the camera.

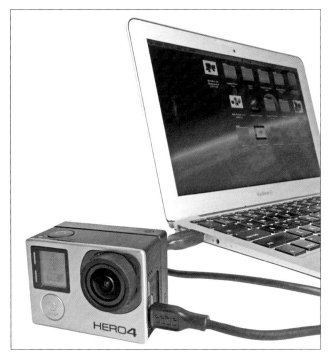

**Plug the camera into an external power source,
such as the USB port of your computer.**

If the first time you attempt to insert a new GoPro or GoPro-compatible battery into a charger it refuses to charge after several hours, chances are the battery is defective and should be returned.

However, first make sure the battery is inserted into the charger correctly. Most chargers have a red LED light that indicates a battery has been inserted correctly and is charging. This light turns green when the battery is fully charged.

When you insert the battery into the charger, if no light comes on, this could mean there's dirt or dust on the battery or charger's connectors. Try blowing on the connectors, or use a dry cloth (not your finger) to gently remove dirt. Then reinsert the battery into the charger.

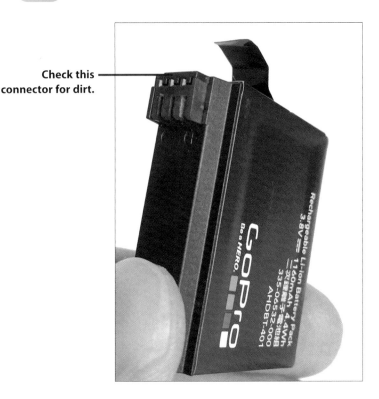

Check this
connector for dirt.

End of Life

Over time, like any rechargeable battery, its capability to retain a full charge will diminish, and its life between charges will shorten. When you notice this happening and the battery's life becomes short, you must replace the battery with a new one.

The Camera Is On, but Unresponsive

If the camera is turned on, but the camera is unresponsive, chances are it simply needs to be reset. This does not erase any content from the memory card, nor does it change any of the camera's settings.

To reset the camera, press and hold down the Power/Mode button for approximately 8 seconds. After this time, the camera will turn itself off. Release the Power/Mode button, and then press it again for approximately 2 seconds to turn the camera back on.

If this problem persists, you should attempt to reset the camera to its factory default settings.

Reset the Camera to Factory Default Settings

If you need to reset the camera to its factory default settings, follow these steps when using the Hero4 camera:

1. Turn on the camera and press the Power/Mode button repeatedly until the Setup (gear-shaped) icon displays on the Status Screen.

2. Press the Shutter/Select button to access the Setup menu.

3. Repeatedly press the Power/Mode button to scroll through the Setup menu options on the Status Screen until the Reset Cam (Reset Camera) option is highlighted.

4. Press the Shutter/Select button to select the highlighted Reset Camera option.

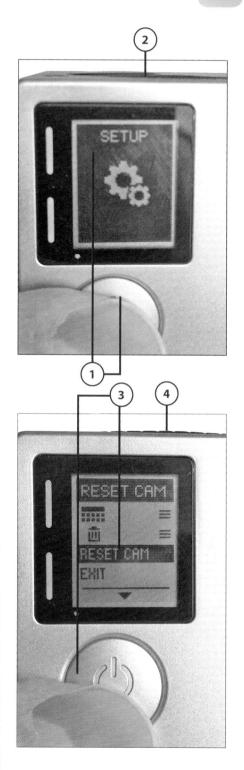

5. When the Cam Reset option appears on the Status Screen, press the Power/Mode button once to highlight and select the Reset option. To exit out of this option without resetting the camera, select the Cancel option.

6. Press the Shutter/Select button to activate the Reset command.

7. When the camera is turned back on, all its user adjustable settings return to their factory default settings.

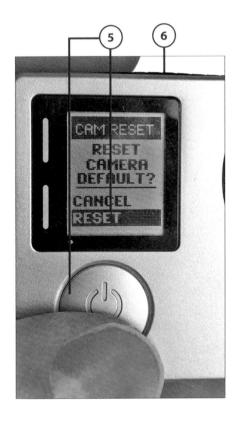

The Camera Won't Connect with the GoPro App or Smart Remote

After you pair the GoPro camera with the Smart Remote (refer to Chapter 5, "Must Have GoPro Camera Accessories") or the GoPro App (refer to Chapter 15, "Using the GoPro Mobile App"), each time you want to establish a connection between your camera and the Smart Remote or GoPro App (running on your smartphone or tablet), the camera's Wireless mode must first be turned on.

Then, if you use the GoPro App, be sure that you access the smartphone or tablet's Wi-Fi menu (from within Settings on an iPhone or iPad), and select the camera's wireless network. (The network uses the same name that you gave the camera when initially setting up the Wireless feature.) You may need to supply the camera's password to access this network with your mobile device.

After launching the GoPro App (or turning on the Smart Remote), a connection should automatically be established. If this does not happen as it should, try turning off the camera and the Smart Remote, and turning them back on. If you use the GoPro App, shut down the app, turn off and then back on the Wi-Fi feature on your mobile device, and then relaunch the app.

Wireless Mode Enabled

For your camera to establish a wireless connection between the Smart Remote or the GoPro App, its Wireless mode must be turned on. This is indicated by the camera's blue Status Light flashing, even if the camera is turned off.

After you initially set up the Wireless feature, to turn on/off the Wireless mode when using a Hero4, press and hold the Settings/Tag button on the side of the camera for approximately 2 seconds. (On other GoPro camera models, press and hold the Wi-Fi button on the side of the camera for approximately 2 seconds.)

Clear Up Lens Fog

When shooting in a hot and humid climate and in and around water, it's common for the camera's lens to fog up when it's fully encased within the Standard or Dive Housing.

To eliminate this fogging, purchase GoPro's optional Anti-Fog Inserts, and insert two of them into the camera's housing.

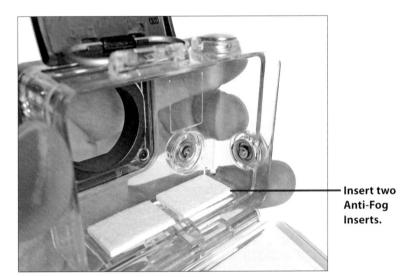

Insert two Anti-Fog Inserts.

Make Sure Your Camera Is Fully Encased in a Housing

Remember, the GoPro camera is not waterproof. The camera becomes waterproof only when it's fully encased within a properly sealed GoPro Standard or Dive Housing.

Before using the camera in or around water, make sure the camera's housing is properly sealed and that the white rubber seal that surrounds the camera's backdoor is clean and fully intact. Otherwise, the seal may not hold and the housing could leak.

Reset Your Camera Name and Password

During the initial Wireless setup process, you're asked to name your camera and create a password for it. This camera name is also used when the camera later creates a wireless network so that it can connect (wirelessly) with the Smart Remote or the GoPro App that runs on your smartphone or tablet.

If you forget the camera's name and password, here's how to reset it:

1. Turn on the camera.

2. Press and hold down the Settings/ Tag button (on the side of the camera). At the same time, press and release the Power/Mode button. On the Status Screen, the Wi-Fi Reset menu appears.

3. Press the Power/Mode button once to highlight the Reset option.

4. Press the Shutter/Select button once to select this option and reset the camera's Wireless feature.

Re-Pairing Your Camera

After you reset the Wi-Fi settings, you need to again go through the pairing process between the camera and the Smart Remote or the camera and the GoPro App. To do this, follow the steps outlined within Chapter 5 or 15, respectively. During this process, you need to create a new camera name and password.

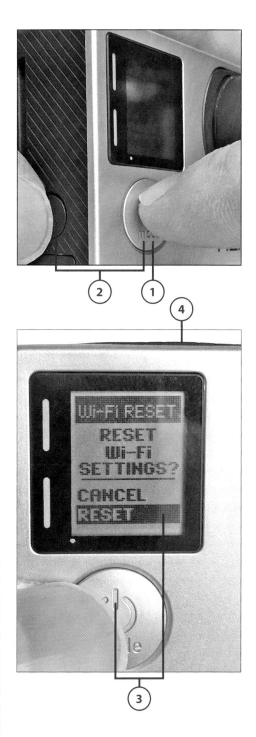

The Status Screen Says No SD, Full, or SD ERR

The camera can generate three memory card-related error messages should
something go wrong with the memory card.

- The NO SD message means that there is no memory card currently
 inserted within the camera. You need to insert one prior to shooting
 photos or video.

- The Full error message means that the card has reached its storage
 capacity. At this point, you either need to transfer content from the
 memory card to your mobile device or computer and then delete that
 content from the memory card; delete memory card content directly
 from the camera, without first transferring it; or replace the memory card
 within the camera with one that has storage space available.

Transfer Content Before Deleting It

You must transfer any content that you want to keep from the memory card to
your computer or mobile device before you delete it from the memory card or
reformat the memory card. Otherwise, this content is lost forever.

- The worst of the memory card-related error messages is SD ERR. This
 means that content stored within the memory card has been corrupted;
 or for some reason, the memory card has been damaged and is no
 longer working.

>>>Go Further

WHAT TO DO WHEN THE SD ERR MESSAGE APPEARS

Should the SD ERR message appear on the camera's Status Screen (which is a
rare occurrence), immediately turn off the camera and remove the memory card.
You do not want to further corrupt any data already stored on the card.

At this point, try inserting the memory card into an optional memory card reader
that's connected to your computer, and see if the content stored within the card
can be accessed and transferred to the computer.

If the microSD memory card is not accessible by your computer, try using specialized data recovery software to access the content. You can purchase and download memory card data recovery software online.

For the PC or Mac, Card Recovery Pro ($49.97, www.cardrecoverypro.com), Card Recovery ($39.95, www.cardrecovery.com) and Card Data Recovery ($39.95, www.card-data-recovery.com) are three memory card data recovery applications that are relatively easy to use.

An alternative is to hire a data recovery service, but this could cost several hundred dollars. However, if the content stored on the card is not important, and you don't mind losing it, try reformatting the memory card within your camera. (See the section "Format a microSD Memory Card Using a Hero4" in Chapter 6 for formatting information.) Take a few test shots and see if this fixes the problem. If an error continues to appear, replace the memory card with a new one.

The File Repair Icon Appears on the Status Screen

During the filming process, if the photo or video doesn't properly get saved to the memory card, the File Repair icon (which looks like a band aid) appears on the Status Screen. When this happens, simply press the Power/Mode or Shutter/Select button, and the camera should automatically fix the problem and repair the corrupted file, as needed.

This problem rarely happens, but when it does, it typically fixes itself. Only on rare occasions might you lose the last photo or video you shot as a result of a corrupted file.

The Camera Has Overheated and the Temperature Icon Displays on the Status Screen

When the Temperature icon (which looks like a thermometer) appears on the Status Screen, this indicates that the camera has overheated. All your content is saved to the camera's memory card, but the camera shuts down automatically.

You then must allow the camera to cool down before you resume normal operation.

Water Spots Have Formed on the Housing

If you allow water drops to dry on the camera's housing, these can ruin your images if they form on the portion of the housing that surrounds the lens. Especially if you've been using the camera in or around salt water, you must rinse off the housing using fresh water as soon as possible, and then gently dry off the housing using a micro fiber cleaning cloth.

If water spots form on the housing, you can wipe these clean using the same micro fiber cleaning cloth. To prevent water spots from forming in the future, consider applying a small amount of Rain-X to the outside of the camera housing, especially around the area that covers the lens. (Do not use Rain-X or any other solution on the actual camera or lens.)

Video Playback Is Choppy on the Computer

When playing video shot with your GoPro camera on your computer screen, if the video is choppy, this is probably an issue with your computer, not with the video file. Make sure the video player you use supports H.264 codec video files and that the computer meets or exceeds GoPro's minimum hardware specifications. This becomes more of an issue when attempting to play back video recorded at high resolutions and frame rates.

To review the minimum hardware requirements for your computer to playback 4K resolution video, for example, visit GoPro's website (http://gopro.com/support/articles/minimum-system-requirements-for-4k-editing-and-playback).

If you have trouble playing back video shot at other resolutions, visit this page of GoPro's website (http://gopro.com/support/articles/how-to-correct-choppy-broken-up-playback) to discover minimum system requirements for your PC or Mac.

Video Doesn't Play Back Properly Using the GoPro App

Due to the resolution of your smartphone or tablet's screen, it cannot display extremely high resolution photos or video. For example, if you set the camera to record at 4K or 4K Superview resolution, the GoPro App cannot serve as a viewfinder, nor can you play back the video on your mobile device's screen.

In these situations, the video file is fine. You just need to view it on a compatible computer monitor or HD television set. Visit the following web page of GoPro's website (http://gopro.com/support/articles/gopro-app-supported-resolutions-for-playback-and-copy) to learn what file formats and resolutions are supported by the GoPro App and which ones are not.

The Camera Is Off, but the Blue Status Lights Are Flashing

A flashing blue Status Light on the camera means that the Wireless feature is turned on and active. This light continues to flash even when the camera is turned off. When Wireless mode is active, you can remotely turn on or off the camera via the Smart Remote or GoPro App.

To turn off Wireless mode, press and hold the Settings/Tag button (Hero4) or Wi-Fi button (other GoPro camera models) for approximately two seconds. When the blue Status Light stops flashing, the Wireless mode is turned off.

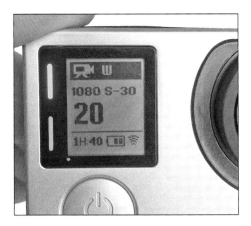

The Menus on Your Camera Are Different from This Book

Throughout this book photos are showcased that depict the various Hero3+ or Hero4 camera menus and screens. If, as you follow the steps described within this book, some menu screens look slightly different, this is because you're either using a different GoPro camera model that does not offer the feature or function described, or the version of the Camera Software running on your camera is different from the version used in the book's examples.

Updating the Camera Software

To ensure that your camera operates correctly, and it offers you all its available features and functions while shooting, be sure you have the most current version of the camera software (its operating system) installed.

Refer to the "Updating Your Camera's Operating System" section of Chapter 2, "Getting Started with Your GoPro Camera," for more directions on how to update the camera software.

The Computer Doesn't Recognize Your Connected Camera

The most common reasons why your camera is not recognized by your computer when you connect the two devices via the supplied USB cable include

- The USB cable is not properly connected to the mini-USB port of the camera and the USB port of the computer. Try removing and reconnecting the cable.

- The cable or its connectors have somehow been damaged, resulting in a faulty cable. Try using a different USB cable.

- The camera needs to be powered on and its Wireless feature needs to be turned on as well for the camera to be recognized by the computer. (The computer also needs to be turned on.)

- There is a compatibility or technical problem with the microSD memory card installed within the camera. Refer to the section "What to Do When the SD ERR Message Appears" earlier in this chapter.

The Camera Is Physically Damaged

When it's properly encased within an appropriate housing, the GoPro camera is well protected against water, dirt, dust, physical abuse, and extreme temperatures. However, if you decide to use the camera without encasing it within a proper housing, or you've been using the Frame Housing (which offers minimal protection), the camera can easily be damaged if it's dropped, exposed to water, or exposed to extreme temperatures. The camera's lens can also easily be scratched if not properly protected.

Should you happen to damage your camera as a result of misuse, this is not covered by GoPro's one-year warranty. Thus, you need to pay to repair any damage.

Before sending your camera to GoPro for repair, you must first contact the company's Customer Service Department. Within the United States, call (888) 600-4659, or visit https://gopro.com/contact-us.

Be sure to request a Return Merchandise Authorization (RMA) number. Then, fully complete the RMA Form that the GoPro Customer Service agent provides, and include it within the package when sending in your camera for repair. Also, write the supplied RMA number on the outside of the shipping package.

After an RMA number has been issued, if you're within the United States, the camera can be sent to: GoPro Warranty Service, 2111 Eastridge Avenue, Riverside, CA 92507. You can find additional information online at http://gopro.com/support/articles/warranty-information.

CONSIDER INSURANCE FOR YOUR CAMERA

Several third-party companies offer insurance for digital cameras (including the GoPro cameras) that covers accidental damage, as well as loss or theft. Be sure to determine what the coverage includes before paying for it. Worth Ave. Group (www.worthavegroup.com/product/camera-insurance) and Square Trade (www.squaretrade.com) are among the independent companies that offer optional insurance for your camera.

Best Buy offers Geek Squad Protection for consumer electronics products. Learn more at www.bestbuy.com or by visiting any Best Buy location. From Amazon (www.amazon.com), you can purchase Canopy Protection for cameras that lasts for up to 3 years. Within Amazon's Search field, enter the phase **Camera Coverage** to learn more.

Overcoming Common Shooting Problems

Beyond what could go wrong technically with your GoPro camera, you can make a variety of mistakes as a photographer or videographer that result in poor-quality photos or videos. This section can help you avoid these common mistakes.

Your Photos or Videos Are Overexposed

A variety of reasons could cause images or video to be overexposed, including:

- The camera's settings are incorrect. For example, you have Auto Low Light, Spot Meter, or Night mode turned on when you shoot in daylight or a brightly lit area.

- The Protune feature is turned on, and one or more Protune options are incorrectly set based on your shooting situation and the available light.

- Your primary light source is positioned in front of the camera, not behind the camera. Thus, the camera's lens is exposed to too much direct light. Try changing your shooting angle and positioning your primary light source (such as the sun), behind you, the photographer/videographer, and the camera.

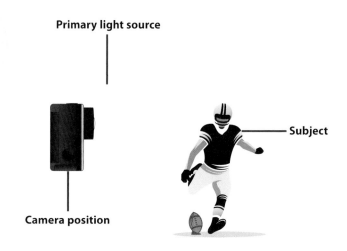

>>>*Go Further*

WHEN THE PRIMARY LIGHT SOURCE SHOULD BE IN FRONT

In a few instances it's beneficial to position your shooting angle or perspective so that your primary light source is in front of the camera, for example, when shooting a sunrise or sunset.

Positioning your primary light source in front of the camera can create glares or a silhouette effect, which can be utilized within photos or video for creative purposes—for example, if you want to showcase a glare from the sun peeking through a tree's limbs.

Video Playback Is Too Shaky

Even though the GoPro cameras are designed to shoot high-action activities, if while shooting the camera is shaken too much or is mounted on something that's continuously vibrating, this excessive movement can make your video footage difficult to watch.

Especially if you shoot in low-light areas, excessive camera shaking or movement can result in blurry images or video. The easiest fix is to securely attach the camera (within a housing) to a mount, and make sure the mount is attached to something stable.

When attaching the camera to yourself, the Head Strap/QuickClip mount enables you to mount the camera directly on your head or on a cap. However, your head will probably move around a lot more than your torso when you're engaged in an activity. This can result in additional jerky or quick motions, in addition to the motion your whole body is experiencing as a result of the activity you engage in.

Instead of using the Head Strap/Quick Clip mount in these situations, to cut down on excessive shaking or motion, consider mounting the camera on your chest, using the Chesty Mount or the captureP.O.V. mount from Peak Design. (Refer to Chapter 4, "Overview of GoPro Camera Mounts," for more information about camera mount options.)

Whenever possible, mount your camera on something stable that does not offer a continuous shake or vibration. Instead of holding the camera in your hands while filming, consider mounting the camera on a handheld grip or use Tiffen's Steadicam Curve (www.tiffen.com/steadicamcurve) to help compensate for excessive camera movement and shaking.

The Camera Mount You're Using Won't Maintain Its Position

The purpose of using a mount with your GoPro camera and a housing is to allow you to attach the camera to something at a specific angle or position. If due to excessive movement or activity, the mount isn't keeping the camera locked at the exact angle you want, try tightening the mount using GoPro's optional accessory, called The Tool Thumb Screw Wrench + Bottle Opener. It's available from GoPro's website ($4.99) and is listed under Accessories.

Use this tool to tighten the Thumb Screw onto the Quick Release Buckle that's associated with your selected mount so that the Thumb Screw is extra tight. This prevents unwanted vertical movement of the mounted camera.

Keep in mind that some mounts come with different size Thumb Screws—so make sure you're using the one that was supplied with the mount, and you don't mix and match them with various mounts. If a Thumb Screw is slightly too short, for example, it won't hold the camera tightly in place.

Low Light Photos or Video Are Blurry or Under Exposed

As with any camera, when you shoot in low light, any movement of the camera could result in a blurry image. There are several ways to compensate for this using a GoPro camera.

- Instead of holding the camera, mount it onto a tripod or something stable.

- Add more light to your shooting area so that the light shines evenly onto your intended subject.

- When shooting photos turn on the Night shooting mode.

- When shooting video turn on the Auto Low Light feature.

- Consider turning on the Protune feature and manually adjusting the ISO Limit and EV Comp (Exposure Compensation) settings.

Photos or Videos Have Excessive Fishesye

The fisheye effect is a byproduct of your camera's ultra wide angle lens. You can minimize or get ride of this effect while shooting in several ways, as well as during the photo or video editing process.

While shooting, instead of choosing the Wide Field of View (or Superview), switch to a Medium or Narrow Field of View. When shooting video, using a

Narrow FOV results in the least amount of fisheye. You can also try moving farther away from your subject.

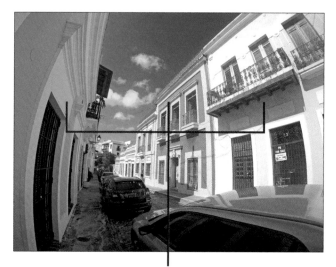

Example of fisheye effect
(Notice the curved buildings)

Narrow FOV Is Offered Only When Shooting Video

When shooting photos, you can typically choose between Medium or Wide FOV based on which resolution the camera is set at. When shooting video, Narrow, Medium, or Wide FOV options are available with some resolution options.

During the photo editing process, use an optional app, such as GoFix or Lens Corrector for GoPro, on your mobile device, or use a fisheye effect removal tool built in to some photo editing software applications for PCs and Macs to reduce or remove this effect.

The Colors in Photos or Video Aren't as Vibrant as They Should Be

This is typically a result of too much light shining directly into the camera's lens. Again, reposition the camera so that your primary light source is behind the camera and shines evenly onto your subject.

Dull colors can also be caused by incorrect camera settings. For example, if your camera is positioned in a dimly lit area, but you shoot something in the

distance that's well lit, be sure to turn on the Spot Meter feature. This can make the colors within the well-lit area appear vibrant.

You can also turn on the Protune feature and then adjust the White Balance and Sharpness options based on your shooting situation.

The Memory Card Fills Up Too Fast When I'm Shooting

How much storage space each digital photo or your HD video takes up is directly related to your shooting resolution. In addition, when shooting video, your Frames Per Second Rate also impacts the file size associated with video, as do any Protune features you manually adjust.

The easiest way to reduce file sizes is to reduce your shooting resolution. This does, however, impact the quality of your photos or videos. Depending on how you plan to showcase your content, the difference between shooting video at 1080p and 2.7K, for example, may not be significant to your project.

Recover Deleted Photos or Video

When you delete a file from your camera's memory card or prior to re-formatting the memory card and erasing its content, you'll always be prompted to confirm your decision. After you confirm that decision and the content is deleted from the memory card, however, there's no "undo" command.

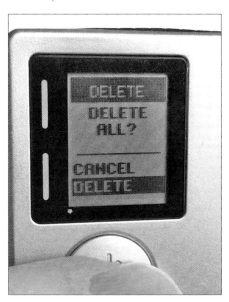

Before you save anything else to the memory card or somehow alter its contents, if you need to recover accidentally deleted content, immediately turn off the camera and remove the memory card. Then, insert the memory card into an optional memory card reader that's attached to your computer, and try running data recovery software to retrieve the accidentally deleted content.

Where to Find Data Recovery Software

Refer to the section earlier in this chapter, "What to Do When the SD ERR Message Appears," for a few data recovery software options for PCs and Macs.

Prior to deleting any content from your camera's memory card, always first transfer the content to your mobile device or computer. Then, when you know a copy of the content is saved, it's safe to delete it from the memory card.

The Memory Card Is Full, but I Want to Keep Shooting

This is where preparation is essential. Always carry with you an extra memory card for your camera. Then, when you fill up one card, you can switch it out and immediately continue shooting without having to delete content while on-the-go.

Alternatively, you can transfer content from the camera's memory card to your mobile device or notebook computer, and then delete the memory card while you're out shooting. As an absolute last resort, you can delete files from the camera's memory card without first transferring them elsewhere, but that content will be lost forever.

Improve Poor Audio Quality

The microphone that's built in to your GoPro camera is sensitive and can pick up and record good-quality audio that's in the vicinity while you shoot video. However, if the camera is fully encased within the Standard or Dive Housing (with a Standard Backdoor), the audio will be muffled by the housing.

Depending on your shooting situation, consider using a Skeleton Backdoor with the Standard Housing, or using the Skeleton Housing or Frame Housing.

The Skeleton Backdoor or Skeleton Housing enables more sound to reach the camera's built-in microphone because the camera is no longer fully encased and sealed within a housing. Using the Frame Housing allows the microphone to be completely exposed, allowing you to capture even better quality sound.

Refer to Chapter 11, "Capturing Sound and Using Artificial Light While Shooting Video," for tips on how to achieve higher-quality sound based on the housing you use and whether you connect an external microphone to the camera.

Avoid Recording Sounds from Your Hand Movements

When using the Frame Housing or no housing, if you hold the camera in your hands while shooting video, sounds associated with your fingers and palms touching the camera and rubbing against it will be recorded. Consider using the Frame Housing and attaching it to a handheld grip so that your hands remain clear of the camera.

Wind Noise Is Ruining the Audio

If your camera will be in motion while you film video, using the Frame or Skeleton Housing allows too much air to directly hit the microphone, which can result in unwanted wind noise. To compensate for this, use a Standard Housing with a Skeleton Backdoor.

Another option is to use an external microphone designed for the type of audio recording that you'll be doing, and then attach a foam windscreen to the microphone.

Seeking Out Creative Inspiration

When taking pictures or shooting video with your GoPro camera, the housing, mount, and accessories you use directly impact the type of shots you can capture. Depending on what activity you shoot, chances are many other GoPro users have encountered the same challenges and obstacles you're about to face.

One way to easily determine the best GoPro equipment to use for a particular shooting situation is to visit the GoPro website, click the Products option at the top of the page, and then select the Shop by Activity option.

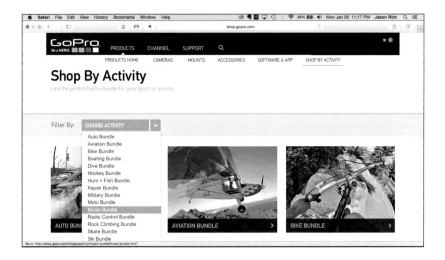

From the Shop by Activity web page, click the activity you want to shoot, and then use the recommended equipment. There are also thousands of free tutorial videos available on YouTube that demonstrate how to use the GoPro camera in specific shooting situations.

In addition, seeing what other GoPro users have accomplished, by looking at their photos and videos, can provide creative inspiration and technical insight.

The GoPro Channel, available from the GoPro website, as well as the GoPro App, enables you to watch videos produced and shared by the global GoPro community. You also can find additional videos on YouTube and on the various GoPro pages on Facebook.

If you want to capture awesome video of yourself snowboarding, biking, skiing, surfing, or off-roading, watch similar videos produced by others, and pay attention to their shooting approach. This can help you determine what camera angles and perspectives work best. You can then apply this knowledge and creative insight while you film with your own camera.

WHERE TO FIND MORE CREATIVE INSPIRATION

Beyond the GoPro Channel on the GoPro website, when visiting YouTube or any Internet search engine, enter a search phrase such as **GoPro Skydiving Video**, or **GoPro Scuba Diving Video** to watch videos shot by others engaged in the activity you want to shoot.

Also while visiting YouTube, if you want to watch GoPro-related tutorial videos that show you how to do something specific with your camera, use a search phrase such as **GoPro underwater photography**. The keyword **GoPro** alone will reveal thousands of free tutorial videos, as well as product review videos, and videos shot using a GoPro camera that you can watch for free.

Available on Que Publishing's YouTube channel (www.youtube.com/user/QuePublishing), you can also discover a handful of GoPro-related tutorial videos.

On Facebook, within the Search field, enter the keyword **GoPro** to access the official GoPro Facebook page (www.facebook.com/gopro), as well as discover Facebook pages created by individual GoPro users, user groups, and third-party companies that offer GoPro-related products.

The GoPro App runs on an iPhone (shown) or iPad, as well as an Android or Windows Mobile smartphone or tablet.

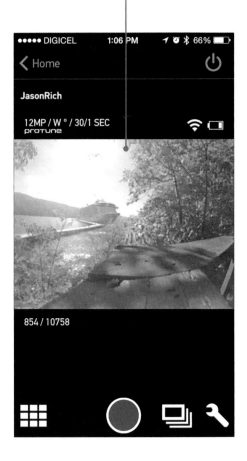

In this chapter, you discover how to use the GoPro App with your camera. Topics include the following:

→ How to pair your camera with a mobile device that runs the GoPro mobile app

→ Remotely control your camera via the GoPro mobile app instead of using the Smart Remote

→ Wirelessly transfer photos or video from your camera's memory card to your mobile device to view, edit, and share that content

Using the GoPro Mobile App

Thanks to the built-in wireless capabilities of your GoPro camera (most models), as well as the Wi-Fi and Bluetooth functionality built into your smartphone or tablet, you can run the optional (and free) GoPro mobile app from your mobile device, which enables you to accomplish a variety of tasks.

- Remotely controlling the camera from your mobile device. You can adjust the camera's Settings and quickly switch between shooting modes without physically touching your camera.

- Using the screen on your mobile device as your camera's real-time and full-color viewfinder. Thus, whatever you see within this viewfinder is what ultimately appears in your photos and video.

- Transferring photos or video from the memory card within your camera wirelessly to your mobile device, where you can view, edit, and then share that content without using a computer or any cables.

Supported Devices

The GoPro mobile app is designed to work with the Apple iPhone or iPad and is available for free from the App Store. An Android version of the GoPro App is available from Google Play, and the Windows Mobile edition of the app is available from the Windows Store. These three versions of the app function similarly.

Getting Started with the App

After you install the app onto your smartphone or tablet, to establish a wireless connection between your mobile device and the camera, you need to initially pair the two devices.

This pairing process needs to be done only once. After that, anytime you turn on the Wireless mode of your GoPro camera, launch the GoPro mobile app on your mobile device, and then connect the mobile device to the camera's Wi-Fi/Bluetooth signal, you can use the app to communicate directly with your camera.

Your mobile device determines how far away you can be from the GoPro camera to remotely control it. This varies based on the smartphone or tablet model you use.

The basic GoPro Hero camera does not have a Wireless mode. Therefore, it is not compatible with the GoPro App. The Hero3 and Hero3+ can connect to your mobile device via Wi-Fi, whereas the Hero4 can establish a connection using Wi-Fi and Bluetooth.

>>>Go Further

THE GOPRO MOBILE APP IS AN ALTERNATIVE TO THE SMART REMOTE

The GoPro mobile app offers a cost-effective and convenient alternative to using the Smart Remote to remotely control your GoPro camera. However, although the mobile app offers a lot of extra functionality when compared to the Smart Remote, the signal radius for establishing a wireless connection between your camera and mobile device (via the GoPro mobile app) is much shorter than the 600-foot signal radius offered by the Smart Remote.

On the plus side, the GoPro App also serves as a full-color, real-time viewfinder (which the Smart Remote does not) and then enables you to view and share your photos or video, which are other tasks the Smart Remote can't handle.

Although you can have both the Smart Remote and the GoPro mobile app set up and paired with your camera, only one of these two options can be used at any given time. Also, the GoPro mobile app (that runs on your mobile device) can be linked or paired only with one GoPro camera at a time, whereas the Smart Remote can be paired with multiple cameras.

Install the GoPro App

To initially find and install the official GoPro App onto your iPhone or iPad (shown), follow these steps:

1. From the Home screen, launch the App Store app. (Make sure you're connected to the Internet.)

2. Within the App Store app's Search field, enter the search word GoPro, and tap the Search key.

3. From the Search Results, select the GoPro App option by tapping the Get button.

4. When the Install button appears, tap it.

5. If prompted to do so, enter your Apple ID password, or use the Touch ID sensor that's built in to your mobile device to confirm your account information and identity.

6. Tap OK. The GoPro App automatically downloads and installs onto your iPhone or iPad.

7. When the process is done, tap the Open button to launch the app.

Launch the App from the Home Screen

Subsequently, after the app is installed, you can launch it from the Home screen by tapping the GoPro App icon that appears there.

Pair the GoPro App with Your GoPro Hero4

The first time you use the GoPro App that runs on your mobile device with your compatible GoPro camera, you need to pair these two devices. Follow these steps for pairing your iOS mobile device with a Hero4 camera:

1. Turn on the Wi-Fi and Bluetooth features of your smartphone or tablet. You can do this from the Control Center (shown), or from within Settings on the iPhone or iPad.

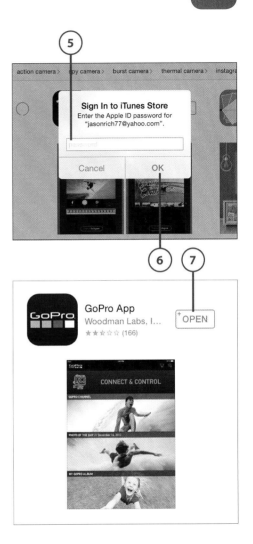

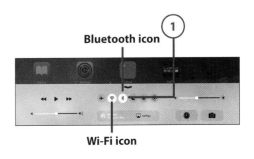

Bluetooth icon

Wi-Fi icon

No Wireless Connection?

The GoPro mobile app will still launch on your smartphone or tablet, without establishing a link with the camera. However, you will not be able to remotely control the camera via the app, or use the app as a real-time viewfinder.

2. Locate the installed GoPro App on your mobile device and tap its icon.

3. From the mobile app's main screen, tap the Connect Your Camera option (after it replaces the initial Searching for a GoPro message).

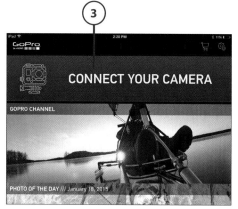

4. Tap the Get Started button in the menu that appears.

5. Select your camera model from the app's menu.

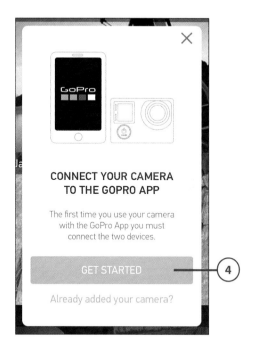

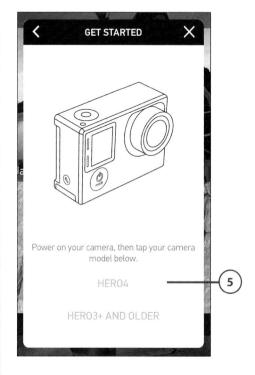

6. Turn on your GoPro Hero4 by pressing and holding the Power/ Mode button for approximately 2 seconds (not pictured).

The LCD Touch BacPac Makes the Pairing Process Easier

If you have the LCD Touch BacPac accessory connected to your GoPro camera, you'll have an easier time navigating through its menu options using the interactive and easy-to-view touch screen display.

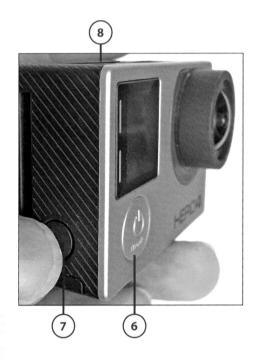

7. Press and hold the Settings/ Tag button on the side of your camera's body until the Wireless menu appears on the display.

8. Press the Shutter button to select the GoPro App option from the camera's Wireless menu. The camera enters into Pairing mode. From the app, tap the Continue option.

9. From the Select Camera screen, tap the displayed GoPro camera listing.

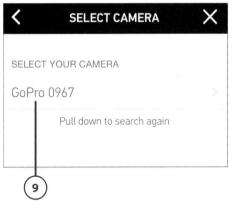

10. From the app's Pair Camera screen, tap the Pair My Camera button.

11. When the Bluetooth Pairing Request window appears on the app's screen, enter the numeric code that displays on the GoPro camera's Status screen, and tap the Pair button.

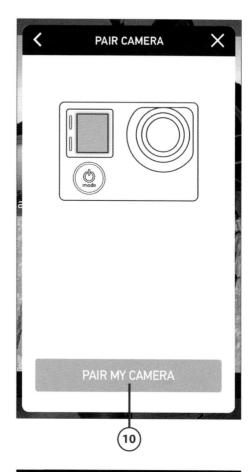

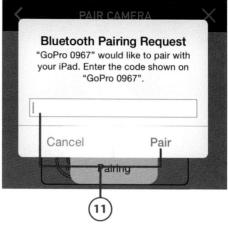

12. After the Paired message appears, create a name and password for your camera (not pictured). The name you select doubles as the name your camera uses when creating its own wireless network.

13. Tap the Continue button (not pictured).

14. From your mobile device, connect to the Wi-Fi wireless network that's now created by your camera. To do this, go to the Wi-Fi page for your device's settings and tap your camera's name under the listed networks.

Enabling GoPro Wireless

To turn on or off the GoPro camera's wireless feature on the Hero3 or Hero3+, press the Wi-Fi button on the side of the camera. On the Hero4, this button is the Settings/Tag button.

15. When prompted, enter your camera's password (not pictured).

16. Relaunch the GoPro App. From the app, tap on the Connect & Control option when it appears. Your camera and the GoPro App (via your mobile device) will now be connected, and the Wireless mode of your camera will be turned on. The camera's blue Status Light should be flashing.

One and Done

From this point forward, when you turn on the GoPro camera's Wireless feature and select the GoPro App option, and then you launch the GoPro App on your mobile device (assuming it's connected to your camera's wireless network), the two devices automatically establish their connection when you tap the app's Connect & Control option.

Taking Control of Your Camera Using the GoPro App

The main menu screen of the mobile app displays when you launch the GoPro App. From the app, tap the Connect & Control option. Your camera beeps three times when the remote connection is established. The camera remote control screen then appears on your smartphone or tablet.

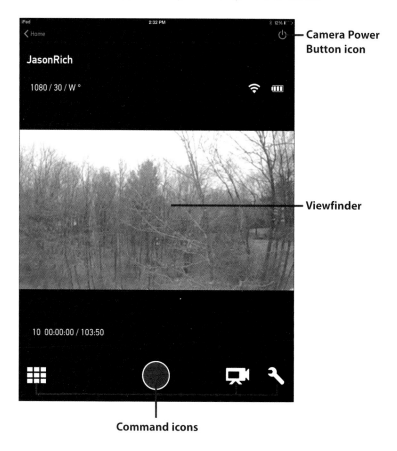

Command icons

With the connection established, the camera's remote viewfinder is in the center of the app screen. Along the bottom of the screen are various command icons for controlling the camera remotely.

The camera's power button displays in the top-right corner of the app screen, which enables you to power on or off the camera directly from the app (assuming the camera is in Wireless mode). Tap the Home button to return to the app's main menu.

Navigating the App Settings Menu

From the GoPro App's main menu, tap the gear-shaped Settings menu icon
to access the app's App Settings menu.

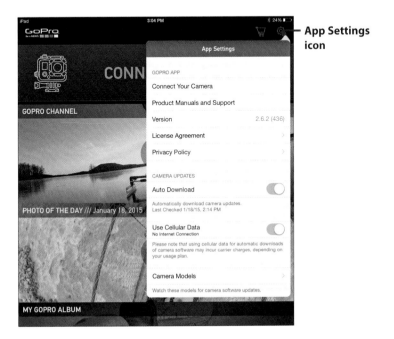

App Settings icon

Following are the menu options:

- **Connect Your Camera:** Tap this to initially pair your GoPro App with your GoPro camera.

- **Product Manuals and Support:** Tap this command to launch your smartphone or tablet's web browser to visit the GoPro website, and then access the online editions of the user manuals for the various GoPro cameras and accessories.

- **Version:** Displayed here is the version number of the GoPro App that's currently running on your mobile device. GoPro periodically updates the app with new features and functions.

- **License Agreement:** Tap here to read GoPro's License Agreement. This is a text-based screen that's chock full of legal information.

- **Privacy Policy:** Tap here to read GoPro's Privacy Policy. This is a text-based screen that's also loaded with legal information.

- **Auto Download:** Turn on the virtual switch that's associated with this option if you want the camera to automatically (and wirelessly) transfer any new photos or video you've shot on your GoPro camera directly to your mobile device whenever a connection between the camera and mobile device is established (via the GoPro App).

- **Use Cellular Data:** Instead of using Wi-Fi (which is free), this option enables your smartphone or tablet to use its 4G (LTE) cellular data connection to establish a link between your camera and the app. If you have a monthly cellular data allocation, turning on the virtual switch for this option results in you using up this monthly allocation quickly because the file sizes associated with your photos and video are rather large. It's best to turn on this option only if you have an unlimited cellular data plan with your wireless service provider. Otherwise, rely on the Wi-Fi connection.

- **Camera Models:** Turn on the virtual switch associated with this option to allow the GoPro App to download and install any Camera Software updates to your GoPro cameras as they're made available. This is the easiest way to update the Camera Software that runs on your GoPro camera.

Accessing Your My GoPro Album

From the GoPro App's main menu, you can access the My GoPro Album option by tapping the photo that displays below this heading. Then, from the Albums screen, access any photos already stored within your mobile device, including those stored within the My GoPro Album, which is reserved for photos taken with your GoPro camera that have been transferred to your mobile device.

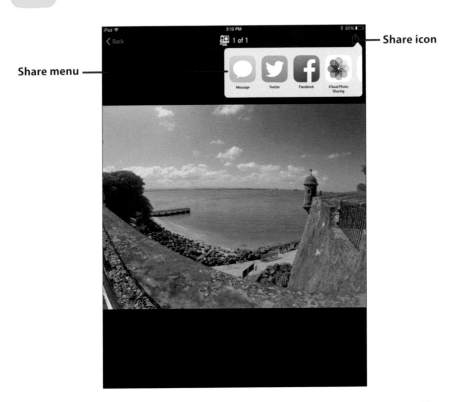

Share menu

Share icon

When viewing a photo, tap on the image to make the menu options and icons appear, then tap the Share icon to share that image via text message, Twitter, Facebook, iCloud Photo Library, or another compatible third-party app.

Transfer Photos or Video from the Memory Card to the GoPro App

After establishing a wireless connection between your camera and the GoPro App, you can transfer photos or video from the memory card within your camera to your mobile device to view, edit, and share them. To transfer selected content, follow these steps:

1. Turn on your GoPro camera and make sure it's in Wireless mode. The blue Status light should flash on the camera.

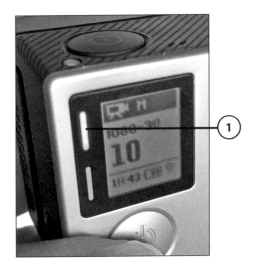

2. Launch the GoPro App on your mobile device, and establish a connection with the camera by tapping the Connect & Control option (not pictured).

3. Tap the Image Preview icon that displays near the bottom-left corner of the screen. When the On My GoPro screen displays, you see thumbnails representing each photo and video stored on the memory card of your camera.

4. Tap the Edit option to select images and videos you want to import from your camera's memory card to your mobile device.

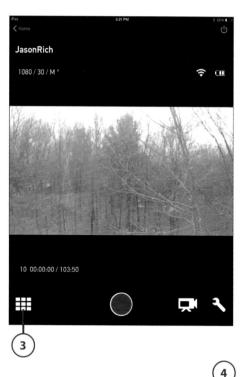

5. One at a time, tap each image thumbnail that represents the image or video you want to transfer. Select any number of images or videos to transfer. As you select each thumbnail, the top-right corner of the image thumbnail turns blue.

Select All

To transfer all the content currently stored on your camera's memory card, tap the Select All option that displays at the bottom center of the GoPro App's Tap to Select screen.

6. Tap the Share icon after selecting all the images you want to transfer.

7. Tap the GoPro Album icon to transfer the selected images and videos to the GoPro Album on your mobile device.

8. When transferring digital images (instead of video), choose between high and low resolution. One at a time, the images and videos wirelessly transfer from your camera's memory card (that's installed within your camera) to your mobile device.

Choosing a Resolution

Choosing High Resolution keeps the resolution of your images intact at the resolution each was shot it. This results in larger file sizes that take up more internal storage space within your mobile device.

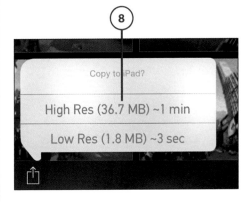

9. When the transfer process is complete, you can exit the GoPro App and launch the Photos app (shown here on the iPad) to edit, share, and organize the images. You can also launch a video editing app, such as iMovie, to edit your videos. If you want to share your photos or videos, use a specialized app for accessing Facebook, Twitter, Instagram, SnapChat, or YouTube, for example.

REMOVE THE FISHEYE EFFECT FROM PHOTOS

Digital images taken using a GoPro camera sometimes display the fisheye effect, which is created when you're positioned too close to your subject and shooting it using the camera's wide angle (170-degree) lens.

You can reduce this effect while shooting by switching from the Wide to Medium or Narrow Field of View. It can also be "fixed" after the fact using an optional mobile app or software on your computer.

To remove this effect from photos after they've been transferred to your iPhone or iPad, install the free GoFix or Lens Corrector for GoPro App ($1.99). The GoFix app removes the fisheye distortion effect and saves a copy of the edited images within your iPhone/iPad's Camera Roll folder. The original version of the edited image remains intact within its original folder.

The Lens Corrector app enables you to import images that were taken using a GoPro camera and that are currently stored within your smartphone or tablet. The app automatically removes the fisheye effect but also offers on-screen sliders that enable you to manually adjust the fisheye removal feature. This gives you more creative control over the appearance of your images.

A feature for removing the fisheye effect from your videos is available within the free GoPro Studio software for PCs and Macs, which is covered in the next chapter.

Controlling Your Camera from the GoPro App

Using the GoPro App, remotely controlling your camera is a rather straightforward process because more information displays on the smartphone or tablet's screen than can display on the camera or Smart Remote's Status Screen.

To remotely power on the camera, when it's in Wireless mode, tap the Power icon that displays in the top-right corner of the app screen. Then, within the center area of the screen, you see your real-time viewfinder.

Just below the viewfinder you can see information about the capacity of your memory card, and how many photos or how much additional video the memory card can hold, assuming you do not change any camera settings.

The Shutter button displays using a red circular icon. Depending on which shooting mode the camera is in, to the right of the Shutter button you see an icon representing the selected and active shooting mode.

Settings Menu icon

Shutter Button icon

Shooting Mode icon

Quickly change the shooting mode by tapping an icon that represents the currently active camera mode. This reveals an icon-based menu.

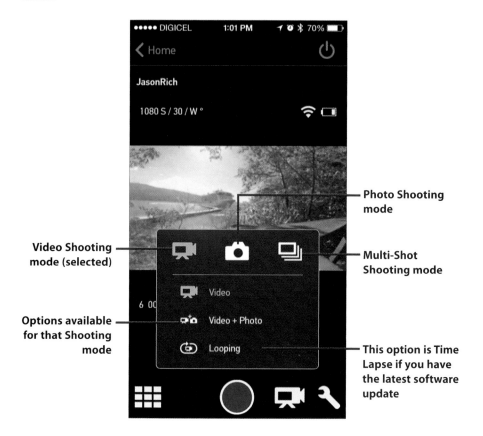

Video Shooting mode (selected)

Options available for that Shooting mode

Photo Shooting mode

Multi-Shot Shooting mode

This option is Time Lapse if you have the latest software update

You can learn more about your camera's shooting modes for photos and video in Chapter 8, "Shooting High-Resolution Photos," and Chapter 10, "Shooting HD Video."

Adjusting the Hero4's Settings from the App

In addition to selecting the camera's shooting mode from the GoPro App, when you tap the wrench-shaped Settings icon that displays in the bottom-right corner of the app, you can adjust specific settings and options related to each shooting mode.

Under each menu heading, the following is a summary of what you can adjust remotely on your Hero4. If you use the Hero3, Hero3+, or another compatible camera model, your options will vary.

- **Video Settings:** These options enable you to customize Video mode-related settings, such as resolution and frames per second. After tapping the Video icon to select it (so it displays in blue), tap the wrench-shaped Settings icon to adjust Video-related settings.

- **Photo Settings:** These options enable you to customize Photo mode-related settings, such as Spot Meter, continuous shooting rate, and Protune settings.

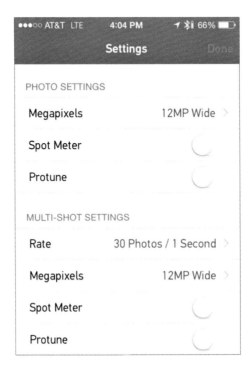

Choosing Settings

You can learn more about the individual settings for photos and video in Chapters 8 and 10.

- **Multi-Shot Settings:** These options enable you to customize settings, such as burst mode shooting rate and time lapse interval, when using the camera's Multi-Shot options.

- **Setup Settings:** Adjust any of the options available from the GoPro camera's main Settings menu, but do it remotely from the GoPro App. From the Settings menu, you can customize more than 10 camera-related features and functions. For example, tap the Default mode option to determine which shooting mode will automatically become active each time you turn on the camera.

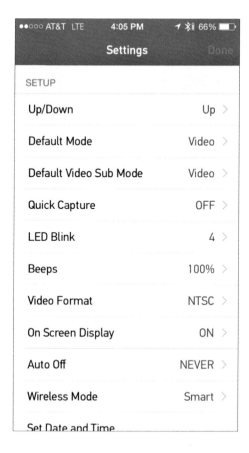

Learn More About the Settings Menu

For complete details on how to utilize all the options available from the Settings menu, see Chapter 12, "Adjusting the Camera's Setup Menu Options."

- **Delete Settings:** Use one of these two commands to delete content from your camera's memory card. The Delete Last File option enables you to delete from the camera's memory card just the last photo or video you've shot, whereas the Delete All Files from SD Card option erases the entire memory card. Do not use this option unless you are 100 percent sure that your content has already been transferred to your computer or mobile device, or you can potentially lose it forever.

- **Camera Info Settings:** When you first paired your camera with your Smart Remote or the GoPro App, you were asked to give your camera a name. Tap the Name option to edit the Name and Password related to your camera and the wireless network it creates.

Locate Your Camera

By turning on the virtual switch associated with Locate Camera, you can remotely instruct the camera to start beeping and flashing its Status Lights. This makes it easier to find when it's in relatively close proximity, but due to its small size, can't be found for whatever reason.

- **Wireless Control Settings:** Use the options offered under this heading to activate either the GoPro Wi-Fi Remote or GoPro Smart Remote. When you do this, however, it deactivates the wireless connection that currently exists between your camera and the GoPro App that runs on your mobile device. Remember, you can have either the GoPro App or the Smart Remote set up to wirelessly control your camera at any given time.

- **Camera Status Settings:** The options offered under this heading display information only. The battery level option displays your camera's current battery life from within the app, whereas tapping the SD Card Capacity option tells you, based on the camera's current settings, how much more video or how many more photos you can store on the camera's memory card. You also see how many photos and videos are currently stored on the card.

●●●○○ AT&T LTE 4:05 PM ⬆ ✳ 65% ■▭

‹ Settings **SD Card Capacity**

GOPRO SD CARD CAPACITY

Videos on Card 10

Video Time Remaining 103:50

Photos on Card 1056

Photos Remaining 10287

>>>Go Further

WHAT ELSE YOU CAN DO FROM THE GOPRO APP

From the GoPro App's main menu, tap the GoPro Channel option to view videos produced using GoPro Hero cameras that have been uploaded by your fellow GoPro users. Think of the GoPro Channel as a free, YouTube-like online service designed specifically for GoPro users.

To see an ever-changing sampling of often amazing digital images taken by your fellow GoPro users, tap the Photo of the Day option.

Tap the My GoPro Album option to view your images and video that you shot with your GoPro camera and that have already been transferred to your smartphone or tablet.

Displayed near the top-right corner of the GoPro App's main screen is a Shopping Cart icon. Tap on this to access GoPro's online store to shop for GoPro cameras, mounts, housings, and accessories directly from your mobile device.

Optional GoPro Mobile Apps

Available from the App Store, or wherever you acquire mobile apps for your smartphone or tablet, you can discover additional third-party apps designed to work with your GoPro camera. To find these apps, enter the search phrase **GoPro** within the App Store's Search field.

This section offers details about three additional GoPro-related apps. These apps are available for the iPhone and iPad. Versions of some of them, as well as other apps, are also available for Android and Windows Mobile smartphones and tablets.

10 – Fast GoPro & DJI Phantom Video Sharing with Music

This optional app enables you to shoot video with your GoPro camera, wirelessly transfer the content to your iPhone or iPad, and then quickly edit the video using simple tools. The app makes it quick and easy to select your favorite shots or scenes and then add special effects, titles, and music to your video. For example, you can speed up or slow down playback with a few on-screen taps.

You can then share your edited video via Facebook, Instagram, Tumblr, YouTube, or Vine from directly within the app; email or message the video to others (via the Mail or Messages app); or upload the video to a cloud-based service, such as Dropbox.

Prizmia for GoPro

You can use this app, which is priced at $9.99, instead of the official GoPro mobile app to remotely control your camera, and then edit and share photos or video from your mobile device. The official GoPro mobile app does not have built-in photo or video editing capabilities.

When using the app as a remote viewfinder when shooting, for example, Prizmia offers a full-screen viewfinder view, regardless of what resolution you shoot in.

What's also unique about this app is that it includes more than 90 special effect filters that can be added to photos or videos, either in real time while the content is shot or after the fact during the editing process. You can also manually control contrast, saturation, gamma, and brightness. In addition,

you can use app-specific features, such as video stabilization and Auto-Lock Focus & Exposure when shooting.

The Prizmia app offers the toolset that you need to take full control over your GoPro camera (remotely) while shooting, but then edit and share your content—all from within a single, well-designed app that integrates nicely with several online social networking services, including Facebook and YouTube. In other words, you won't need to transfer your content to a computer to edit and share it, which means you can handle these tasks from virtually anywhere.

Beyond purchasing the app, several additional special effect filter sets, including Bleach Bypass Filter Effects, Dusk Filter Effects, Colors Filter Effects, B&W Filter Effects, and Vintage Filter Effects, are sold separately as in-app purchases for $0.99 per set, so to unlock all that this Prizmia app has to offer, plan on spending approximately $15.00.

Lab for GoPro

The free Lab for GoPro App is designed to help you quickly edit and share digital photos taken with a GoPro camera that you've wirelessly transferred to your mobile device.

This app includes 16 special effect filters. In addition you can make manual adjustments to a photo's brightness, saturation, contrast, blur, focus, tone curves, and exposure.

Then you can overlay text and supplied digital clip art (stickers) over your image before sharing it from within the app via Facebook, Twitter, Instagram, WhatsApp, iPhoto, Dropbox, Pintrest, or Tumblr.

Other Choices

After you transfer your photo or video content from your GoPro camera to your mobile device, you can use any photo or video editing app on your smartphone or tablet to edit that content.

On the iPhone or iPad, for example, you can use the Photos app for editing digital images or clipping video content, whereas you can use Apple's iMovie app for video editing while on the go.

For third-party apps, the Replay app is a powerful, but easy-to-use video editor, whereas apps such as Pixelmator, SnapSeed, Photogene 4, Adobe Photoshop Express, Adobe Photoshop Touch, Afterlight, and Pinnacle Studio offer powerful photo editing tools.

Using the free GoPro Studio software, editing HD video, and transforming raw video footage into professional-quality video projects is relatively easy.

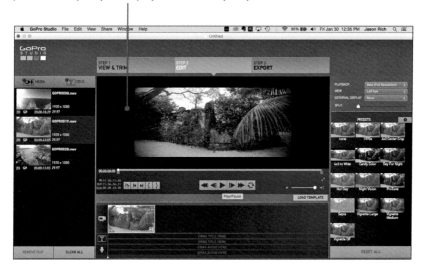

In this chapter, you are introduced to the free GoPro Studio software, which is powerful video editing software for the PC and Mac. Topics include the following:

→ Getting an overview of the GoPro Studio software's key features and functions, and discovering why this software is the perfect companion for GoPro cameras

→ Discovering how to import content from your camera into the software for editing

→ Using video export options offered by the GoPro Studio software

→ Gaining an overview of other video editing computer software packages and mobile apps

Using the GoPro Studio Software

Although you can use GoPro cameras for shooting HD video, after you shoot the video, it needs to be edited prior to being presented to your intended audiences. Although many easy-to-use and versatile video editing software applications are available for PCs and Macs, the GoPro-developed GoPro Studio software is designed specifically for editing video shot using the GoPro cameras.

As a result, this free software, which you can download from GoPro's website (www.GoPro.com), offers many editing and video enhancement tools that you will not find in most other video editing software or mobile apps.

For example, using GoPro Studio, you can import raw (unedited) video footage shot at different resolutions, Frames Per Second rates, and with varying Fields of View and edit them together into one seamless video presentation. You can also reduce or remove the unwanted fisheye effect that may appear in your raw video

footage. At the same time, you can utilize many common video editing and enhancement tools that are built into GoPro Studio.

Without investing a tremendous amount of time editing your videos, you can achieve professional quality results, which can include adding visual special effects, smooth scene transitions, titles, captions, background music, sound effects, voiceovers, and other post production elements into your video projects.

Directly from the GoPro Studio software, you can export and save your video in a variety of industry-standard video file formats.

Just like digital photography and videography, editing video is both a skill and an art form. In this case, the skill involves learning how to effectively use the video editing tools at your disposal and becoming proficient using your video editing software.

The art form aspect of video editing relates to all the creative decisions you need to make during the editing process. For example, the raw footage you decide to use, the music you include, your use of special effects and animated scene transitions, and what wording you use within your titles are all creative decisions that directly impact the story your video project tells or the message it conveys to your audience.

> > > Go Further

MINIMUM SPECS FOR EDITING

Prior to downloading and installing the GoPro Studio software (or any video editing software) on your PC or Mac, make sure that your computer meets or exceeds the minimum system requirements needed to run the software. This is important because editing HD video requires extensive processing power, at least 4GB of RAM, a powerful enough graphics card, and a hard drive with plenty of available storage space.

To determine the minimum system requirements for the most current version of GoPro Studio, visit http://shop.gopro.com/softwareandapp, and click the System Requirements tab. If you plan to edit video shot at 4K resolution, you also need a compatible computer monitor. For example, you can use Apple's latest iMac with Retina 5K Display (www.apple.com/imac-with-retina) for this purpose.

Remember, minimum system requirements mean just that. Using a computer that has a faster processor, much more RAM, a faster hard drive, and a better graphics card than what's recommended will always serve you well and provide for a more enjoyable editing experience when you work with massive video files.

Understanding the Video Editor's Role

Learning to become an amateur video editor is an entirely different skillset than being a videographer. Your goal as the video editor is to analyze the raw (unedited) video that's been shot using the GoPro camera, and then choose the best shots and scenes to include in the final video presentation.

Your responsibilities include creatively piecing the best of the raw content together into a presentation that appeals to the intended audience. A good videographer always shoots plenty of extra raw video footage so that the video editor has as much content as possible to work with.

As the video editor, you may start with several hours' worth of raw video footage but then need to select only the best content to showcase within your much shorter video presentation (which may be only 3 to 5 minutes, for example).

During the video editing process, you need to utilize the video editing software's tools to seamlessly blend various shots and scenes together so that they tell a coherent story in the least amount of time possible. Most videos on YouTube, for example, are between 3 and 5 minutes in length and are seldom longer than 10 minutes, due to the short attention span of viewers.

When necessary, as the video editor, you also need to choose the best visual special effects, animated scene transitions, frame/image enhancements, and audio (music, sound effects, prerecorded audio, and voiceovers) to enhance the professional quality of your project.

Learning to effectively and efficiently use a powerful video editing software application or mobile app takes time, dedication, and practice. This chapter offers you an overview of what's possible using the GoPro Studio software on your PC or Mac, as well as an introduction to several other computer software and mobile app options for editing raw video shot using your GoPro camera.

>>>*Go Further*

DOWNLOAD THE FREE GOPRO STUDIO USER MANUAL

To learn how to use all the GoPro Studio software's features and functions, and start developing the core skills you need as a video editor, download the free, 100+ page user manual for this software.

The *GoPro Studio User Manual for Windows Operating Systems,* and the *GoPro Studio User Manual for Mac Operating Systems* manuals are available from GoPro's website (http://gopro.com/support/product-manuals-support).

Getting Started

Regardless of which video editing software you use, when you finish filming your video, break down your post production efforts into several key steps. All creative decisions you make from this point forward should be based on what you believe will appeal to your intended target audience, and how you can effectively capture and hold their attention as your video entertains, informs, or achieves its ultimate goal.

These key video editing steps include

- Transferring the raw video content from your GoPro camera's memory card into your video editing software

- Gathering other production elements to include within your video project, such as digital photos, sound effects, and music tracks

- Storyboarding your video project, and deciding which shots or scenes to edit together and in what order; done in your head or actually drawn out on paper using a storyboard format

- Using the video editing software to trim or edit each video scene, shot, or clip, and then placing that content into your video project

- Adding special effects or visual enhancements to the video footage as needed

- Incorporating visually interesting shot or scene transitions to help your video flow smoothly

- Editing or enhancing the video's audio, and deciding when and where to include sound effects, appropriate background music, and voiceover narration

- Creating and inserting text-based titles and captions into your video

- Previewing the edited video, and making any final editing decisions to make the project appeal even more to its intended audience

- Saving the edited video, and exporting it into an appropriate file format and resolution, based on how it will be utilized, distributed, or presented

CONSIDER STORYBOARDS

A storyboard is a group of rectangular boxes on paper that can help you outline the key scenes or shots in your video production. You can use storyboarding to help you decide what to shoot, or later to help you decide the order in which to present your content. In addition, using a storyboard can assist you in fleshing out your story or visualizing what content to include within your video.

You can create a storyboard using blank sheets of paper to sketch out or write out your ideas. There are also storyboarding software packages and mobile apps, as well as preprinted paper-based pads that use a storyboard format.

Levenger ($23.00, www.levenger.com/Special-Request-Storyboard-Unpunched-Ltr-Core-8106.aspx), for example, offers preprinted storyboard pages in packages of 100 sheets. There's also the StoryBoard Quick software for PCs and Macs ($179.00, www.writersstore.com/storyboard-quick) that you can use to storyboard more elaborate video projects. StoryBoard Pro for PCs (www.download366.com/storyboard-pro) offers similar functionality but is offered as freeware.

Download GoPro Studio

If you use the GoPro Studio software as your primary video editing tool, begin by downloading the latest version of the software to your PC or Mac. To do this, follow these steps:

1. Visit the GoPro.com website.

2. Click the Products option.

3. Click the Software & App link.

4. Click the GoPro Studio software option on the Capture Create Share page.

5. Click the Download Now button on the GoPro Studio download page.

6. Select your computer's operating system from the pull-down menu.

7. Enter your email address. (Deselect the email subscription options if you prefer.)

8. Click the Download Now button to continue. The software downloads to your computer.

9. When this process is done, double-click the downloaded file's icon to install it, as shown here on a Mac. Follow any on-screen directions you receive.

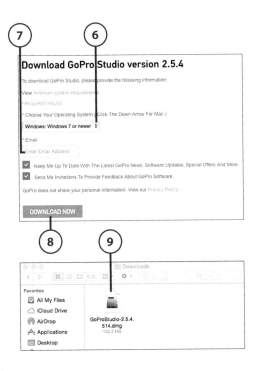

Run GoPro Studio

When the installation process finishes, launch the software to begin using it, and follow these steps to complete your setup:

1. Open the GoPro Studio pull-down menu at the top of the screen, and access the Preferences menu. From here, you can adjust options to help you work efficiently. When in doubt, leave an option at its default setting.

Don't Delete

The Preferences menu has an option that lets you automatically delete data from the camera's memory card after it's transferred to your computer. Do not activate this option. Ensure all your content has transferred correctly and is safely stored on your computer before you manually delete the original content from the camera's memory card.

2. Turn on the AutoSave option by adding a check mark to the option's check box.

3. Decide how often you want a backup of your work to be created. The default option is every minute. Should the software crash, or if something goes wrong during the editing process, with this feature turned on, you shouldn't lose more than 1 minute of work.

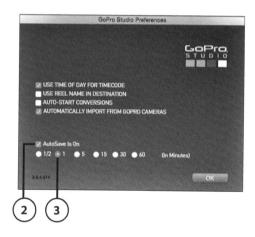

>>>Go Further

SAVE TIME BY USING AN EDIT TEMPLATE

Don't forget that you can also download free GoPro Studio Edit Templates, which are basically pre-edited video shells (created by professionals) that enable you to simply drag and drop your content into the template to produce professional-quality videos in much less time and with fewer creative decisions to make.

When you first click the Edit button within the GoPro Studio software, after you import your content (see "Transferring Raw Video to Your Computer" later in this chapter), you can preview, select, and download your choice of Edit Templates. Choose one that best fits the video style or theme you want to create. You'll learn more about this process in the later section, "Beginning the Editing Process."

To find, preview, and download additional Edit Templates, visit www.gopro.com/studio-templates-download.

It's Not All Good

Manually Save Your Work in Progress

Regardless of which video editing software you use, get into the habit of periodically saving your work in progress to an external hard drive, cloud-based service, or an alternative storage option instead of your computer's hard drive. This way, if the software or computer crashes, the power fails, or something else happens, you know you won't lose several hours worth of editing work.

Getting to Know GoPro Studio's Layout

GoPro Studio breaks up the editing process into three main steps: View & Trim, Edit, and Export. You can quickly move between these separate work spaces by clicking the appropriate tab that displays near the top center of the screen.

Edit mode selected Preview window

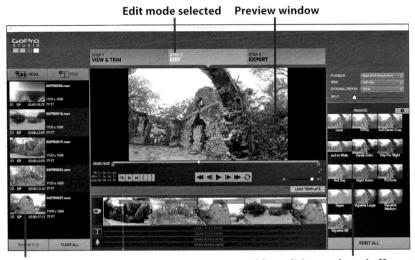

Imported video files Video editing tools and effect presets

Based on which workspace you use, what displays on the right and left sides of the center Preview window vary. Initially, on the left is the Import New Files area. From here, you can access the tools needed to import raw video footage from your GoPro camera (and other sources) into the editing software.

Within the middle portion of the screen are your Preview Window and Playback Controls. What else displays within the center of the screen varies based on whether you're in View & Trim mode, Edit mode, or Export mode.

For example, when in Edit mode, the Storyboard Window, as well as icons for accessing and utilizing various other tools needed to piece together your raw video clips and other content to put together your video production, are offered.

What displays on the right side of the screen can also vary. When in Edit mode, for example, some of your available editing tools and Effect Presets become accessible.

To export your content, what displays on the screen includes the tools needed to choose your file export options. The software offers a selection of Export Presets (Mobile, HD720p, HD1080p, Archive, Vimeo, and YouTube), but you can also choose the Custom option to select your own export options and resolution.

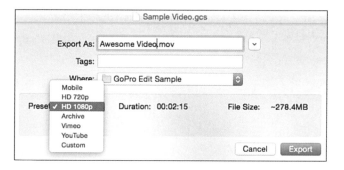

You need to understand each of the GoPro Studio's video editing steps and tools, so you can best use them to meet your needs. As you get to know the software, you can save a lot of time and potential frustration by using a GoPro Studio Edit Template instead of editing the entire video from scratch.

Transferring Raw Video to Your Computer

To import your raw video content into the GoPro Studio software, you can keep your original video files intact, or you can combine video clips shot with different camera settings, and make everything look consistent and smooth within your edited video project.

The first step, however, involves using the GoPro Studio Importer to transfer your raw video content that's currently stored on your camera's microSD memory card, and move it into the GoPro Studio video editing software.

You can do this in two ways:

- By connecting your camera directly to your computer using the supplied USB cable (which plugs into the mini-USB port of your camera and the USB port of your computer)

- By connecting an optional memory card reader to your computer via its USB port, and then removing the microSD memory card from the camera and inserting it into the card reader.

Transfer Content to Your Computer

If you use the supplied USB cable to transfer content from your GoPro camera's memory card to your computer, follow these steps:

1. Launch the GoPro Studio software on your computer.

2. Connect the supplied USB cable to the mini USB port on your camera.

3. Connect the opposite end of the USB cable to your computer.

4. Turn on your GoPro camera by pressing the Power/Mode button for about two seconds.

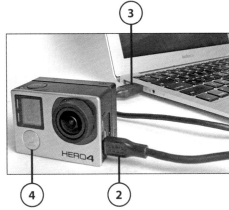

5. Your computer identifies the memory card within your camera, and a connection between your camera and the computer is established. The camera's Status Screen displays a Connection Established icon.

6. You are then prompted to transfer content from your camera's memory card to the GoPro Studio software via the GoPro Studio Importer. Choose a storage location to store the imported content and the content transfer process commences. Based on the length of your videos and the resolution they were shot in, this could take several minutes. A progress meter displays on the screen.

7. Your raw video is imported into the GoPro Studio software and placed within the Import Bin. You can now preview the individual raw video clips and trim them.

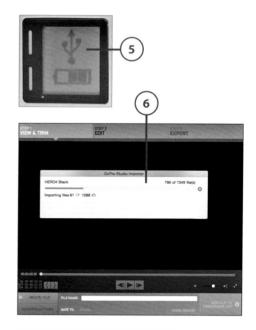

What It Means to Trim a Clip

When you trim a video clip, this means you use tools built in to the software to select and edit out or delete portions of the beginning and end (and sometimes content in the middle) of the clip to eliminate unnecessary or unusable footage.

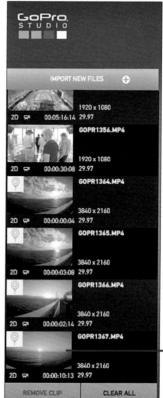

>> >Go Further

USING HIGH-RESOLUTION PHOTOS IN VIDEOS

As you edit your raw video footage into a well-produced presentation, you can include high-resolution digital photos into your project that you shot using your GoPro camera.

To do this, transfer the wanted photos from the camera's memory card (or wherever they're currently stored) into the GoPro Studio software, and then drop them into your video as you see fit. These still images can be cropped, enhanced, and used with an animated effect to make them visually interesting within your video.

Beginning the Editing Process

The video editing process begins after you import raw video content into the software. You can then preview and trim that content as needed.

At this point, it's time to create a new project, which ultimately becomes your final edited video. Begin by piecing together your video clips, raw video footage, and scenes, converting these files into the GoPro Studio software's CineForm file format, and if necessary, making them all compatible prior to incorporating them into your project. Details about each raw clip you have imported and that is being converted displays on the right side of the screen when in the View & Trim workspace.

View & Trim mode is selected.

After selected raw video is imported, it needs to be converted to the CineForm format.

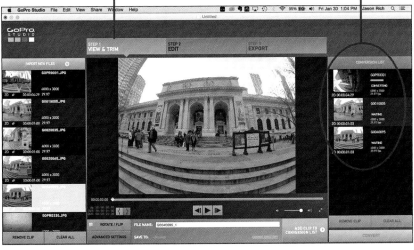

Select and Convert Clips

After you import content into the GoPro Studio Import Bin (on the left side of the screen), follow these steps to choose video clips or still photos to include within your video project:

1. Make sure you have selected the Step #1 View & Trim tab, if it's not already selected.

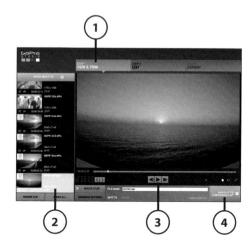

Importing Video

If you don't have any photos or video in the Import Bin on the left side of the screen, follow the steps in the previous section, "Transfer Content to Your Computer."

2. Click on a video clip to preview that clip.

3. Use the on-screen controls near the bottom center of the preview window to control the playback.

4. If you want to use the selected video clip within your video project, click on the Add Clip To Conversion List button.

5. A thumbnail for the clip is displayed on the right side of the screen, under the Conversion List heading.

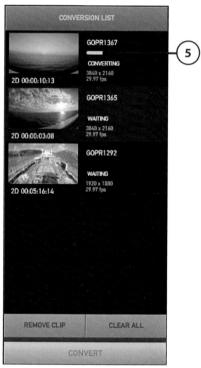

6. The GoPro Studio software automatically prompts you to name your video project, if you haven't done this on your own. Click the Name Project button when this reminder window appears, and then give your video project a filename.

7. After you've selected all the clips you want to use within your video project, click the Convert button. The GoPro Studio software converts the selected video clips into the proper file format for editing. As soon as this conversion process is completed, you're ready to move on to the GoPro Studio software's Step #2: Edit.

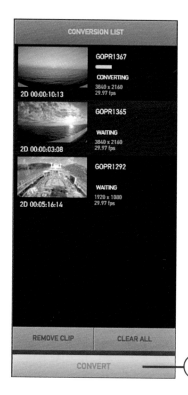

Converting Videos

Click the Convert button, and your selected files are converted one at a time. This could take several minutes, depending on the resolution, the length of the video clips, and the processing power of your computer.

8. Click the Proceed To Step 2 button that replaces the Convert button in the bottom-right corner of the screen (not pictured).

Edit Your Video

Now that you've selected the raw video clips (and potentially still images) you want to incorporate into your video project, it's time to edit the pieces together and add various visual effects, titles, music, and so on.

1. Select a video template, when prompted. (This happens as soon as GoPro Studio finishes converting your videos, per Step 8 of the previous task.)

Video Templates

GoPro Studio's video templates are created by professional videographers and video editors. Using them makes the video editing process much faster and easier because, after selecting a template, all you need to do is drag and drop in your own video clips and content to create a professional-looking video. If you want total editing freedom, select the Blank template option.

2. Click the Create button to continue.

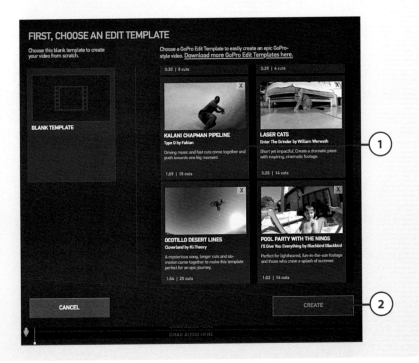

3. On the left side of the screen are your selected video clips. Click and drag a clip onto the timeline to work with it.

4. Displayed in the center of the screen is your editing/playback window and beneath it is your video timeline, which you can use to arrange and trim your clips.

5. On the right side of the screen are your video editing tools and menus, which you can use to alter image quality and add effects.

Learning to Edit

A full tutorial on how to edit video is beyond the scope of this chapter. Refer to the GoPro Studio manual to discover all the editing tools available to you.

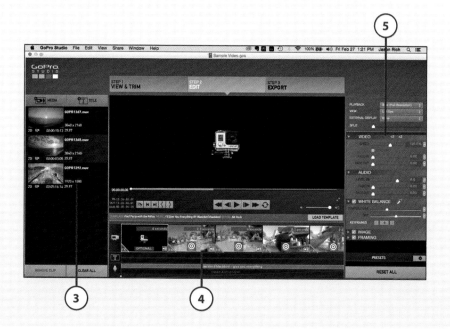

6. Click the arrow next to a tool category to expand it and gain access to more controls.

7. Adding text in the Fonts category, for example, adds labels you can use for titles to your video.

8. After you edit your video, click on the Step #3 Export tab to begin the export process.

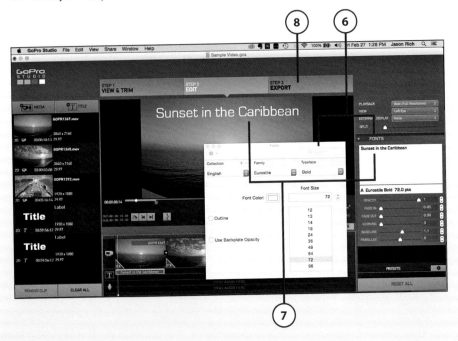

9. When prompted, enter a project name, choose the location where you want the exported video saved, and adjust the resolution of the video from the Preset menu.

10. Click Export to create the video file and save it to your computer. You can now share it with others in a variety of ways, such as via email, or by posting it on YouTube or Facebook.

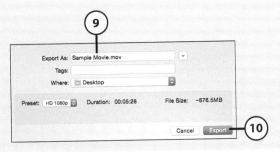

What's Possible During the Editing Process

When editing your video, you can modify (crop) your video frame, enhance its quality, remove the fish eye effect, trim and combine multiple video clips on the storyboard, add scene/shot transitions, add music and sound effects, add titles, add fade in or fade out effects, and add Effect Presets to your footage to alter its look using visual effects.

Adding Flourishes

As you edit your video, the GoPro Studio software enables you to speed up playback, create a motion blur effect, or use a slow motion effect. These effects work well when presenting action scenes, which the GoPro cameras are good at filming.

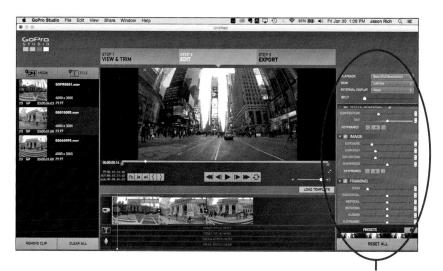

Image Editing tools

Throughout the editing process, be sure to preview your work in progress (or sections of your video) within the Preview Window, and if necessary, advance frame-by-frame. There's also a full-screen Preview option available by clicking the full-screen icon.

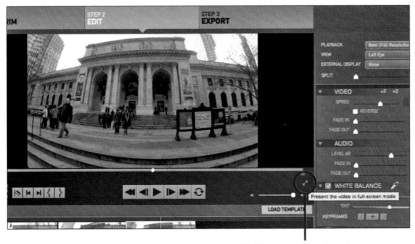

Full-Screen Preview icon

It's Not All Good

Don't Over Use Special Effects and Flashy Visuals

Although the GoPro Studio software (or whichever video editing software you use) offers a vast selection of visual special effects and flashy scene transitions that you can easily include within your video presentations, this does not mean you need to or should use all of them.

One of your goals as a video editor is to create a video that's visually appealing to your intended audience. You want to tell a story in the easiest and fastest way possible. Adding too many special effects or an abundance of unnecessary flashy graphics can distract your audience, so use these tools sparingly and in a way that's beneficial to your video's core message, story, or goal.

In other words, just because you have a vast assortment of Hollywood-style special effects at your disposal, this does not mean you should overuse them within your productions.

Enhancing Flawed Video Footage

If a particular portion of your video is overexposed, underexposed, or somehow needs to be enhanced, the GoPro Studio software offers editing tools that enable you to reframe and rotate your content, as well as manually adjust things such as White Balance, Exposure, Contrast, Saturation, and Sharpness. This is in addition to the Effect Presets that you can add to video footage to subtly or dramatically alter its appearance.

Effect Presets built into GoPro Studio include Protune, 1970s, 4X3 Center Crop, 4X3 To Wide, Candy Color, Day For Night, Hot Day, Night Vision, Sepia, Vignette Large, Vignette Medium, and Vignette Off. You can also customize these Effect Presets or create your own using the editing tools built in to the software.

The Framing tools enable you to cut away unwanted background content to virtually zoom in on your intended subject or easily reframe your shots. This gives you a tremendous level of additional creative control over your raw footage if, for example, you forgot to film an important close up of your subject.

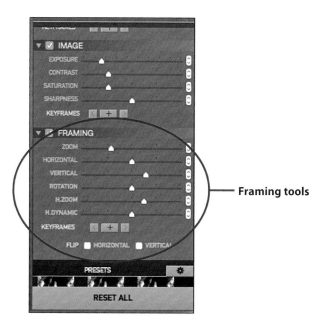

Framing tools

Considering Sound

In almost any video project, the sounds your audience hears while watching your video can be as important as what's actually shown. Music, for example, can set a mood. Sound effects can add a sense of realism or authenticity to your video or help to capture someone's attention, whereas a voiceover narration can be used to explain or convey information.

You can use these audio elements in addition to or instead of the audio that was recorded during the filming process. The GoPro Studio software enables you to edit the recorded audio track separately from the video, plus add music, sound effects, or voiceover tracks to be heard at specific points in your video.

As the video editor, you ultimately decide what's heard and when it's heard, just as you determine what your audience sees. You must adjust the audio levels within your video so that they're at the appropriate volume, and if you mix different types of audio, that each audio element can be heard at the appropriate volume.

If there's talking during a scene, the music you add should not overpower the voice tracks, and whatever music you do decide to add should be appropriate for that scene.

Saving, Exporting, and Sharing Your Video Projects

If you edit a relatively short video, when you become proficient using the GoPro Studio software, especially if you use one of the Edit Templates, you should create professional quality results within a few hours or less. How much time and effort you invest in your projects is entirely up to you.

When you finish the editing and you're satisfied with the result after viewing your video within the Preview window or using the Full-Screen Preview option, the next step is to export your video using a file format and resolution of your choosing.

Based on how you plan to share your video, this determines what format and resolution it should be saved in. Click the Export tab, and then select the Export .MOV option from the Share menu.

You now see a selection of export options. If you plan to upload the video file and share it on YouTube, select the YouTube option. If you plan to play back

the video on a high-definition 1080p flat screen television, for example, select the HD 1080p export option. If the video will be viewed only on the screens of mobile devices (smartphones or tablets), choose the Mobile Device option.

After choosing your export options, follow the onscreen prompts to complete the file export and saving process.

Video Editing Tips to Make Your Videos Better

Like any art form, there are no strict rules for editing video. There are, however, strategies that can help you create video projects that your audience can truly enjoy and appreciate.

That being said, your first task should be to identify your audience and then put yourself in their shoes when making all creative decisions. Consider how you want each of your editing decisions to impact your audience.

Most important, when deciding on content to include within your video, get right to the point. Never overwhelm your viewers with too much visual eye candy or distracting audio. Just tell you story or convey your message in a straightforward and entertaining way. Allow the stunning visuals you've captured by your GoPro camera to speak for themselves.

The attention span of your audience is relatively short. If your video drags on, is repetitive, or becomes dull to watch, people will simply stop watching, tune out, or surf elsewhere on the Internet and watch something else.

EDITING IN YOUR MIND WHILE YOU SHOOT

To ensure you have the best raw footage to meet your needs, as you shoot, think about how you'll later edit your video and what you want to accomplish. If you want to show an action or activity from multiple shooting angles or perspectives, be sure you shoot this content, so it's at your disposal when it comes to editing and you don't have to make compromises later.

If you shoot with a GoPro Hero4, take advantage of the Tag feature to mark the shots, scenes, or takes that you know you'll want to use later when editing.

Following are some other items you should consider while editing:

- **Focus on your intended audience and tell your story.** Set a primary goal for your video, as well as a target length. Are you creating a video just to entertain your audience, or is the goal to convey a message, illicit an emotion from the audience, or educate in some way?

- **Use an organized approach.** It's a good idea to first create a "rough cut" of your video and then add in the additional production elements. Begin by watching all your raw video footage and gathering the content you know you'll want to use. Then collect the most desirable raw footage that you want to use, trim those video clips, and then place them in order using your video editing software. Next, get rid of the unusable shots and ancillary raw footage you know you won't be using. When you're satisfied, begin adding in production elements such as scene transitions and music.

- **Use shots that will keep your audience's attention.** If you watch any television show or movie, you'll notice that the editor switches camera angles or shots every 5 to 10 seconds to keep things visually interesting for the audience. This is a good strategy to follow as you edit your videos. If you don't have footage that showcases multiple camera angles for each shot or scene to choose from, focus on using your most compelling content.

- **Use titles and captions to your advantage.** Most videos can benefit from an animated title sequence at the beginning that sets the scene and tells people what they're about to watch. Then, as needed, you can add text-based captions within your video to help move your story along or convey your message using text to accompany your video and audio.

Font Color Selection tool **Title Editing Window and tools**

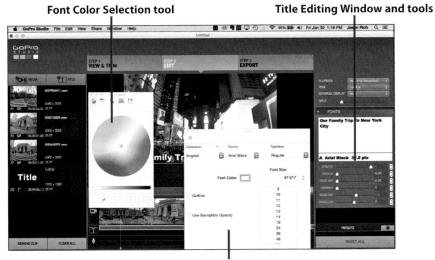

Font Selection and Adjustment tool

Size Matters

As you choose a font, font style, and type size for your titles and captions, consider that some people may watch your video on a small screen or their smartphone or tablet, instead of a large computer monitor or 52-inch HD television set. Make sure that your titles and captions are easily readable, not too wordy, and aren't overused.

- **Don't expect Hollywood-style results.** Learning to be a skilled video editor, regardless of which video editing software you use, takes time and practice. Start by editing with minimal special effects a few simple video projects. As you become more comfortable using your video editing software, start experimenting with its various features and functions.

Considering Other Editing Software Options

Although the GoPro Studio software offers editing tools that are custom-tailored to the features and functions of your GoPro camera, you always have the option of using third-party video editing software instead of, or in addition to, the GoPro Studio software.

Literally dozens of powerful video editing software packages are available for PCs and Macs. Some are free, whereas others cost money. For example, Apple offers the iMovie software for the Macs and iPad, whereas Microsoft offers its entry-level Microsoft Movie Maker software for PCs. These are straightforward, consumer-oriented video editing applications that are relatively easy to learn.

Wondershare Video Editor (www.wondershare.net/video-editor) and Pinnacle Studio 18 (www.pinnaclesys.com) are two other examples of consumer-oriented PC and Mac video editors that are relatively easy to use but still feature-packed.

For more professional-level editing tools that have a much steeper learning curve and higher price tag, consider using Final Cut Pro X (www.apple.com/final-cut-pro), Avid Media Composer (http://connect.avid.com/media-composer-trial.html), or Adobe Premiere Pro CC (www.adobe.com/products/premiere.html).

You can also do video editing on-the-go using a tablet, such as the iPad. For example, you can transfer video content from your GoPro camera (as long as it's shot at a resolution your tablet can support) and then use a video editing app to edit and ultimately share your video without using a computer.

Plenty of Video Editing Apps Are Available for the iPad

In addition to the iMovie app for the iPad, you can find a vast selection of other video editing mobile apps within the Photo & Video section of the App Store. For example, there's Clips Video Editor, Videoshop Video Editor, Cinamatic, iMotion Pro, and the powerful Replay Video Editor.

After you shoot photos or videos using your GoPro camera, it's easy to share them online using email, cloud-based photo sharing services, and online social media.

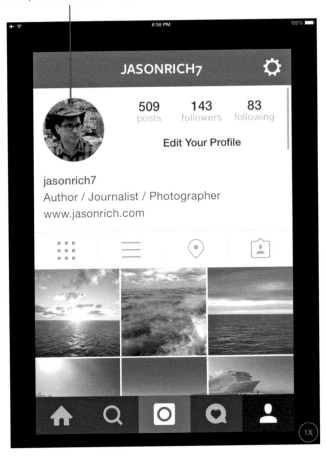

In this chapter, you discover how to share photos and videos shot with your GoPro camera with other people via the Internet. Topics include the following:

→ Sharing photos via email
→ Uploading and sharing content using a cloud-based photo or file sharing service
→ Sharing photos and video on Facebook, Instagram, and Twitter
→ Publishing videos on YouTube

Sharing Your Photos and Videos

After you shoot photos and video using your GoPro camera and then transfer that content to your mobile device or computer to be edited, you can also share your images and video productions with specific people, or the general public, using a variety of free online-based tools and services.

The online services discussed in this chapter are continuously evolving. So, before you start uploading your content to any of these services, you need to understand how to adjust that service's privacy settings and determine exactly who can view and potentially share your content.

Some people enjoy sharing their photos and videos with the general public via social media, whereas others prefer to share their personal content only with close friends and family members. What you decide to share and how you opt to share it is entirely up to you.

This chapter introduces you to some of the ways you can share photos and videos online, and points out the pros and cons related

to each option. Because the actual process for uploading and sharing photos and videos via these services changes often, this chapter focuses more on what's possible. Each service offers its own online Help features, as well as tutorials, that walk you through the step-by-step process of sharing your content online using the service you opt to use.

It's Not All Good

Tag Someone in a Photo or Video

Many of the services that enable you to upload and share photos or videos encourage you to provide details about that content, including when and where it was shot, a text-based caption, as well as who or what is featured within it.

Anytime you attach someone's name to a photo or video, this is called tagging. What this does is link the tagged person's name directly with the photo or video file. As a result, the content typically becomes searchable online based on the tagged person's name.

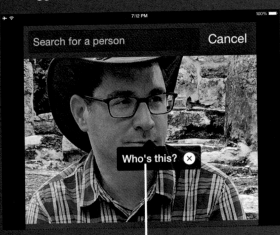

Instagram asks you to tag a person's
name before uploading a photo.

When you tag someone in a photo and video, this in essence takes away the tagged person's privacy. Think twice before tagging your children or grandchildren in photos and video or before tagging people who are featured in your content doing potentially embarrassing or incriminating activities. Relatives, coworkers, employers, classmates, or total strangers could gain access to the content based on where it's uploaded and what privacy settings for that content are active.

Depending on what you publish online, you might also think twice about adding location information to your content. This is called geotagging, and it links the exact location where the content was created with the photo and video file. Thus, if you post content shot in your home, a stranger could easily learn where you live.

Anytime you post photos and videos to any online service, you have the option to determine what searchable information is included with that content, and in some cases who can see that content.

If you share a "private" photo or video with a friend, initially while only that person may access the content you publish online, that friend could easily forward it to others or later publish the content in a more public online forum, which means your content is no longer private.

As a general rule, do not publish anything online on any online service that you would not want made public. Use common sense and act responsibly when publishing photos or videos online.

Sharing Photos via Email

When you store photos within your computer or mobile device, you can share them with other individuals or small groups using email. Sending video, however, is another story. HD video files tend to be large and often exceed the file size limit imposed by most email service providers. Thus, using email, you're typically limited to sending short video clips instead of longer length videos.

Depending on what you want the email's recipients to do with the content you send, the email software or app you use to compose and send the email messages can reduce the file sizes associated with photos. However, by reducing the file size of your content, you're also reducing the quality.

**Most email software, including the Mail
app on the Mac, allows you to adjust the
file size associated with photos being sent.**

If you just want to send a few high-resolution images within an email
message, you can typically leave their file size and image quality intact. To
send more than a few images, however, or to send longer length videos, you
need to use an alternative sharing method.

As you compose an email message using your email management software
or app (for example, the Mail app on a Mac, iPhone, or iPad), use the Attach
File command to select and then attach your content's files to the outgoing
message as it's being composed. This icon typically looks like a paperclip.

Easy Sharing
Many photo editing mobile apps and software packages have a built-in Share
feature that enables you to compose and send email messages from within the
app or software that include photos or video clips you select.

SHARING LARGE PHOTO OR VIDEO FILES

Most email services have limitations for attaching photo or video files to outgoing messages. However, you can use other options for sharing content with a large file size associated with it.

Instead of sending emails that contain your content, you can upload the content to a cloud-based file sharing service, such as iCloud (if you're an Apple user), Microsoft OneDrive (for Windows users), Dropbox (www.dropbox.com), or an online photo sharing service (such as Shutterfly.com, Smugmug.com, or Flickr. com) and then invite people to access specific online Albums that contain only the photos or videos you want to share with the individuals you choose.

If you want to send specific people large groups of images or large video files, another option is to use a fee-based service, such as Hightail (www.hightail. com), which enables you to send extremely large files to others via email. The attachments are stored online and assigned a private link that only the email recipients can use to access the content, as if it were an email attachment.

Sharing Photos Using a Cloud-Based Service

A variety of online, cloud-based file sharing services enable you to upload and store a vast amount of content online within individual folders, directories, or albums. You can then choose to share access to specific content with specific people while keeping the rest of your content private.

Apple users can use the company's iCloud Photo Library feature to share photos, videos, or Albums, whereas Windows-based PC users can use Microsoft's OneDrive service. In addition, online-based services are dedicated specifically to photo and video sharing, including Shutterfly.com, Smugmug. com, Snapfish.com, and Flickr.com. Dropbox enables you to archive and share all types of files, including photo and video files.

Some of these cloud-based photo and video sharing services are free to sign up for and use. However, most enable you to set up a free account and then provide a predetermined amount of free online storage space. When you go

beyond that online storage space allocation, you pay a monthly or annual fee for additional online storage space.

In many cases, you can use these services to create an online archive of your entire digital photo library or video project collection. When the content is online, it can be accessed by any of your Internet-enabled computers or mobile devices.

In addition, some of these services have professional photo labs linked to them. So, if you want to have traditional prints, enlargements, or photo products (gifts) created and sent, this can be done online, often for less money than using a 1-hour photo lab.

It's Not All Good

File Size Reduction

Anytime you opt to upload photos using a social media service, such as Facebook, the service automatically reduces the file size and resolution of your content to reduce the amount of online storage space that's required and also to speed up the upload and download process.

Services that automatically reduce image resolution should never be used as an online photo or video backup or storage option. These services, however, are ideal for sharing photos or videos with others.

Whether a cloud-based photo/video sharing service automatically alters the file size and resolution of your content varies based on the service. So, before backing up and storing your entire digital photo library or video projects online, be sure the content will be kept at its original file size, resolution, and file format.

>>>Go Further

SHUTTERFLY.COM ADVANTAGES

In addition to offering the features and functions of a cloud-based photo sharing service, Shutterfly.com, as well as many others like it, enables you to order traditional prints and enlargements that are created by a professional photo lab and then mailed within a few business days to the address you provide.

In addition, services such as Shutterfly.com enable you to design high-quality and highly personalized photo gifts/products, including T-shirts, mugs, mouse pads, holiday ornaments, and greeting cards that feature your photos.

Whether you use the Shutterfly.com website or the Shutterfly mobile app, designing and ordering prints and photo gifts is easy and affordable.

To discover discounts of up to 50 percent, plus free shipping options for your orders, before placing an online order with Shutterfly, click the Special Offers menu option tab near the top of the screen.

Alternatively, using any search engine, enter the search phrase, "Shutterfly Coupon Code." You can often discover sales or special promotional codes that offer free ground or two-day shipping, and/or up to 50 percent off of an item, or your total purchase.

Sharing Photos and Videos Using Social Media

Literally billions of people from all over the world and from all walks of life are active users of online social media services, such as Facebook, Twitter, and Instagram. One of the most popular features of services such as Facebook is that you can easily share individual photos or groups of photos (within online Albums) with your online friends and family members. People can then

"like" or comment on your photos and potentially share them with their own online friends and acquaintances.

Setting up a free account so that you can use a social media service takes just minutes. Then you can upload photos and videos, plus share other types of content, interact with other people, and communicate in a variety of public or private ways.

Some of these services are set up to allow for private communication and the sharing of information between two people or small groups of people. Other services, however, are designed to be public forums. Thus, after you publish something online, it becomes accessible by virtually anyone.

Before becoming active on any of these services, for sharing photos or video, be sure you understand how the specific service works, and invest a few minutes to access and customize the Privacy settings associated with your account. Also, based on your personal comfort level, decide how much information you want to share within your public profile, for example, any information about yourself that's included within your profile becomes public and searchable.

USE APPS TO ACCESS SOCIAL MEDIA

One of the great things about accessing a social media service, such as Facebook, is that it's easy to use. From any computer that's connected to the Internet, simply launch the web browser and visit www.facebook.com. Then, sign in using your account username and password.

To make things even easier when using a smartphone or tablet, services such as Facebook, Twitter, Instagram, SnapChat, Vine, and YouTube have their own proprietary apps that make it easier to manage your online account and use all the service's features and functions directly from your mobile device. This includes the ability to share GoPro camera-created content.

Many smartphones and tablets, including the iPhone and iPad, have Facebook and Twitter integration built in to the operating system, as well as many of the apps that come bundled with the device. Thus, from directly within the Photos app, you can upload photos to your Facebook account in the form of a Status Update, Check-In, or online Album.

Sharing with Facebook

To share photos and videos, Facebook enables users to upload and post one or more images or video clips at a time to their Facebook Wall as a Status Update or Check-In Update, or just as easily create online Albums that can contain groups of images or video clips. (Check-In updates can only be done from a mobile device.)

Each photo or video that is uploaded to Facebook can include a text-based caption, location information, tags, as well as when the content was created. This makes it easy for people to share their experiences, in almost real time, from almost anywhere, using their smartphone or tablet.

Be Sure to Adjust Your Facebook Privacy Settings

When you have an active Facebook account, be sure to adjust your Privacy settings. There are many individual settings to adjust, but it's a good idea to invest the time necessary to do this. From any computer web browser, visit www.facebook.com/settings?tab=privacy.

From the Facebook iPhone/iPad app, tap the More icon at the bottom of the screen, scroll down within the menu, and tap the Privacy Shortcuts option. Then tap on each option separately from the Privacy Shortcuts menu to adjust individual settings.

There are several ways you can upload one or more photos (or video clips) to your Facebook account, and then share them with one or more fellow Facebook users. This can be done from the Facebook mobile app on your smartphone or tablet, from within the photo editing software or mobile app you're running on your computer or mobile device, or from your computer's web browser, for example.

In addition to various ways to upload photos (and video clips), you must also decide if the photo(s) will be part of a Facebook Status Update, a Facebook Check-In (which also shows your location), and/or a Facebook Photo Album.

Upload A Photo To Facebook

To update your Facebook Status using the web browser on your computer, and include one or more photos within that Status Update, follow these steps:

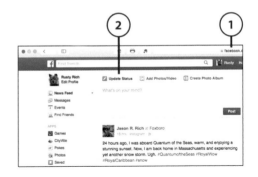

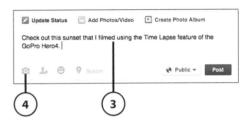

1. Launch your web browser and visit www.facebook.com. Log in, if you're not logged in already, so that you can see your Facebook timeline. (Not shown.)

2. Click the Update Status tab near the top-center of the browser window.

3. Within the What's On Your Mind? field, type any text you want to accompany your photos.

4. Click the camera-shaped Attachment icon located near the bottom-left corner of the Update Status window.

5. Locate and select one or more digital images or video clips that are stored within your computer and that you want to share on Facebook as part of your Status Update. The selected photo(s) or video clip(s) are displayed as thumbnails within the Update Status window.

Adding Details

You can use the tags, emoticon, or location icons to add further context to your post, such as who you're with, what you're doing, or where you are.

6. Click the Public button to alter the message's privacy settings. When set to Public (default), any Facebook user who views your profile or Facebook page can view your photos. If you select the Friends option, only your Facebook friends can see the posting that contains your photos. Click More Options to view and potentially select other privacy setting options that will apply only to this posting that you're currently composing.

7. Click the Post button to publish your Status Update and the photos or video clips attached to it on your Facebook Wall.

8. Within a few seconds, your Status Update is displayed on your Facebook Wall. It includes the attached photo(s) or video clip(s), for your online audience to see.

Add statement or emoticon **Add location**

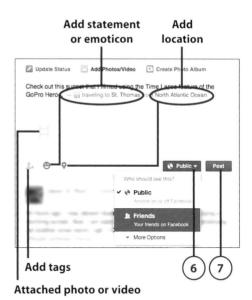

Add tags ⑥ ⑦

Attached photo or video

⑧

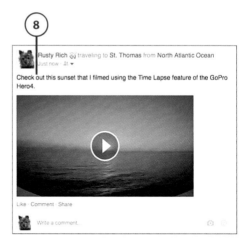

USING ALBUMS

If you want to create an album for uploading and organizing multiple photos or videos, instead of clicking the Update Status option, click the Create Photo Album option to create a separate online photo album that becomes accessible through your Facebook account. An album is a group of photos (or video clips) that are showcased together. An album can contain its own title and be kept separate from other albums. Each image or video clip can have its own caption, display tags, location details, and other information about the photo, including the date and time it was taken. Use albums to keep your images organized on Facebook.

Sharing with Twitter and Instagram

Twitter (www.twitter.com) and Instagram (www.instagram.com) are like scaled-down versions of Facebook; you can use them to share small amounts of information with online friends or the general public in a forum that's referred to as your timeline or feed.

One reason why Twitter and Instagram have become so popular is that they're designed to be accessed from a smartphone or tablet from virtually anywhere. Thus, it's easy to publish a photo or short video clip from wherever you are or communicate with online friends while you're out-and-about, sitting at your desk, or relaxing on your couch at home.

After setting up a free Twitter account, you can post individual messages (called tweets) that can contain up to 140 characters. You can also attach a single photo or video clip to each message, as well as your location information.

Twitter is useful for sending individual photos or short video clips with a short text-based message. Each time you publish a tweet, it's added to your timeline, which displays your tweets in chronological order, with the most recent tweet displayed first. The tweet also appears within the feeds of your followers as soon as it's published online.

BETTER VISIBILITY THROUGH HASHTAGS

To help people who aren't your online Twitter friends (referred to as followers) find and view your content, each tweet can be accompanied by hashtags, which include relevant keywords. For example, if you decide to post a photo taken with your GoPro camera that features you skydiving in Florida, hashtags within or at the end of the message might include #skydiving and #Florida.

Hashtags are searchable by anyone. So, while using Twitter, if you want to find other people online who are posting tweets about skydiving or visiting Florida, within the Search field, enter these hashtags.

Instagram works much like Twitter, but instead of focusing on text messages that can include a photo or video clip, Instagram showcases the photo or video clip but enables you to add a text-based caption (as well as other details about the photo, including tags).

After you set up a free Instagram account, you can publish one photo or video clip at a time, which can then be viewed by your online followers as well as the general public. By default, everything published on Instagram is public and searchable, again using hashtag keywords or searchable tags.

BENEFITS OF INSTRAGRAM

For GoPro users, one of the awesome features of the Instagram app that's available for virtually all smartphones or tablets is that after you import an image into the app, before publishing it on Instagram, you can use the app's powerful but easy-to-use special effect filters and editing tools to quickly edit or enhance the image.

Like Twitter, you can use Instagram to share short video clips, but the primary focus of this service is to allow users to quickly edit and share individual digital images. Prior to publishing an image, you can add a short, text-based caption, tag people in the photo, and add location information (and a map showing exactly where the photo was taken).

Tweet Photos from the Twitter App

To use the official Twitter app (on an iPhone, for example) to compose a tweet and attach a photo to it, find a photo you want to share and follow these steps:

1. Launch the Twitter app from your mobile device's Home screen.

2. Tap the Compose icon near the top-right corner of the screen.

3. Tap the Photo icon to attach a photo to your outgoing tweet. By default, the All Photos album is displayed.

Attach the Photo First

When composing a tweet, you typically have up to 140 characters for your message. When you attach a photo, however, this reduces your character count, so attach your photo first.

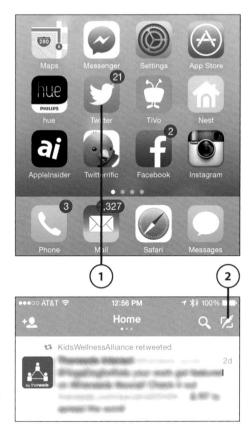

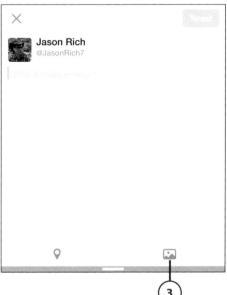

4. Locate and tap the image you want to include within your tweet. The image is attached to your outgoing tweet.

Optional Features

To add another photo, tap the "+" icon next to the image thumbnail within the Compose window. There are also buttons for tagging people featured in the photo, adding a location, and for making basic edits to the image.

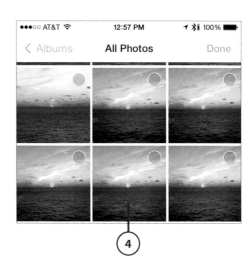

5. Enter a short message in the What's Happening? field. Located next to the Tweet button (in the top-right corner of the screen) is a character counter. This tells you how many characters you have remaining within your outgoing message.

Using Hashtags

Within the text-based portion of your message (or at the end of it), include hashtags that contain relevant keywords, so people searching for tweets under that hashtag can more easily find your photo. Each hashtag is always preceded by the "#" symbol.

6. Tap the Tweet button to publish your tweet. (Be sure to proof it first!) The tweet will become part of your Twitter timeline within seconds.

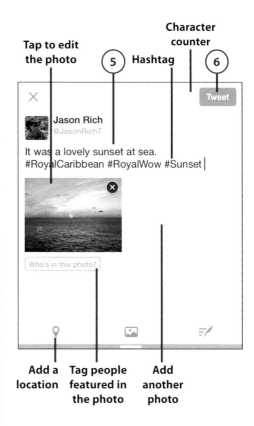

7. This is what your tweet will look like when your followers view it using the official Twitter app on their iPhone, for example.

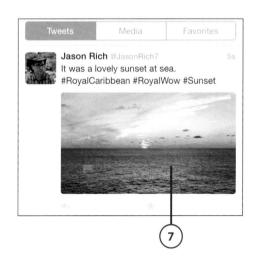

Tweet Photos from the Photos App

To compose and send a tweet from within the Photos app, using the Photos app on an iPhone or iPad, locate the photo within the app and follow these steps:

1. Tap the Select option in the top-right corner of the screen.

2. Tap the image thumbnail you want to send via Twitter to select it. A blue and white checkmark icon appears within that thumbnail.

3. Tap the Share icon near the bottom-left corner of the screen.

4. Tap the Twitter icon. Within the Compose Tweet window, your selected photo is automatically attached to the outgoing message (tweet).

5. Type your text-based message (caption). If you choose, add hashtags to your message. The character counter is located in the bottom-left corner of the message composition field.

Other Options

Tap the Location option if you want to share your location within the outgoing tweet. If you manage multiple Twitter accounts from your mobile device, tap the Account option to select which account you want to send the outgoing tweet from.

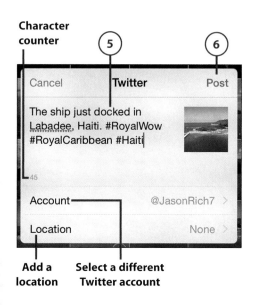

Character counter

Add a location

Select a different Twitter account

6. Tap Post to publish your tweet online.

It's Not All Good

Careful Tweeting

Remember that anytime you publish a tweet on Twitter, it becomes public information and searchable by anyone. If you follow someone on Twitter and they follow you, you can send a Direct Message, which in theory is private. However, the recipient can easily retweet your private message and make it public or share it with other people.

Publish A Photo On Instagram From Your iPhone/iPad

To publish an image on Instagram, open the app on your device (iPhone version is shown here) and follow these steps:

1. Tap the Photo icon at the bottom-center of the screen.

2. When the Viewfinder screen appears, tap the Image Thumbnail in the bottom-left corner of the screen.

3. From the Select screen, scroll through your images/video clips and tap the one you want to publish on Instagram to select it. That image will be displayed in a larger format, within the top portion of the screen.

4. Use a pinch finger gesture to zoom in/out, or place your finger within the image frame and drag it around to re-frame your image. Keep in mind that when you publish an image on Instagram, it uses a square-shaped image format.

5. Tap the Next option that's located in the top-right corner of the screen to continue.

6. Tap the Filters icon to see a list of available filters you can apply.

7. Tap an (optional) image filter to select (you can swipe up to see more). Each filter dramatically alters the image's appearance.

8. Tap the Brightness/Contrast icon to manually adjust the image's brightness and contrast using a slider. As you do this, your image is altered in real-time, so you can see the impact of the edit. Tap the checkmark icon to save your changes, or tap the "X" icon to abort your edits and return to the previous screen. (Not shown.)

9. Tap the Edit Tools icon (the right-most icon) to display Instagram's Photo Editing toolbox. Each of these tools has a different adjustable slider, so you can utilize it within your image. You use one or more tools to alter your image.

10. To use one of these tools, tap its icon.

11. To use the Saturation tool icon, for example, slide the dot on the Saturation slider to the right to intensify the colors within your image. Drag it to the left to soften the colors.

12. When you're done, tap the checkmark icon to save your changes and return to the previous menu, or tap the "X" icon to discard your changes (without saving them) and return to the previous menu.

13. After you have edited your image using one or more of the image editing and enhancement tools available, tap the Next option in the top-right corner of the screen.

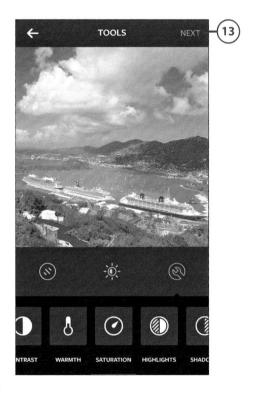

14. If you want to publish this photo so everyone on Instagram can potentially see it, tap the Followers tab (the default) near the top-center of the screen. Tap the Direct tab to send the image to just the Instagram users you select.

15. Enter a message within the Write A Caption field. This can include relevant hashtags. Tap the OK option to continue.

Other Options

As with Twitter and Facebook, you can add location information to your post or tag people featured in your post. To add a location, you first must turn on the Add to Photo Map switch. Your smartphone or tablet determines your location and allows you to select it.

16. If you have linked your Instagram account with other compatible social media services, like Facebook, Twitter, Tumblr, or Flickr, tap those icons if you want to simultaneously publish your Instagram posting on the services you select.

17. Tap the Share button at the bottom of the screen to publish your image on Instagram.

Add tags

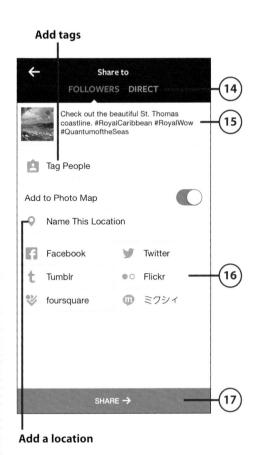

Add a location

OTHER SERVICES: SNAPCHAT, PINTEREST, AND TUMBLR

Many people, younger users in particular, have moved away from services such as Facebook and Instagram in favor of SnapChat (www.snapchat.com). The big differentiator with this service is that after a message (or photo/video clip) is viewed by the recipient, it automatically self-destructs and is deleted forever. Thus, there's no record of the message. If the recipient wants to save and potentially share the incoming SnapChat message, he can perform a screen capture by simultaneously pressing the Home and Power button on his iPhone or iPad; so, this self-destruct/privacy option that's built into SnapChat is not flawless.

Like Twitter and Instagram, SnapChat is designed for use on a mobile device using a proprietary app, which can be downloaded and installed for free. The iPhone/iPad version, for example, is available from the App Store.

Pinterest (www.pinterest.com) is another social media service that enables users to easily share one or more photos using a public online forum. This service's main emphasis is on sharing photos.

Tumblr (www.tumblr.com) is an easy-to-use (and free) blogging service that makes it easy to share photos or video clips with the masses. Using Tumblr, there's no page formatting or programming required to set up, maintain, and update your own Tumblr feed.

Publishing Videos on YouTube

Many GoPro users enjoy creating visually stunning HD videos of themselves engaged in all sorts of exciting adventures and then opt to share their videos with friends, family, and the general public.

YouTube (www.youtube.com) continues to be the world's most popular video sharing service and it's ideal for GoPro users for a variety of reasons. First and foremost, YouTube supports a wide range of video resolutions and formats, so you can use this service to showcase your video projects exactly as they were intended to be viewed.

YouTube integration is also built in to many video editing apps, including GoPro Studio, so as soon as you finish editing your project, you can upload the video to your personal YouTube Channel and begin sharing it online.

If you plan to create content to be shared on YouTube, you need to create a free YouTube Channel. This is your own virtual space on YouTube where you can store and showcase your video projects. After you create a YouTube Channel, you can adjust a wide range of privacy options, so you can make your entire channel accessible by the general public or lock it down so only certain people (who you invite) can access it.

You can also adjust privacy settings for individual videos. This makes it an ideal (and free) online backup and archival service because you can upload a video and make it private, so only someone signed in using your personal account can access and view it.

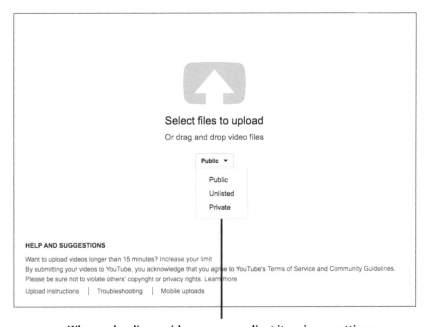

When uploading a video, you can adjust its privacy settings.

YouTube, however, is designed to be a public forum. Thus, when you upload a video, you're asked to provide a title, description, keywords, location information, and other information that all becomes searchable and makes it easy for people who don't already subscribe to your YouTube Channel to find and view your content.

YouTube Is Owned and Operated by Google

Because Google owns YouTube, within moments after you publish video content on YouTube, it becomes searchable via both YouTube and Google. While Google is the world's most popular Internet search engine, YouTube is ranked the second most popular.

When someone subscribes to your YouTube Channel, they're notified each time you upload and publish a new video. Anyone who views your videos can "like" or "dislike" the video with a single click or write a text-based comment about the video. These comments can be made viewable by the general public or by just the YouTube channel operators.

YouTube is an advertiser-supported service. Thus, when people view your videos, they may see different types of ads within or around the video window. In some cases, a short TV commercial-like video will play before the selected video, or a banner ad will be superimposed over the lower portion of your video for a few seconds as it starts playing. The good news is that as a content producer, if you start getting a lot of views for your videos, YouTube will share this advertising revenue with you.

For the average GoPro videographer, however, YouTube offers a simple and free way to share HD video with friends and family, or the general public, through this extremely popular and ever-growing online community.

There are many ways to publish a video on YouTube. This can be done directly from some video editing applications running on your computer, from the web browser on your mobile device, from the official YouTube app that's running on your mobile device, or from your computer using your favorite web browser.

Upload and Publish a Video on YouTube

To upload a YouTube video from your computer using a web browser, follow these steps. You must already have a YouTube Channel created in order to do this.

1. Launch your computer's web browser and access the YouTube website at www.youtube.com.

Be Sure to Sign In

If you have not already done so, click the Sign in button in the top-right corner of the browser window. When prompted, enter your YouTube username and password, or select the saved account details from the displayed menu. (Not shown.)

2. Click the Upload button in the top-right corner of the screen.

3. Click the large Select Files to Upload icon near the center of the browser window.

4. Select the video file you want to upload that's stored within your computer.

5. Select Choose (this button's label will vary depending on your web browser).

6. Wait while the video uploads. Depending on the length, resolution, and file size of your video, as well as the speed of your Internet connection, the upload process can take a while.

7. Fill in the various fields displayed within the Upload Progress screen, adding a title, description, and any keyword tags you want to associate with your video.

8. Adjust your video's Privacy settings by clicking the Privacy option. Public is the default option, but you can also choose to make your video Private and accessible only by invite; Unlisted isn't searchable and requires viewers to navigate directly to its web address.

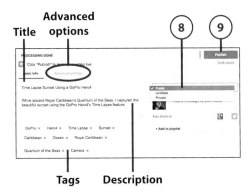

9. Click the Publish button when you're ready to publish your video. If the video was set to be Public, it will become accessible to others almost immediately after it's published online.

Keep it Searchable

Everything you type within these fields is searchable on YouTube, Google, and other search engines, so use keywords and descriptive phrases directly related to your video's content. When entering tags, separate each word or phrase with a comma.

Advanced Options

The options available under the Advanced Settings tab allow you to adjust additional options related specifically to the video you're uploading. These options include controls for comment moderation, video category, and more. You can learn more about uploading to YouTube at the YouTube Support web page at https://support.google.com/youtube/.

Making Changes

At any time in the future, you can access your YouTube Channel Video Manager page by clicking the menu icon near the top-left corner of the screen (or by visiting www.youtube.com/my_videos) in order to adjust your video's settings and accessibility.

SHARING VIDEO ON VINE

Instead of sharing longer length HD video, if you want to share short video clips, Vine (www.vine.com) enables people to produce and upload six-second looping videos and share them with the Vine community, primarily via their smartphone or tablet.

Sharing Photos and Videos via the GoPro Channel

GoPro, Inc. started by developing, manufacturing, and selling its ultra-small digital camera. However, GoPro camera users have become so dedicated to the cameras, and the GoPro brand, that a large and ever-growing community has emerged.

This is because most GoPro users are not professional photographers or videographers. Instead, they're everyday people who enjoy adventure, activity, and capturing the world around them in vibrant digital photos or using HD video.

Some GoPro users excel in a particular sport or activity, and use their GoPro camera to share what they do with the world from a unique first-person video perspective.

To help these people, as well as everyday GoPro camera users share their video projects and photos with the GoPro community, the company has created the GoPro Channel. Accessible from the GoPro website (www.gopro.com), as well as via the GoPro App on any smartphone or tablet, this free service works something like YouTube and enables people to publish and share their GoPro photos and videos with the public.

Every hour of everyday, new content is added to the GoPro Channel by people just like you, as well as professional adventurers and athletes that GoPro works with. So, anytime you access the GoPro Channel, you have the opportunity to experience other people's adventures from a point of view that GoPro cameras can capture brilliantly.

Access the GoPro Channel

To access the GoPro Channel, follow these steps:

1. From any Internet-enabled computer, visit www.gopro.com and click the Channel option near the top center of the screen.

2. From the GoPro mobile app, tap either the GoPro Channel option to watch video or the Photo of the Day option to view other people's digital images taken using a GoPro camera.

Sharing to the GoPro Channel

As a GoPro user, you are welcome to share your content via the GoPro Channel, providing the content meets the community's guidelines. To do this, access the GoPro Channel web page, and click the Submit Your Photos or Videos button. Then from the Show Us What You've Got screen, click the Get Started option. You need to create a free GoPro Channel account, which includes creating a public profile.

Not all photos or videos uploaded to the GoPro Channel actually are featured. The GoPro Channel's operators curate the channel and select only the best of the best to showcase.

To reward participants, prizes are given out to content providers on a regular basis. Details for the GoPro's photo and video contests can be found on the GoPro website.

Upload to the GoPro Channel

You can upload videos or photos you've shot using your GoPro camera so that they might be published as part of the GoPro Channel's ever-changing content. One way to do this is from your Internet-enabled computer, using your web browser. Follow these steps:

1. Launch your computer's web browser and visit www.gopro.com. (Not shown.)

2. Click the Channel option near the top-center of the browser window.

3. Click the Submit Your Photos or Videos button below the Video of the Day menu.

4. From the Show Us What You've Got screen, click the Get Started button.

5. Log in to your GoPro Channel Email Address and Password. (If you don't have an account set up, you need to create one.)

6. From the Submit Your Best GoPro Photos and Videos screen, click the Select Files button to locate the content you want to share online and select it.

7. Select the video or photo file you want to upload from your computer.

8. Click the Choose button (the label may vary based on your web browser). Your content will start uploading to the GoPro Channel. During this upload process (which could take a while, based on the file size of your content), a Status Meter is displayed near the top of the browser window. When the upload process is done, the Finished Uploading message appears.

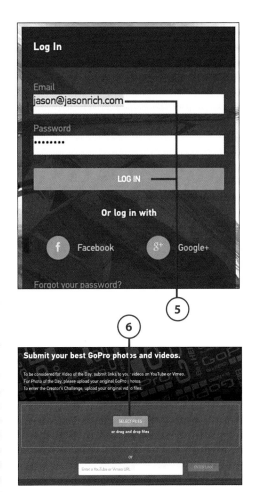

9. Fill in the Title, Location, Description, Activity, and Products Used fields with information that's relevant to your video.

10. Click the Accept Terms & Conditions button to confirm your video adheres to the GoPro Channel's guidelines.

11. Click the Submit button. At this point, it will be up to the people who curate the GoPro Channel to determine if your content is suitable and worthy of being published as part of the GoPro Channel. Uploading your content to the GoPro Channel does not guarantee it will be published online for all to see. If you want to guarantee your video will be viewable by the public, publish it on YouTube.

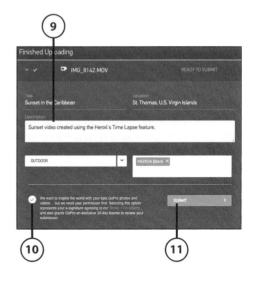

Other Ways to Showcase Your Photos and Videos

After you shoot photos or video using your GoPro camera, you can showcase or share that content in literally hundreds of other ways. Here's just a sampling of what's possible after you transfer and edit content to your mobile device or computer.

Ways to Showcase Photos

Following are some of the ways you can share and showcase digital photos shot using your GoPro camera:

- Create traditional prints, which can be framed or displayed within a photo album, scrapbook, or within a picture frame. Do this using a home photo printer, 1-hour photo lab, or photo service (such as Shutterfly. com).

- Display your favorite images as your computer screensaver or as the wallpaper on your smartphone or tablet. This is set up from the computer's operating system Control Panel. On a Mac, open System Preferences, and then click the Desktop & Screen Saver option. Using an iPhone or iPad, launch Settings, tap the Wallpaper option, tap the Choose a New Wallpaper option, and then follow the onscreen prompts.

- Create a professionally bound photo book that showcases your photos in a hardcover or softcover book that you create. Many photo book publishing companies offer free photo book design software and then handle the printing and binding. Blurb.com is one example.

- Display the photos on your HD television screen either directly from your camera or via your computer or mobile device. Do this using a special cable that connects between the micro-HDMI port within your camera and the HDMI port on your HD television set or wirelessly via your mobile device (as long as your TV has compatible equipment to handle this feature).

- Instead of creating traditional enlargements, have your images printed on canvas, wood, plastic, or other material that can display on any wall without using a traditional frame. Most 1-hour photo labs, as well as online photo services (such as Shutterfly.com, fotoflot.com, or EasyCanvasPrints.com) offer this service.

- Send photos via a text message to others via your smartphone.

Ways to Showcase Video

Following are some of the ways you can share and showcase HD video taken using your GoPro camera:

- Create and distribute DVDs that can be played on any DVD player. Most video editing software offers this option, providing you have a writable DVD drive connected to your computer.

- Copy your HD video files to a flash memory card (thumb drive) and distribute them to friends and family.

- Upload your video to a video sharing service, such as YouTube.

- Watch your edited videos on your computer or mobile device.

That's a Wrap!

Now that you understand how to operate your GoPro camera, and you've learned a handful of useful photography and videography strategies for creating professional-quality content, the rest is up to you.

Your GoPro camera is extremely powerful and enables you to capture photos or video in ways that have never before been possible. Use this technology to your advantage, and begin capturing moments and activities in your life that you want to remember and share with others.

Never before has taking high-resolution photos or shooting HD video been so accessible to so many people, at a relatively low cost. It's now up to you to use this ultra-compact and durable technology in creative and fun ways. As you've seen throughout this book, and as you can see on YouTube or the GoPro Channel, the possibilities are truly limitless.

Welcome to the GoPro community!

Index

B

F

I

J-K

L

W-X-Y-Z

REGISTER THIS PRODUCT
SAVE 35%*
ON YOUR NEXT PURCHASE!

🖥 How to Register Your Product

- Go to quepublishing.com/register
- Sign in or create an account
- Enter the 10- or 13-digit ISBN that appears

es
rkshop files
next

n
column

ions and

y by product.
egistered Products.

s will not be sold to

ation is valid on most
QuePublishing.com.
and is not redeemable
he time of product